Second Edition

Selling Art
WITHOUT
Galleries

*Toward Making a Living
from Your Art*

Daniel Grant

ALLWORTH PRESS
NEW YORK

Allworth Press books may be purchased in bulk at special discounts for sales promotion, corporate gifts, fund-raising, or educational purposes. Special editions can also be created to specifications. For details, contact the Special Sales Department, Allworth Press, 307 West 36th Street, 11th Floor, New York, NY 10018 or info@skyhorsepublishing.com.

21 20 19 18 17 5 4 3 2 1

Published by Allworth Press, an imprint of Skyhorse Publishing, Inc., 307 West 36th Street, 11th Floor, New York, NY 10018. Allworth Press® is a registered trademark of Skyhorse Publishing, Inc.®, a Delaware corporation.

www.allworth.com

Cover design by Mary Belibasakis
Cover illustration by iStockphoto

Library of Congress Cataloging-in-Publication Data

Names: Grant, Daniel, author.
Title: Selling art without galleries: toward making a living from your art /
 Daniel Grant.
Description: Second edition. | New York: Allworth Press, 2017. | Includes
 index.
Identifiers: LCCN 2017041469 (print) | LCCN 2017042597 (ebook) | ISBN
 9781621536161 (E-book) | ISBN 9781621536116 (pbk.: alk. paper)
Subjects: LCSH: Art—United States—Marketing.
Classification: LCC N8600 (ebook) | LCC N8600 .G715 2017 (print) | DDC
 706.8—dc23
LC record available at https://lccn.loc.gov/2017041469

Print ISBN: 978-1-62153-611-6
Ebook ISBN: 978-1-62153-616-1

Printed in the United States of America

Contents

Introduction

Difficulties (and Benefits) of Going It Alone

FOR MANY UP-AND-COMING ARTISTS, THE GOAL MAY be getting into a gallery. That is not necessarily the same goal as selling their work or supporting themselves from those sales, but it is easy to get lost in the idea that a gallery equals prestige, art world acceptance, and a ready group of buyers. Certainly, galleries stay in business because they do sell artwork, but not every artist they show or represent makes out as well as every other. Lots of gallery shows take place that do not result in sales or reviews; they may not be advertised or memorialized in a catalogue (two expenses on which dealers increasingly have cut back), and the exhibiting artists may find themselves out the costs of framing, shipping, and insurance (dealers have cut back there, as well). Too, lots of places that call themselves galleries primarily make their money as poster or frame shops, with original art as a sideline. Added to this, there are far more artists wanting to exhibit and sell their work than galleries to show it.

A growing number of other artists are looking at galleries as just one part—perhaps, not even a part at all—of their plans to show and sell work. They look to a variety of exhibition venues, such as nonprofit art spaces, cooperative galleries, art fairs, and even their own studios, to present their work, unmediated by a dealer who also takes a hefty percentage of the sale price. These artists are also aware that they can speak for their art better than any third party and that, in fact, many collectors are eager to speak with the artists directly rather than with a gallery owner.

"Some artists just want to live like hermits, sending in their art to a gallery and otherwise avoiding the art world, but not me," said seventy-something-year-old Pop Art painter James Rosenquist. "I like to meet my

collectors." He has had a lot of that in the past few years, having left New York's Gagosian Gallery in a dispute ("There was no communication. I said to Larry, 'I can never talk to you,' and he said, 'That's the way it is'"). And, for a number of years before returning to a gallery's fold, he was the main source of his new and unsold older work for would-be collectors, handling inquiries out of his studio. There had been commissions and get-togethers with younger and more mature buyers. Perhaps some of the face-to-face stuff lost its appeal, but there are some benefits, principally not having to lose so much of the sale price in a gallery commission and not needing to rely on those mercurial beings called dealers.

Rosenquist has not been alone in this. Painter Frank Stella also has taken on the responsibility of arranging exhibitions and commissions. "As Barnett Newman used to say, 'I'm flying under my own colors now,'" Stella said. He does claim to enjoy acting as the primary agent for his own sales: "I'm not particularly good at it, and I don't particularly like doing it, but that's life. Someone has to sell the pictures." One trend that has emerged in the 1990s is for artists to reject an exclusive relationship with a particular dealer, opting instead for what painter Peter Halley called "a constellation of galleries that represent my work." Exclusivity means that all exhibitions and sales go through a particular dealer. Halley had exclusive relationships with the Sonnabend Gallery and Larry Gagosian but left both in part because dealers elsewhere did not want to share sales commissions with New York galleries, resulting in lost sales. "Seventy-five percent of my market is in Europe," he said. "My collectors are not likely to come to New York to buy. Dealers in Europe chafe under the requirement that they pay half of the commission they earn to my New York dealer. Europeans like to buy from dealers they know and trust and with whom they have a personal relationship. For instance, I have found that German collectors will only buy from a German dealer. I found that I could do better establishing relationships with half a dozen dealers around the world than by participating in an exclusive relationship with a New York dealer."

His point has been taken: artists are no longer willing to be defined by their gallery, and a growing number have grudgingly or happily taken on the job of promoting sales of their own work. In the last nineteen years of his life, Andrew Wyeth, who died in 2009, had not been represented by any commercial art gallery. However, he continued to produce new

work, directing particular pieces to an agent in Tennessee and others to galleries in a few cities around the United States.

Halley's other point has also been heard, as dealers are recognizing the need to pursue sales opportunities around the world, traipsing from art fair to art fair, spending less time in their galleries even while some artists strive to get into them. (Perhaps gallery owners have been learning what the artists and craftspeople who regularly participate in arts festivals have long known.) More and more, these fairs are where the action is, where a growing chunk of the contemporary art market is going on. New, and sometimes staggering amounts of, wealth are being generated in China, Russia, the Middle East, and a variety of countries that used to be categorized as the Third World, and these new buyers expect sellers of art to come to them rather than their having to travel to New York or London, for example. In many instances, dealers have the artist on hand at these fairs to meet with prospective buyers, because they also know that collectors frequently want to meet the creator and that investment in time makes a sale more likely. In addition, when they are not packing for the next art fair, dealers are spending an increasing amount of time online, sending JPEGs to would-be collectors and arranging sales to people around the world. The traditional brick-and-mortar gallery still has primacy, but far less than five or ten years ago. It is sometimes thought that by working outside the dealer-gallery-artist-critic-curator nexus, artists are isolating themselves from the value mechanics of the market for art, limiting their prestige and prices. However, the changing patterns of exhibiting and buying art have weakened somewhat that center of power.

One also sees that museum curators more and more are on the prowl for new artists, refusing to wait for gallery shows and purchases by collectors to affirm the importance of artwork—almost all of the exhibitions to date of digital art have taken place at museums and fairs, for instance. These curators of contemporary art know that the work of less-well-known artists may become expensive seemingly overnight, and they have become aggressive in seeking out pieces that their limited budgets can afford, rather than wait for donations sometime down the road.

There still is a place for the artist who wants to be a hermit (albeit a hermit with a large following of collectors), and certainly, not every artist has the personality or temperament to be the spokesperson and seller of his or her own work. Talking about one's own art, determining

the audience for that art, promoting it, and negotiating its price are not skills that anyone is born with: these need to be learned and, like everything else, require practice. This book describes what is involved in artists exhibiting and selling their work directly to the public and where much of this activity takes place. The ideas and examples presented are drawn from the experience of artists themselves, as often as feasible in their own words, rather than a dry discussion of theoretical possibilities. This is not a how-to book, but a description of options available to artists; being grown-ups, artists can determine for themselves the avenues they choose to pursue. Right and wrong take a back seat to what has or has not proven effective for certain artists. The only directive is for readers—artists—to think of themselves as directing the course of their own careers, not waiting for the career to begin when someone else takes over the business aspects and not requiring some gallery owner to validate them as professionals.

CHAPTER 1

Adjusting One's Expectations

BETH KANTROWITZ, AN ART ADVISOR AND ONE-TIME director of the Allston Skirt Gallery in Boston, Massachusetts, tells her mostly emerging and midcareer artists the same thing before a show and after a show. "I always say, the show will be the best we can do," she said. "I can't promise that we will sell anything. I can't promise that the artist will get a review." Such candor and earnestness should go a long way toward assuaging dashed hopes, yet Kantrowitz must still face some bitterly disappointed artists who had expectations for something much better. Some percentage of these artists believe (dream?) that the exhibition will sell out, that reviews will be written (and be glowing), that a major New York City gallery will snatch the artist up, the cover of *Art in America* and museum retrospectives to follow.

Are You Being Realistic?

And why not? Most students in art schools and university art departments are only connected to the practicing art world through the art magazines, which highlight success and the latest new thing. Expectations soar for something big and soon to happen, and the reality rarely comes close. Kantrowitz stated that an artist "should expect a gallery to do with it says it will do," but some artists hear more than the words spoken to them.

Unrealistic expectations may get in the way of building a career—for instance, if the artist launches into a diatribe when sales and acclaim do not follow the very first exhibition ("The critics hated the Impressionists, too"), or if a dealer or exhibition sponsor is treated as a stepping stone to another that is more prestigious, or if useful gallery

affiliations are passed over because an artist has his or her heart set on a particular dealer. Such expectations can lead to self-defeating behavior (the artist strikes people as angry, the artist doesn't work as hard or produce as much). Framingham, Massachusetts, painter Ben Aronson noted that, early in his career, he had sabotaged relationships with some dealers by being too "self-directed," rarely talking with the dealers and gallery staff, never showing up at gallery openings and other events. "You can't just produce work, send it on to the gallery, and expect everything to go well," he said. Another painter, John Morra of Stuyvesant, New York, claimed that he took a bad attitude toward galleries into his first meeting with San Francisco art dealer John Pence. His friend and former teacher Jacob Collins "got me into the John Pence Gallery by going to bat for me," Morra said, but at that meeting "I was being grumpy and weird, saying, 'I don't want to be a careerist.' At the time, I thought that supporting myself as an artist was selling, but John Pence said to me, 'Young man, you should make a more professional presentation.'" Time and economic necessity brought a change in Morra's thinking.

One self-defeating belief is that pursuing potential buyers and sales is contrary to the nature of art, and that such a use of time should be labeled "careerism." (There are a lot of terms that artists who do not have a history of sales use to boost their own egos and others—derogatory—for artists who do exhibit and sell.) Collectors, critics, and dealers don't beat a path to one's door, and artists need to be proactive in presenting themselves and their work to a world in which there is an ever-expanding oversupply of art.

The artists on whom this more assertive approach is probably the most incumbent are those living in rural areas, apart from other artists (who could provide support and feedback) and separated by vast distances from exhibition opportunities. There are often few places to find certain art supplies, as well as discrimination against these artists both within the rural setting (where they may be viewed as oddballs) and in the larger cities (simply because the artists live in the boondocks). Artists who put where they want to live ahead of where the art scene is happening sometimes adjust to their surroundings in the way they buy materials and ship artwork (downsizing their pieces, reducing weight, or even changing media, from oil on canvas to watercolor on paper), learning

how to build a crate (to save money on shipping), buying a comfortable van or station wagon and learning to enjoy long rides (distances west of the Mississippi are measured less in miles than in hours in the car). They may focus on the local audience, offering lower-priced pieces (watercolors are less expensive than oils) of recognizable subject matter, or they might gain local attention through teaching and demonstrations (at libraries and local clubs, for instance), which, perhaps, will turn some locals into buyers. They join clubs, societies, and artist membership organizations, as well as get on the mailing list of the state arts agency (which sends useful information about art competitions and news in the field), and develop good work habits that allow them to continue working at a high level even when lonely.

Expectations change through life experience. When he entered an art career, Longwood, Colorado, painter Scott Fraser looked for one big, powerful gallery—such as Marlborough or Pace Wildenstein in New York City—to handle his work. His experience with some larger galleries led him to see that "I like more galleries and smaller ones, where I can talk to the director." In addition, he found out "pretty early out of art school that I can't just do one big painting and assume that will make my reputation. Now, I want to sell regularly."

Part of the maturation process for an artist is learning to align one's hopes with reality, or it may entail changing the reality. Daniel Sprick, a painter in Glenwood Springs, Colorado, spent twenty years grumbling about what his dealers were not doing for him. In 2002, he decided to become his own dealer, advertising in *American Art Review* (always including the line "No dealer inquiries"), developing a website, and selling his work directly to buyers.

"When I left school, I thought I'd get a dealer who would take care of all the selling and financial stuff, so all I would have to do is paint," he said. He went through a number of dealers—there was a problem with almost every one—before becoming his own salesman. Sprick claimed that he does a superior job of discussing his artwork than any dealer ever did ("When you communicate through an intermediary, a lot is lost," he said. "No one cares about your baby the way you do"), and he prefers to earn all of the money from sales rather than just half. "When I had heard of other artists who were selling their own work, I thought they were crazy, egomaniacs," he said. "There is a specter of self-promotion that is

ugly, but I'm over that now. I serve my needs better than anyone else." He added that "all my work of the past two years has sold."

Much of what an artist wants to happen might happen anyway, but the process may take a far longer period of time than he or she anticipates. The 1980s generated the idea of the fine artist as rock star, coming on fast and furious at a young age, entering the international art circuit, cashing in quickly because no one lasts more than a decade. It can happen, it has happened, but it doesn't happen very often. Julian Schnabel, David Salle, Mark Kostabi, Robert Longo, Kenny Scharf, and a variety of others may not be the most appropriate role models for artists, who, instead, need to understand that it takes years to develop a collector base.

Nobody paints simply to have a studio filled with paintings. Art is a form of expression, and artists, like everyone else, want their voices to be heard. But they want more than to have their works seen; they want appreciation and esteem, they want their work to be coveted. If they see themselves as professionals, artists want sales and they want to be written about; dare we say they want—fame? A person who decides to become an artist primarily because he wants to be a celebrity or because he wants to prove he is unique is likely to be disappointed. In a world where there appears to be an oversupply of artists, many feel the need to stand out from the crowd: Will artwork that shocks public sensibilities or blocks traffic do the trick? Certainly, as many artists discover, renown is quite limited in scope and brief in duration, and even successful artists—success defined as the ability to support themselves from the sale of their work—remain on fame's periphery.

Expectations aren't something that only get lowered; in time, they may broaden and reach unanticipated levels. When she began her career, Watertown, Massachusetts, artist Susan Schwalb wanted her work in the type of New York galleries that didn't exhibit her type of art, just because they were the "hottest" galleries, and she "wanted to be on the cover of *Art in America*, like someone else might want to be Miss America." Neither of those hopes panned out, but her work was taken on by a Manhattan art dealer (Robert Steele Gallery) and a half dozen others around the country as well, and her goals changed with the increasing number of sales during the 1990s. "At a certain level, you begin to see the possibilities at a higher level," Schwalb said. "The Museum of Modern Art owns one of my works; I want them to acquire more. I would like a print

publisher to come to me to produce an edition of prints. I would like a write-up in the *New York Times*. I'd like a retrospective at a museum and a book about my work. When I started out, I wouldn't have been thinking in these terms, but now I don't see it as so unrealistic."

Marketing Artwork

Before trying to sell anything, one needs to find the appropriate audience. This is the central concept of marketing, and it is as true for artwork as it is for toothpaste and automobiles. Not everyone is going to want to buy a work of art, and not everyone who collects art is likely to purchase a particular artist's work. Finding the right niche—the type of collectors who are interested in art, or the specific galleries or juried art shows featuring a certain type of artwork, for example—is the most important first step to developing sales.

There is often a lot of trial and error in marketing as artists winnow down the potential avenues for sales to those that show the best results. "I used the spaghetti method of marketing," said James Wall, a painter in Charlottesville, Virginia. "You throw spaghetti at the wall and what sticks you stay with." He tried sending out brochures of his work to art consultants ("haven't done a great deal for me"), art dealers ("not a lot of interest"), licensing agents ("nothing has happened"), and print publishers ("nothing"). He offered to paint a mural on the wall of a restaurant for the modest price of $2,000, believing that "a lot of people will see my work that way," and that has resulted in some sales to diners.

Most successful for him has been entering local art exhibitions, where digital reproductions of his botanical motif paintings have sold to both Charlottesville natives and tourists, usually while he is present. For all the effort Wall has put into his paintings and brochures, it is his personality that assures potential buyers that his artwork is the product of someone in whom they can feel confidence. "I used to worry about what to say to people when they looked at my work," he said. "Often, I didn't say anything, or not much. Then, I relaxed about the whole thing and just started talking naturally to people, about their children, about the weather, about anything. If they asked me questions about my work or my technique, I would answer them, but I never put pressure on anyone to buy something." Based on his experience, Wall now makes a point of

being at shows of his work as often as possible, "because my presence really has an effect."

Like James Wall, New York City abstract expressionist painter and printmaker Mike Filan also struck out in a variety of directions when he first began to seek his market, investing $8,000 one year for a booth at the annual Art Expo in Manhattan ("I sat there for a week, and people just walked by") and $300 for a booth at the annual conference of the American Society of Interior Designers ("it didn't pan out for me"). Yet another $300 was spent on bottles of wine ("good wine seemed like the capper") for a three-day open studio sales event that a friend who was looking to become a corporate art consultant organized on his behalf, but that also didn't result in any sales. In contrast to James Wall, the benefit of his presence and personality did not create any converts; however, Filan did have more luck than Wall with brochures.

He spent $2,000 to print 4,000 foldout brochures that featured a number of color images of his work with a small bio on the back and another $2,000 for mailing. Filan was fortunate that the design of the brochure by another friend only cost one of his prints in barter. Several hundred dollars were also spent on purchasing mailing lists of art dealers and consultants. Between 5 and 7 percent of those people to whom he sent a brochure responded to his mailer, and "out of that, three percent have actually sold work," he said. "All you need is one, two, or three corporate consultants to sell your work regularly." Most of the sales have been prints—a dealer in Florida sold five, while a dealer in Texas sold ten, and there were sales of five others to Colgate-Palmolive, ten to Pfizer, and twenty to a group of teachers. All in all, Filan has earned $30,000 from that one mailer.

Joan Gold, a painter in Eureka, California, has also had success marketing artwork to consultants who, in turn, act as agents for her work to private—usually corporate—clients, taking a percentage of the sales price (from 30 to 50 percent) as a commission. "Eureka is at the end of the world," she said. "There aren't many galleries close by." She added that her few experiences going from one gallery to the next were "just plain bad."

Gold purchased her list of consultants from artists' career advisor Caroll Michels and sent each person on the list a brochure of her work. The result was responses from dozens of consultants to whom she began

sending out her original paintings, rolling her canvases and placing them into hard cardboard tubes that are sent through Federal Express. "The benefit of consigning work to consultants is that you get a commission without additional expenses," she said. "The consultant pays for framing." Gold works with thirty consultants, twenty of whom are actively promoting her paintings at any given time, and "I keep in touch with all of them by cards, mailers, phone calls—they need to be reminded of who you are and what you do." One or two paintings (with an average price of $3,000–$6,000 before commission) sell somewhere each month, and she has sold between fifteen and twenty paintings per year.

There are probably as many successful approaches to marketing art as there artists who have sold their work; some artists have sold work through a website, while others earn a following at selected juried art competitions. Still other artists maneuver to know the right people.

When selling on their own, many artists also have found it advisable to have a friend, relative, or spouse on hand at exhibitions, art fairs, and open studio events in order to take on some of the business aspects of marketing and sales, allowing the artist to take a more Olympian role (talking about art, sources of inspiration, technique, philosophy, or artistic influences, among other topics). A spouse, for instance, might lead visitors over to the guest sign-in book or discuss the price range for artworks on display or just chat up guests who show interest in the art. What type of art do they like? Whose artwork have they purchased? Where do they live? What are their domestic arrangements? Do they have children? Where do they work? What are their hobbies or interests? Are they members of any clubs or associations? This is the kind of survey information that constitutes marketing and, when conducted informally, is not likely to irritate visitors. Most people like to talk about themselves, and the information that an artist or a spouse/friend/relative can gather will help determine where future exhibitions should take place and who should be invited.

For instance, the artist's spouse/friend/relative might say, "I noticed you've been looking at this painting for a while. It's one of my favorites. What do you like about it?"

Or, "Have you seen this artist's work before? Would you like to meet him/her? I would be happy to introduce you."

Determining one's audience is crucial, because not all art appeals to everyone. Some artwork may find a greater response among women than

men, homeowners rather than apartment dwellers, corporate office decorators more than homeowners, the young more than those over forty. The knowledge will inform where future exhibitions might take place.

Exhibits ought to be seen as an element of marketing rather than just a vehicle for sales. Art shows are major events for artists, but to most other people, they come and go without leaving much of a trace, maybe a line on a résumé; a catalogue provides a record of an exhibition and gives a longer afterlife, but catalogues are expensive (the artist usually pays all or most of the costs) and usually are not produced. Often, artists go a year or two or three between shows, and it is not at all clear that the people who came to the last show will remember whatever enthusiasm they might have felt back then when the next exhibit occurs, if they even recall the artist's name. Artists need to maintain contact with the people who visited their shows (the guest sign-in book isn't just a formality) in those in-between times through periodic mailings of postcards, brochures, or newsletters that describe what the artist is doing—such as having a new exhibition, producing a new series of prints, teaching a class or workshop, giving a talk—and many of these communications can be personalized, depending upon how much information the artist has accumulated about the recipient: As the holiday season is approaching, how about buying your wife something unique for Christmas/Hanukkah/Kwanza/Ramadan (better find out which one), such as an etching? What could be a better way to celebrate your twenty-fifth wedding anniversary than a statue? Now that you bought that summer cottage on Martha's Vineyard, you are probably turning your thoughts to decorating. . . .

Exhibitions start a process of developing a network that, eventually, may become a customer base. Of course, artists are not starting from zero in this; they already know people—colleagues and supervisors at work, friends and relatives (who also have colleagues and supervisors)—who know other people, and this may build out into an extensive list of potential collectors. If new exhibition opportunities are not soon in coming for a growing list of interested people, artists may create their own, by opening up their studios for visits (see Chapter 3), creating a display of work in their own home or that of a friend, bringing work to the home or office of a prospective buyer (a modified Tupperware party), or arranging an exhibition at nonprofit (library, arts center, senior center, town hall) or commercial (bank lobby, restaurant, book store) space.

It was more than serendipity that enabled Denise Shaw, a yoga instructor and painter of abstract imagery on Japanese rice paper using oriental brush techniques, to sell all of the works from a show hung at the Yoga Connection in downtown Manhattan. A suitable mix of Eastern-oriented art and an audience of people involved in an Eastern exercise and meditation was the key. The Yoga Connection did not have a gallery space, but Shaw identified an opportunity and seized it. She also received several commissions for new work from people who practice yoga there and saw her art. "My work appeals to a certain kind of person who practices yoga who is into my use of psychological concepts and poetry," Shaw said. Noting that her work regularly is displayed at the Yoga Connection, she called the studio "a pretty good venue for me," far superior to the commercial, nonprofit, and co-op galleries where her work has been exhibited in the past that did not result in sales.

While some marketing efforts are hit or miss, others are the result of painstaking planning and research. Painter and printmaker Anne Raymond, based in Long Island, New York, scours art and general interest magazines (*Art in America*, *ARTnews*, and *New Republic*, among others) for the type of artwork that is appreciated and bought in certain cities around the United States ("the prices for my paintings are just too low for New York City, under $10,000"). She hones in on the galleries that feature realist painting in these cities, looking for the type of artists represented there and the price range, as well as how long they have been in business and their location. Many galleries also have their own websites from which other or corroborating information may be obtained. Finally, Raymond travels to the city—she averages two of these business trips per year (to Santa Fe, New Mexico; Scottsdale, Arizona; Boston; Philadelphia; Chicago)—to look at the galleries in person and show her work.

The level of courtesy that she finds at the gallery is very important to her—"if anyone is snobby or rude to me, that's a turnoff right away from an artist's point of view or a customer's"—and Raymond also checks that the information she read or heard about a gallery is borne out.

"I go into a gallery and tell them, 'I'm Anne Raymond. I live in New York, and I'm going to be in town only two days. I'd really like you to look at my work.' It's important that I mention only being in town for two days; otherwise they might never get back to you." Lugging sizeable paintings around from one gallery to the next is no easy matter, and when

she visited the Peter Bartlow Gallery in Chicago, she brought photographic images and told the gallery director that he could see originals in her hotel room. "Since I was only going to be there for two days, the director agreed to see my work that afternoon." At first, the Bartlow Gallery took on her monotypes but later began handling her paintings and has sold a number of both. There are now three other galleries around the United States that also show and sell her art.

Another artist who sought to broaden his market is Dan Namingha of Santa Fe, New Mexico. There currently are private and public collectors of his work on four continents, although his career might easily have taken a less global turn but for some aggressive marketing on his part and that of his wife. Winning awards such as Distinguished Artist of the Year from the Santa Fe Rotary Foundation and an Award for Excellence from the governor of New Mexico, as well as a number of exhibition credits at galleries and museums throughout the Southwest, Namingha, who grew up on a reservation in Polacca, New Mexico, could have relied on a solid standing as a regional artist. He and his wife, Frances, opened a gallery (Niman Fine Arts) in order to display his work and that of their sculptor son, Arlo, but they were not content to wait for people to find their way to the gallery. Frances Namingha invited Jorg W. Ludwig to visit Niman Fine Arts in the early 1980s, because she knew he was an exhibition coordinator for the United States Information Agency. Impressed by Namingha's painting, which interweaves Hopi symbols into his artwork, Ludwig in fact did arrange a series of shows of the artist's work at US embassies and national museums in Central Europe (Austria, Bulgaria, Czechoslovakia, Germany, and Roumania) from 1983 to 1986. These shows brought considerable attention to Namingha's work, leading to purchases by both public and private collectors abroad. Additionally, United States embassies in both Caracas, Venezuela, and La Paz, Bolivia, have purchased Namingha's work for their collections.

Frances Namingha has also traveled to a number of art museums on the East Coast in order to make presentations of her husband's work to curators who "often had never heard of him," she said. The result has been major shows at such notable institutions as the Fogg Art Museum in Cambridge, Massachusetts, and the Reading Public Museum and Carnegie Mellon in Pittsburgh.

A Short Course in Public Relations

If someone were to create a job description for a fine artist, the list of responsibilities might be very long indeed. There's making the art, of course, but then comes the part of letting others know that the artwork exists and is worth buying. (This is where the list lengthens.) Artwork must be photographed, perhaps framed (and matted), crated, and shipped; it may need to be promoted to the media, dealers, curators, and critics, and advertised to the public. A website might be created, which then must be updated on a regular basis. A considerable amount of time may be spent with designers and publishers of brochures, postcards and prints; telephone calls (and follow-up calls) ought to be made; personal notes should be written; and the people who are to receive the portfolios, brochures, cards, phone calls, and notes have to be researched or found by networking. That's a lot for any one person.

It was certainly too much for Brooklyn, New York, painter Robert Zakanitch, who, in 2000, contacted Pat Hamilton of Los Angeles to help promote his work to museum curators around the United States. "It's not part of my temperament to go and schmooze and be impersonal about it," he said. "You need a thick skin to do this, which I don't have. Someone says something about my work, and I take it personally instead of just smiling and keeping the conversation going. I pay Pat to be a buffer between me and the art world."

Among the services that Hamilton performed was producing a brochure about Zakanitch's work, which she sent to more than 200 museum directors, the result of which was a touring exhibit of the artist's work that traveled to five institutions in the course of a year. For another artist, Robert Dash, a painter in Sagaponack, New York, Hamilton promoted the artist's work to a variety of media outlets, and there were reviews of Dash's shows at New York's ACA Galleries in *Art Forum* and *ARTnews* magazines. One might have thought that Robert Dash's gallery would handle the job of aggressively pursuing reviews in major art publications and that Dash himself would not need to pay Hamilton a $1,500-per-month retainer to hound the magazine critics and editors, but "ACA has a larger roster of artists—far too many, to my mind—and they can't attend to me and my work nearly as much as I would like," he said.

Art is often thought of as a go-it-alone profession, but many artists use studio assistants to create the work and a battery of other help (business managers, career advisors, artist representatives, web designers, publicists, and extraneous others) to promote and sell the finished pieces. Each type of help is specific, but there is sometimes a blending of roles—some career advisors write press releases or arrange for shows, for instance, while some business managers negotiate sales agreements.

All of these helpers are middlemen, acting in the space between the artist and the collector. Publicists in the art field work with other middlemen—the media (press, radio, and television), as well as those who sell art (dealers) or present it (curators)—preparing press releases, visual images, and biographical materials (occasionally venturing into the creation of a catalogue or coffee table art book—again, as a promotional tool), following up with telephone calls and personal appeals. "It's not brain surgery," said New York City publicist Robyn Liverant, "but you need to know who to contact and how to present information to people, and then follow up. It's very labor-intensive work."

In the case of Robert Dash, an artist contracted the services of a publicist because his gallery was not publicizing shows to his satisfaction. Another artist, Gary Welton, a painter in Long Island, New York, hired Manhattan publicist Shannon Wilkinson to promote an upcoming university gallery show. She created a small catalogue for the exhibition, which was then mailed to a variety of museum and gallery directors around the world. "Shannon knows a lot of people in the art world," Welton said, "and she made sure the right people saw the catalogue. Her efforts resulted in Welton's work being shown in a number of locations, including three in Minneapolis, two in Puerto Vallarta, Mexico, and one in Jaipur, India.

The job of a publicist is not only to tout some person or object to the world but also to "position" the client in the world, establishing that individual's or thing's uniqueness. To Shannon Wilkinson, getting a lot of attention earns a person a "buzz," and other people think it "cool" to be around that individual or what the person creates. That is no easy task in the art world where there is an abundance of artists. "Promoting one over another seems very subjective," said Richard Phillips, president of the Sedona, Arizona, publicity firm Phillips & Partners. As a result, when Curt Walters, a California painter who has created

numerous images of the Grand Canyon, some of which he has donated in lieu of a cash contribution to the Grand Canyon Trust, came to the company several years ago to develop a media campaign to augment the promotional efforts of his gallery, Phillips made the focus of Walters's publicity not so much the quality of his art ("you don't want to deal with the subjectivity of who's a better artist") as his devotion to the cause of environmental conservation.

"We developed a program of promoting him as an environmentalist," Phillips said. "You couldn't get anyone to just write about his art, but we were able to find newspapers and television stations that were very willing to report on him as an expert on environmental conservation who happens to also be an artist."

Working with a publicist can be quite expensive, and the results are neither assured—no publicist will guarantee that an artist's show will be reviewed or that the artist will be profiled in a newspaper or magazine—nor necessarily even measurable. Walters's career has prospered during the three years that he has worked with Phillips, but are these sales attributable to the work of the publicist or the natural progression of an increasingly successful artist's career? No one can definitively say. What is clear is that Phillips charges a retainer of $2,500 per month, or $30,000 per year. "If you want the car to run, you've got to put gas in the tank every month," Phillips said. A lot of months can go by before any results take place, "results" defined as something written about the artist. Phillips noted that he "worked for three years to get an Associated Press story of Curt Walters," making that a very costly article for the artist, which may not have been read by art collectors. Shannon Wilkinson has a range of fees—per project ($5,000) and a monthly retainer ($4,000)—depending upon the type of work required, although she stated that "you never know for certain if something will happen." With Gary Welton, what happened was a number of exhibitions of his work, but these shows have not been accompanied by a number of sales that would pay for the work Wilkinson did and the costs of producing the 2,000 copies of a catalogue. Claiming that "I'm not in a position right now to spend more money on publicity," Welton said that "if I know it would produce income for sure, I wouldn't hesitate to spend the money."

The primary rule of thumb for publicity, as for advertising, is that this is a long-term commitment; results cannot be purchased on the cheap,

with one professionally produced press release or a few telephone calls. "You may not find a lot of people willing to work with individual artists," Robyn Liverant said, "because they don't usually have the means to pay." She largely confines her work to larger arts organizations and arts institutions, taking on the occasional fine artist. Liverant turns many artists away, such as the painter who "wanted me to do four months' worth of work for $500. I was never more insulted in my career."

Every professional is told of the importance of investing in one's career, but publicity is an investment that may not work for every artist. "If little is happening in a career—not much is selling, there's no connection to a gallery, there's no collector base—you have the lowest potential results," Wilkinson said. "Getting a critical review in a major art magazine or the *New York Times* is the most measurable thing, and it is the least likely to happen. It takes a long time to develop a marketing presence and to cultivate saleability." On the other hand, she noted, self-supporting, midcareer artists whose work is regularly exhibited should earn twice the amount they spend on publicity and marketing over a two-year period. Because of the very real potential that an artist may spend a considerable amount of money and still not garner any significant media attention or resultant sales, Wilkinson and other publicists who work with individual fine artists usually offer an initial consultation to determine what the artist wants and expects, and how likely it is that that can be achieved.

Artists need to carefully interview prospective publicists to ensure that their hopes are realistic and to determine what is possible (critical review, feature article, calendar listing, or smaller mention). Liverant said that, when contacting a large public relations agency, artists should ask whether the person whom they are interviewing will handle their account "or if it will be staffed out to someone else at the firm. It's not uncommon that you'll interview a senior person at the firm, and then the work is delegated to more junior people." At a smaller firm or with an independent publicist, artists should inquire "what kind of client load the person is carrying. Will you get personal attention, or is the publicist juggling too many people?"

Artists would also want to know what other types of arts-related projects and clients the publicist has previously represented, in order to determine how strong a relationship the publicist has with that segment

of the press, and they might ask to look at a clip book (containing stories generated through a past public relations campaign) or an outline of a publicity campaign. "The subject of money," Liverant said, "should come up later in the conversation. You want to get a sense of how long a project might take and what the publicist believes that he or she can realistically do for you. If it is publicizing one show, that may require a certain number of months of work. Image building, on the other hand, may take much longer."

She added that, when an exhibition is planned, artists may suggest to their galleries the idea of sharing the costs of hiring a publicist, which would be to the dealers' benefit, since the people who are brought to the galleries by the media are apt to return even when other artists' work is shown. The likelihood of galleries agreeing to this arrangement is small, however, Richard Phillips stated, because "media relations is long-term and therefore seen as a waste of time by galleries, which only want advertising and to sell paintings."

The Public Relations Society of America (33 Maiden Lane, New York, NY 10038, 212-460–1400, www.prsa.org) offers information to would-be public relations clients on which publicists might be best suited to their needs. By telephone, one may speak with counselors, who would take down information and create a list of eligible publicists or firms. Online, there is a searchable "red book" directory of publicists, categorized geographically and by fields of expertise.

Certainly, artists can learn some basic principles of publicity, taking on the job themselves. The material sent to a reporter or editor should consist of a well-written, interesting press release and high-quality, reproducible (in a newspaper or magazine) visual images. A press package contains a press release, but it also includes additional material that may be of interest to a reporter or editor, such as illustrations (slides, photographs, or color copies), biography or résumé of the artist, artist statement (if relevant), and clippings of past articles about the artist's work or career (those with photographs of the artist and/or his or her work are most likely to catch the eye of a journalist, who may not choose to read the entire article). It is extremely rare that a journalist will actually read through a previous article; the fact that the artist has been written about before makes that person more worthy of being reported on again, regardless of whether the original article or review was praising

or scornful. If the artwork is key to the story, as in an exhibition or demonstration, there should be an accompanying image, or more than one. Bombarded by a myriad of press releases, journalists need their information presented in the most time-efficient manner, and a good quality image—no snapshots—says more than a thousand words.

Usually, if the press release isn't absolutely pertinent to what the editor or reporter is doing, it is tossed out. Journalists also are inundated with press releases, which requires that the information they are sent be eye-catching, concise, and followed up with additional releases and telephone calls. A somewhat cynical rule of thumb in marketing events to journalists is that the second you hang up the telephone, they have forgotten the entire conversation. Second mailings (and subsequently telephone calls) should note that there had been a conversation with the journalist, with a clear and concise summary of what the artist wants the journalist to do. Follow-up work is the major activity of publicists, contacting media sources repeatedly in the hope of generating coverage, which is the reason that their clients often hire them on a monthly retainer even when their work involves one single event.

Magazines have a longer "lead" time than newspapers, and artists should prepare press releases and packages for them as much as six months in advance. With newspapers, six weeks is usually sufficient, unless there is a holiday tie-in, which may involve a special section and more time. According to Wilkinson, "most artists (and many, many other types of clients, too) begin publicity five months too late. Most people, in fact, will call a month or two weeks before an exhibition opens to discuss publicity. It is not only too late for 99 percent of public relations people, it is too late for 99 percent of publicity."

When preparing a media campaign, there are two critical points: to whom the press release or package should be sent, and how to write the release. In most cases, a press release should mimic a news article in a newspaper, with a headline in bold letters that tells journalists something quickly about the event and keeps them reading. According to Jane Wesman, who heads a New York City–based public relations firm of the same name that specializes in artists and writers, "You could write, 'Jane Wesman to Talk about Art World at Conference,' which is all right if everyone knows who Jane Wesman is. Probably better is, 'World's Greatest Publicist Presents Inside Look at the Art World.'"

The press release should be in a newspaper's inverted pyramid style, with the most important news featured at the beginning and the less vital information at the end. Many smaller publications type news releases directly into the newspaper, and if there are any cuts to be made (usually for reasons of space), the editing is done from the bottom up. The most important information is what is happening (exhibition, demonstration, class), when (time and dates), and where (street address, floor number), noting the significance or uniqueness of the event (for instance, printed by photogravure, first time these works have been shown publicly, honoring a recently deceased parent or public figure). Depending upon the nature of the event, this initial lead could be followed up by more information about the artistic process, the cost of attending the class or demonstration, or a quote by the artist or a third party (a critic or gallery director, perhaps) about the nature of the artwork.

The artist's previous experience (where exhibited or taught before) and educational background may have greater value to the local media if that show or class or schooling took place locally, and it might be placed higher in the press release; otherwise, this information should appear farther down. Absolutely, contact information—where to reach the artist (home, office or studio telephone, cell phone, email)—must be included for reporters who have additional questions.

Beyond learning how to write a release, artists should become familiar with the media outlets where they live or where their work will be displayed in order to make their own contacts. Reading the newspapers, and listening to the radio and television stations, on a regular basis is the most immediate way to find out who does what. Additionally, Burrelle's (www.burrelles.com) publishes media directories that list the names and titles of reporters and editors, as well as how to contact them. These directories are published annually, costing $200 apiece, but they are often found in public library reference departments. Of course, journalism and the media in general is a nomadic profession, in which people may change jobs regularly; artists should check with the media source before sending off any material to an individual listed in even the most recently updated directory.

Artists should also look to cultivate relationships with journalists and other members of the media that will last longer than just the most current exhibition but will be extant for the next show and project after

that, creating an investment in one's career on the part of the particular editor or reporter. And, since journalists tend to migrate from one job to another, artists should be prepared to like the new editor or reporter as much as the last. This relationship may start with an invitation to one's studio or—a more neutral territory—a museum, art gallery, or café. "The New York artists I represent, who have become friendly with freelance art critics, are generally the most successful," Wesman said. "You need to cultivate the people who can be helpful in your career."

Newspapers cover a wide range of interests and are read by many more potential art buyers than those who avidly follow the critics. Among the possible editors of sections to contact are the lifestyle editor, home (or home and garden) editor, real estate editor, business editor, features and Sunday features editor (often two different people), hometown editor, learning or education editor. There may also be women's page editors or specific writers who concentrate on the accomplishments of women. These editors may require a different "pitch" (story suggestion) than critics that ties in a topic with a certain news event or trend and would include compelling visuals that will entice them into wanting to know more. Wesman noted that artists should not confine themselves to art magazines in their press marketing efforts, perhaps sending press material to an airline or fashion magazine. "You want to broaden your audience to people who don't necessarily read art magazines, because those people may have money and interest, too," she said.

Internet Marketing and Promotion

Cost cutting is the byword of our time, but it is not always clear which expenditures are essential and which can be eliminated more painlessly. Take, for instance, mailing out printed event announcements and flyers. A growing number of artists and art galleries are getting rid of them, as doing so is a clear source of savings and allows people to feel ecologically conscious, switching in whole or in part to emails and social media to tell their story. In the digital era, too, a paper trail can seem superfluous, throwing away money. Smart, right? What remains to be seen is if the buying public responds to online communications in the same way they do to printed ones.

"We do only emails, having stopped sending out postcards and other mailers a few years ago," said Romy Silverstein, director of Addison/Ripley Gallery in Washington, DC. "It saves us a lot of money, not only in terms of dollars and cents, but in staff time, since we don't need to have people stuffing envelopes every five weeks." Emails, she added, also reach "a much broader audience," because the gallery's email list is larger than its postal mailing list.

It has been years since Boston's Robert Klein Gallery last sent out "hard copy announcements," according to its director, Maja Orsic. Old clients do not appear to mind, and newer ones are accustomed to communicating through emails and social media, such as Facebook, Instagram, and Twitter. The gallery does continue to print a small number of postcards and brochures—"500 or so, which is not so great an expense"—for visitors to the gallery and at art fairs so that they may take a memento home with them.

At the Marianne Boesky Gallery in New York City, it is pretty much all online communication. "People don't like to receive mail," said the gallery's codirector Kelly Woods. On the other hand, at Manhattan's Peter Blum Gallery, mailed announcements still go out, claimed Andrea Serbonich, associate director, because "a lot of people don't want emails. They already get too many." That doesn't stop the gallery from sending out email announcements (a month before an exhibition) and reminders (a week before an exhibit closes) to all the same people, as well as keeping up with "friends" on Facebook and followers on Instagram and Twitter. Try a little of everything.

Based on a random survey of several dozen art galleries around the country, the approach at the Peter Blum Gallery appears to be the most typical. Promoting exhibits and events may require both mailers and online notices, which may reveal a lack of commitment on the part of gallery owners to either one or the other approach, or it may suggest that no channels of potential communication can be ignored.

The Sperone Westwater Gallery in New York City asks people how they prefer to be notified of gallery events "quite regularly, and we adjust what we do," said Walter Biggs, the gallery's managing director. "We go through our lists and make modifications." A different system is used at the Rhona Hoffman Gallery in Chicago, which sends out printed material to regular clients ("people who have bought from us within the past few years or contacts we have made recently at art fairs," said associate

director Cara Megan Lewis) and email announcements to a group five or six times larger in size, consisting of media contacts, art consultants, students, and more casual visitors.

To a certain degree, the move toward email-only communication is becoming less of a choice for gallery owners and, by extension, for artists. Fewer and fewer actual and prospective collectors offer their traditional home addresses and home telephone numbers on those sign-in books at the gallery desk or when they meet dealers at galleries or art fairs, preferring the more anonymous cell phones and email addresses. Jessica Martin, a painter in Healdsburg, California, stated that between one-quarter and one-third of her mailing list is email addresses only, and she claimed that "the Internet is the primary source of information for more and more of the people interested in my work." The artist sends "physical announcements"—postcards and flyers—for major events, such as solo exhibitions, but emails for everything else (inclusion in a group show, updates about her career, notices about newly produced paintings, new galleries representing her work). When people on her mailing list move, the postcards are often returned by the postal service, "but people keep their email addresses, so they get the information anyway."

These modern forms of communication allow would-be buyers to be more accessible wherever they are and whatever they are doing, and it is also a way of being "green" by opting out of the cut-down-trees system of information dissemination, saving tens of thousands of dollars (and sometimes far more) in the process.

Sometimes, of course, immediacy sounds better than it actually is. "I called up one collector on his cell phone to ask, 'Are you still interested in that $35,000 painting?' and he said, 'I'm in the bathroom now,'" Louis Newman, director of New York's David Findlay Jr. Fine Art, said. "Another time, I called up a collector who told me that he is in his doctor's office." After that, Newman specifically began to request landlines when asking for contact information of gallery visitors and collectors. Those kinds of awkward moments occur with increasing regularity these days. "It's not a big deal," said Andrew Witkin, director of Boston's Barbara Krakow Gallery, who has had similar experiences. "Everyone's polite and understanding."

With readable material, gallery owners are of two minds about which form of communication is best. "I don't want to underestimate the value

of printed mailers," said Jane Cohan, one of the directors of New York's James Cohan Gallery. "They are beautiful, meaningful objects that you can hold in your hand" and attach with magnets to a refrigerator. "People wake up to fifty emails in their inbox every morning, and the first thing they do is look for the ones they can delete," Biggs said. "I routinely delete batches of emails." He also doesn't bring a date book to the computer in order to jot down exhibition openings, and even the emails Biggs doesn't immediately delete he rarely keeps for more than a day or two. A printed announcement, on the other hand, takes more looking at; it can be left somewhere that he will see it again or attached by magnet to the refrigerator door. If prospective buyers at the gallery or at an art fair booth only offer their email addresses, "we'll ask for more information, and we usually get it."

Next to the crowd of emails stuffing inboxes, an interesting piece of regular mail can be a treat. Several art dealers noted that a postcard can be unique in look and texture, while emails tend to be more alike than different. "The picture on the postcard is the first work in any show that will sell," said Piero Spadaro, director of San Francisco's Hang Art gallery. "I just like how it feels in my hand." The sensual experience of holding a postcard, however, has its price, as Hang Art's printing costs were between two dollars and three dollars per card (not including postage expenses) for the more than 7,000 cards that had been sent out annually up until eight years ago. Since then, the gallery has upped its online communications and diminished the number of mailers it sends out, without a noticeable diminution in sales or buyers, he claimed.

Making a complete switch presents clear risks. "You are saving money, but are you losing audience?" said Jackie Hitchon, chair of the department of advertising at the University of Illinois's College of Media. "We find that when we look to communicate with alumni, we don't have email addresses for everybody, and we find that a lot of our emails automatically go into a spam folder, because their email service thinks that what we're sending comes from a tacky solicitor."

Another Internet marketing expert, Courtney Sturniolo of Meggitt Sensing Systems in Orange Country, California, stated that "tons of studies" have revealed that more than 80 percent of emails that are promoting some event are deleted without being read, and that number is

often higher than 90 percent. "The general consensus is that email is no sure way of being in communication with someone. It's one touch, but you need multiple touches across multiple media in order to reach your target audience." Besides emails, those "touches" include mailers, social media, and telephone calls. "They all need to be part of the mix, but it takes time and money to do all those things, which is why some companies prefer to do fewer."

Sending out a large number of emails at one time—the term of art is an "email blast"—is usually forbidden by Internet service providers, such as Yahoo! and AOL, requiring artists, galleries, and other small businesses to hire an email marketing service, of which there are many around the country. The costs are generally low and based on usage: Constant Contact, which is based in Waltham, Massachusetts, charges a $20 fee for sending up to 500 emails per month, $45 for between 501 and 2,500 emails, $50 for 5,001–10,000, and on and on. The Atlanta-based MailChimp charges between $10 and $25 up to 2,000, with varying rates above that. The San Francisco–based Vertical Response has a $7.50 fee for up to 300 emails in one month, and Benchmark Email in Long Beach, California, charges $9.95 for up to 600 emails per month, $12.95 for up to 1,000, and $19.95 for 2,500. All of these email marketing service companies provide JPEG templates on which one may create a new message or announcement, along with images, hyperlinks, and the opportunity to group lists of email contacts (for instance, only recipients living in Illinois and Indiana) for blasts that are more targeted. They also offer other services that might be useful, such as whether a particular recipient opened an email or just deleted it outright, whether the recipient linked to another site from the email, and if the email bounced back because the address is no longer valid.

Finding out who opened one's email, who clicked to link to another site, and who opened an attachment, such as a PDF or JPEG, is the real stuff of marketing, as it identifies an audience of people who show some interest. However, it is not fully reliable as a gauge since many recipients of emails will refuse to open an attachment, fearing the introduction of a virus into their computer systems. That is why emails may need to be part of a larger promotional campaign and not the entirety of it.

In the gallery world, a rule of thumb says that dealers need to make seven "touches" for every sale. Those touches now come in many forms,

from the traditional face-to-face meetings to calls to mobile, office, and home phones; email as well as regular mail; texting and tweeting; and any combination thereof. New technology allows more ways to keep in touch, with each of these forms of communication having its own weight with different audiences.

Publicity and Social Media

Perhaps you associate social media with Kim and Kanye, with beer pong videos and thumbs-at-the-ready politicians and gossip that comes with a hashtag, or maybe you just want to remind friends of your existence through uploaded images, tweets (or retweets), and likes and texted messages. Shannon Wilkinson, chief executive officer of the New York City–based Reputation Communications, wants you to think of social media as a career-building tool.

"Social media culture is a community," she said. "First and foremost, it is about connecting and sharing. It is not about endless self-promotion, although many people misuse it in that way."

The first step is building a community of what she called "influencers," referring to gallery owners, museum staff, grant-making and awards organizations, journalists, critics, collectors, and sponsors, as well as other artists—"people who play active roles in making decisions, policies, and statements that impact the art world, in particular, the art world that is most relevant to an artist."

Building that community involves researching the audience that matters to the particular artist. For instance, a sculptor might conduct a hashtag search for *#sculpture*, which will offer a sense of what is currently on Twitter and Instagram in that space. Next, artists should conduct searches for the magazines, writers, institutions, and organizations that are most active in supporting their particular type of art, following those that interest them and are relevant to their careers. After that, artists might start examining whom those people and institutions follow, following the ones who interest them.

Wilkinson also recommended conducting a search outside the more narrow confines of the art world. "If science is a theme in your work, or nature, research the journalists in those areas, including bloggers, starting with the same hashtag search," she said. "Bloggers are more

accessible than magazine editors and often freelance for them." Even better, bloggers generally respond before mainstream editors and writers do, as there is less competition for their time. "When they publish posts about art or other topics, it provides instant online forums for it that can be built upon and expanded."

Print publications are on the decline, being reborn as digital publications. However, all digital magazines and blogs have social media platforms. Artists who are not aware of them, much less following and engaging with them, are restricting their opportunities. Much publicity is now being done digitally, and publicists are connecting with writers online because so many are independent; they are freelancing more and less likely to be a full-time staffer. Often, these writers also write for other online publications, ones that curators read. Being active on social media enables artists to see who those writers are and where they are publishing.

Social media should be used to support, rather than replace, other forms of marketing and public relations, she claimed. For example, an artist preparing a mailing of printed promotional material for art consultants and editors at art publications to announce a recently installed commission might look to maximize the marketing opportunities by researching all of those individuals on Twitter and other social media platforms and connect with the ones she finds. Begin sharing their posts (with the goal that they will notice and follow her back). That can lead to what is called "engagement" on social media—also known as a "conversation." If that occurs, the artist might send a private message letting the contact know to look for his or her announcement. If it does not occur, the artist can still include the person's Twitter handle or Instagram address on future posts with pictures of her new commission.

Similarly, when artists have an exhibition and know there is a critic who is likely to respond to their work (based on the reviews the critic writes about other artists with commonalities), they can follow the critic on social media and ensure that his Twitter/Instagram handles are included in posts with images from the upcoming show. "That is a very easy way to increase awareness about the upcoming exhibition," she said. "It reinforces the message that is being sent on other channels, such as direct mail, perhaps in advertising as well as from a gallery or PR consultant."

Different social media platforms should be used in different ways. Facebook, for instance, should serve as a portfolio, while Twitter would be used to gather information and to build an audience, and Instagram can showcase one's work. Using hashtags on posts helps to reach new audiences. For instance, she said, "if you just finished a painting in Sedona or the Hudson Valley, make sure an Instagram post about it includes *#Sedona* or *#Hudson Valley*. Otherwise, you might be missing exactly the type of audience that wouldn't otherwise know about it, and who may respond to it."

We live in a world of people seemingly glued to their phones and tablets for hours every day, following So-and-So and posting images from their drive home (or whatever struck their fancy). Social media might seem to fine artists like an enormous time suck whose rewards are only theoretical, while the requirements only guarantee distraction and time away from work in the studio. However, Wilkinson said that two or three hours per week would be sufficient, using that time "to scan the posts and tweets made by the community they have built, which provides them with marketing insight about news, reviews, and opportunities within their sphere, and to compose and schedule periodic posts for the coming week. That may be as little as three posts in a week, two of which may be just sharing someone else's content." She recommended several free and low-cost social media management systems—such as Hootsuite (www.hootsuite.com), Buffer (www.buffer.com), and Sprout Social (www.sproutsocial.com)—that enable users to read the social media posts of anyone they want to follow, as well as schedule and publish one's posts on social media platforms. That enables artists to participate within that community, and the alternative is to be invisible to it "at least in the digital space."

. . . On the Other Hand, the Problem with Posting Art Images

As routine as covering their mouths when they cough, people these days whip out their phones to take a picture of something of interest and then upload that image to some social media site. Look what I just saw! Artists are no less immune to this, regularly posting images of their exhibitions, their newest completed pieces, and even works in progress. Look what I just did! Very quickly, they can be in (online) communication with other artists, their collectors and dealers, art critics, museum curators,

and anyone else who has interest in what these artists are up to. In a world crowded with artists, putting up images of one's work and hoping that they are liked, shared, retweeted, and go viral may be the best and fastest way of garnering attention.

It also may be the fastest way of having one's images downloaded, perhaps altered to some degree and sold commercially—what one calls copyright infringement—by someone in the cybersphere. In fact, such an event has happened. In 2014, appropriation artist Richard Prince exhibited thirty-seven prints on canvas at New York's Gagosian Gallery of "screen saves" of posts on Instagram, the social media website, all enlarged to 4' × 5' and preserving the visuals and text of the poster's username, the time stamp, the number of "likes" that the post received, and website user comments. At the bottom of each print, Prince added his own nonsensical comment. One of those comments, below a photograph taken by photographer Donald Graham of a Rastafarian smoking a joint, reads, "Canal Zinian da lam jam," and the artist also added an emoji. Ten of the other works in the Gagosian exhibition were Instagram images of pin-up models and burlesque performers who are part of an art collective called SuicideGirls. Each of the thirty-seven canvases was priced at $90,000, and the one with the Donald Graham image was purchased by gallery owner Larry Gagosian himself. Graham brought a lawsuit in January claiming copyright infringement, to which Prince responded that his work represented what copyright law calls "fair use."

None of the SuicideGirls brought a legal action, confining their efforts to making their own reproductions of Prince's canvases and selling them for $90 apiece, donating the proceeds to the Electronic Frontier Foundation, a nonprofit organization that defends civil liberties. (Take that, Richard Prince!) Prince did not file a copyright infringement lawsuit against SuicideGirls, according to his lawyer Joshua Schiller, because their reproductions were also "a form of fair use. Their reproductions are interesting and complimentary, a duplicate of a work of art as a work of art."

Social media represents "an opportunity and a risk for artists, depending upon the business model of the artist," said New York University School of Law professor Christopher Jon Sprigman. If an artist's aim is to bring their work to the attention of prospective buyers quickly, "the

exposure can be very good, and in this case I believe it was very good for SuicideGirls. Not many people knew about them before, and now a lot of people have heard of them." For artists, too, who "want people to share their images, pass them around, social media allows people to interact with their artwork in a number of ways."

Nancy E. Wolff, a partner in the New York law firm of Cowan, DeBaets, Abrahams, and Sheppard, noted that many artists and commercial photographers regularly use Instagram as an online portfolio. "For photographers with a social media following, Instagram serves a good purpose, leading to jobs and sales," she said.

On the other hand, for artists whose business model relies on wanting to reserve all rights to their artwork, posting images of their art on social media may be tantamount to flashing expensive jewelry while walking at night in a bad neighborhood. Laws—in this case, copyright law—exist to protect people from harm, but the risk of some harm taking place is high. Posting an image online, for instance on an artist's own website, does not necessarily imply the hope or expectation that the image will be passed around from one interested person to another, but posting within the social media environment likely implies that its owner is licensing it for some form of distribution by other site users, for instance through the share function at Facebook or retweeting at Twitter, and that the image will go viral.

The risks are relative, less for sculptors, since images are imperfect replacements for three-dimensional pieces, and painters than for photographers, because a downloaded high-resolution image of a photograph will look largely identical to the original. The customary solutions for artists are to post low-resolution images of their work, which displays the art very well at a small size on the screen but does not look good when enlarged and reproduced, and to embed metadata (information about whether the image is copyrighted and to whom, who owns the particular image, the camera that took the image, and the exposure used) in the image. "I always advise artists never to post high-resolution images online and to embed images with copyright management information or watermarks," said New York art lawyer Barbara Hoffman. A problem arises when certain social media websites automatically strip out any and all identifying metadata when images are uploaded to their sites, making it more difficult to learn if an image is copyrighted and by whom.

The terms and conditions pages of social media sites indicate what the site operators and users may do with posted material. Instagram, for instance, claims no ownership of this material. However, "By displaying or publishing ('posting') any Content on or through the Instagram Services, you hereby grant to Instagram a non-exclusive, fully paid and royalty-free, worldwide, limited license to use, modify, delete from, add to, publicly perform, publicly display, reproduce and translate such Content, including without limitation distributing part or all of the Site in any media formats through any media channels, except Content not shared publicly ('private') will not be distributed outside the Instagram Services." This language would appear to give Instagram—and by extension, its users?—the unfettered right to use, display, perform, and modify the content of an image without the permission of the work's creator, which vitiates the copyright. This is the price someone pays for the ability to use this free service, and undoubtedly many users consider that the potential drawbacks are greatly outweighed by the benefits.

The lawsuit against Richard Prince by Donald Graham has similarities to another brought against the artist by French photographer Patrick Cariou after Prince exhibited in 2008 at the Gagosian Gallery a number of collage paintings using Cariou's images of Jamaican Rastafarians from his 2000 book *Yes Rasta*. There were thirty works in that 2008 exhibition. Prince scanned several of Cariou's images of people and landscapes into his computer and printed them directly onto his canvases, defacing them in limited ways (placing an electric guitar in one Rastafarian's hands and daubing paint onto the face, for instance), as well as adding other elements to the paintings. In that case, a district court in 2011 found that Prince had infringed on the photographer's copyright, but that decision was overturned in 2013 by an appeals court, which found that Prince's paintings were "transformative and constitutes fair use of Cariou's copyrighted photographs" under US copyright law. The Graham lawsuit may result in a different outcome, according to Washington, DC, art lawyer Joshua Kaufman, because "the facts in the case are very different than with Cariou. Both Graham and Prince are artists and make a living in the same marketplace. Their artworks are about the same size and sell in the same price range, and there is nothing transformative that Prince had done to Graham's images except add nonsensical comments."

An earlier copyright infringement case involving social media—when the photographic images of the devastation in Haiti in 2010 after an earthquake were posted on Twitter by the person who had taken those pictures, Daniel Morel, and then illegally downloaded and distributed by the international photo licensing service Agence France-Presse and its US partner Getty Images—was won by the photographer. The photographs used were not credited to Morel, and a jury found that Agence France-Presse had made no effort to locate the photographer before making use of his images and had altered the copyright management information imbedded in his images. As a result, the photo service's infringement was deemed willful, and in 2013 Morel was awarded $1.22 million.

There are ways in which artists posting images on social media sites may protect or strengthen their legal position in the event of copyright infringement, such as registering images before posting them with the US Copyright Office and embedding the copyright notice on the posted image. Registration before an infringement entitles copyright holders to sue infringers for both actual and statutory damages, as well as for all legal costs in pursuing a lawsuit. (Donald Graham only registered his Rastafarian image after Richard Prince made use of it, limiting him only to actual damages, in this case the amount that Prince earned from the sale of his painting.) An artist also might purchase software that requires anyone seeking to download his or her images to accept a licensing agreement—known as clickwrap—and accept its terms and conditions before one may access the image. With both an embedded copyright notice and a clickwrap, an infringer could not make the argument that an illegal use of an image was done unknowingly.

Donald Graham himself had not posted his photograph on Instagram. It was an Instagram user who went by the handle "rastajay92" and who originally had uploaded the image onto the social media site a couple of years earlier, and "rastajay92" had added below the image a comment, "Real Bongo Nyah man a real Congo Nyah," as well as an emoji. Under the Digital Millennium Copyright Act (DMCA), Graham would have been empowered to send the host site either a cease-and-desist letter or a DMCA takedown notice, requiring the removal of the copyrighted image. The courts may decide whether or not Prince violated his copyright, but Graham's failure to have the image removed may be seen as an implicit endorsement of its presence on social media.

From meetings with celebrities to reports of police misconduct, nothing seems real these days unless it is recorded in a photograph or video and posted online. There is an immediacy to this uploading that is important to real-time-obsessed social media, whereas the steps to protect copyright—registration with the Copyright Office and the acquisition of clickwrap software—takes time. This is a realm of trade-offs, requiring artists to balance the value of online exposure and greater vulnerability.

CHAPTER 2

Fairs, Festivals, and Vending Your Wares in Plein Air

EVERY YEAR, AN ESTIMATED 10,000–15,000 ART FAIRS, arts and crafts festivals, and juried art competitions take place throughout the United States. They offer artists an enormous opportunity to present their work directly to the buying public, allowing them in part or completely to bypass the art gallery system, where commissions are high, exhibitions are rare, and salesmanship may often seem indifferent. However, choosing among the 10,000–15,000 shows is an enormous undertaking, and it is difficult for newcomers and even for more experienced hands to feel confident, especially when the cost of participating in a given show is understood (entry fees, booth fees, insurance, shipping, crating, mileage, accommodations, meals, "lost" production time). Which fairs feature artists and artwork at my level? Which shows actually draw in visitors, and how much actual buying takes place? At what price range? How well run are these shows? Does "arts and crafts" mean crafters?

Finding answers to these and other questions is a job in itself. The best way to collect information involves a bit of trial and error—taking part in one or more shows, talking with other artists and exhibitors, even talking with collectors about competitions and festivals they would recommend.

How to Find Fairs and Festivals

There is a two-step process involved in obtaining information about suitable shows when you don't have the guidance of someone who has

been there and done that: the first is discovering when and where all these events are being held, and the second is evaluating those shows that seem to hold the greatest potential. No one publication or website will provide complete information, requiring artists to check a number of different listings. Probably the largest single source of information is the monthly magazine *Sunshine Artist* ($34.95 per year, 3210 Dade Avenue, Orlando, FL 32804, 800-597-2573, www.sunshineartist.com), which lists upcoming shows, complete with numerical coding, such as this sample:

APR 30–MAY 1
RICHMOND, VIRGINIA
45th Arts in the Park. Byrd Park. App. Fee: $15
Space size: 10x10. Jury by 4 photos of work. 45 years
at this site. 400 exhibitor spaces. 100% outdoor.

> Event category: 1, 4
> Acceptable work: 1,2,3,4,11
> Section method: 2

> Contact: Carillon Civic Association, Jennifer
> Hulzing, 3113 Rendale Avenue, Richmond, VA 23221.
> 804-358-2711. www.richmondartsinthepark.com.

The magazine also pays local reviewers to attend certain shows, reporting back briefly on how well a show did, how good it looked, how well managed the event seemed, and what unnamed participating artists and other exhibitors had to say about it. Every other year, the magazine publishes its *Audit Book* ($54.00), which recapitulates in brief those magazine reviews for approximately 5,000 shows, giving each event an A, B, C, D, or F grade. (A potentially less expensive way to obtain some of that same information is online, through www.artsandcraftshows-usa.com, festivalnet.com, or www.fairsandfestivals.net, which breaks down events by state.)

There are far more shows taking place than the magazine or the *Audit Book* describe, in part because the magazine charges show organizers for listings, making it more of an advertising section than editorial space.

Presumably, there is no fault to be found with the shows whose organizers did not choose to pay a listing fee.

Is This Show for You?

None of the listings, paid or unpaid, long or abbreviated, tells enough, however. Online or hardcopy listings of shows offer the who-what-and-where but tend to be short on details, such as who is assigned responsibility in the event of damage, fire, loss, or theft, how art is to be shipped and insured (and who pays for shipping and insurance), if there will be prizes offered (and in which categories), if the show sponsor will take commissions on sale of artwork (will the artist report sales to the sponsor or route sales through the sponsor?), whether or not every item must be for sale (or within a certain price range), and if the artists are obliged to provide door prizes or other donations to the sponsor. For this, artists should request a prospectus, outlining what the show is, where and when it will take place, how many artists are to be selected, the type of art (subject matter and media) that will be featured, the names of the jurors selecting among the applicants, and other relevant information. Artists should send for this information before submitting slides and any money to be in the exhibits.

Other questions may arise that the prospectus does not answer, and artists should make inquiries (by email or regular mail, even by telephone) before submitting their applications: If the event is outdoors, what provisions have been made in the event of rain? What type of marketing (to potential visitors and collectors) and promotion (to the media) are planned to ensure strong attendance and media coverage? Some show organizers highlight the prize money they offer to artist exhibitors who are judged to be winners in certain categories, and this acts as an inducement to bring in better artists, but they may have no budget for advertising, which would bring in more visitors. If an artist has to choose between one show with possibly better artists and another with potentially more sales, which would he or she pick? If this is the first year of a show, what experience do the sponsors have in staging an event of this sort? If the show took place in prior years, what was the overall attendance and gross sales, and is that information documented (for instance, in newspaper accounts)?

Whenever there is a jurying system, artists should be informed who the judge(s) or juror(s) will be in advance of applying, as it is the prestige of those persons that gives importance and validity to the event. If one also knows something about the juror—he is a dealer of mostly avant-garde art, she paints watercolor landscapes—that may help potential applicants assess the chances of having their work selected. It doesn't tell potential applicants much when Art Enterprizes of Lompoc, California, announces that its First Annual Art Competition will be "juried by professional artists." Similarly, the one-time International Biennale, organized in Miami, Florida, for the Musée d'Art Moderne in Bordeaux, France, informed artists that art would be chosen "by international selection committee appointed by museum director." For some artists, the possibility of having their work displayed abroad may outweigh not knowing who the jurors are and the unwillingness of the French museum to take responsibility "for loss or damage of any kind for any work." It is a difficult decision to make, but artists should at least know what they are facing.

Arts and arts and crafts fairs come in all types. At times, a prospectus or a publication's description won't reveal enough, requiring artists to ask questions of current or past exhibitors or just attend the event as a visitor. If a fair advertises itself as having only original art, does that allow for reproductions of an exhibitor's original art, such as an offset lithograph or digital print? If the event is an arts and crafts fair, are the craft items unique (one of a kind) or production pieces (such as coffee mugs), nonutilitarian (sculptural) or useful (a vase, for instance), high end (costly, artistic) or crafter (lower-priced gift items)? Some crafts shows feature or include what is called "buy-sell" items, meaning objects manufactured elsewhere that the exhibitor may have adorned to a large or small degree. Certain show sponsors will still call items "handmade" if they determine that a certain percentage (40 percent? 50 percent?) of the finished piece was actually produced by the exhibitor, such as the face of a clock or base of a lamp (it is not assumed that craftspeople should make their own time pieces or lamp sockets). The distinctions between types of work are important, because certain categories will appeal to different prospective buyers. A fine artist surrounded by crafters is not a good mix, for instance, because the collectors of one will not be interested in the other: the fine artist is apt to be seen as overpriced or, worse, in the league of crafters. There tend to be

more arts and crafts fairs than pure original art shows, requiring artists to be selective.

Making Art Look Good

Applications are filled out, and images uploaded and attached, then sent out electronically. The artwork presumably looks good enough, it is hoped, to be juried in. But, of course, acceptance by a juror isn't the same as actually selling something, which raises a question every artist wants answered: What actually sells a work of art? Perhaps good art sells itself, or it may be the price or something the artist (or dealer) says. Maybe the difference between selling or not has to do with the artwork already being attractively framed or how the exhibition space is designed. Artists all want to believe their art is compelling enough not to need any props, but most of them sense that more is required than just putting something on view. Artists who sell directly to the public, particularly at fairs and festivals where there may be hundreds of booths and tents filled with artwork and the individual artists who created it (all earnestly describing their technique and inspiration), recognize a need to set themselves apart. At outdoor fairs, most tents are white canopied (many show organizers require them to be white), and some artists have had positive results from creating an environment within them that enhances the visitor's experience of looking at the art.

"I have the usual white tent, like everyone else, four-sided, 10' × 10'," said Christopher McCall, a painter in Doylestown, Pennsylvania, who has been setting up his tent at various shows since the early 1990s. His prior experience in retail sales, as a gift shop owner in New York City, led him to customize his tent, adding dark gray fabric on the walls and a large vase with fresh flowers on a round table covered by a tablecloth, "to present things as it would look in someone's home." Under the table is a CD player that pipes in classical music—Bach, Beethoven, Haydn—that "complements the art," he said. People have commented on the look and sound of the display, often favorably, sometimes comically: "They see the tablecloth and flowers and think they need a reservation for dinner."

In all, the display has cost McCall approximately $2,500 ($1,000 for the tent, another $1,000 for the fabric to cover nine display panels being the largest expenses), which he believes has been recompensed by more

sales than if he hadn't created such an environment. A high-toned presentation also may suggest high quality and be its own justification for high prices.

Other artists have also seen advantages in putting more time and money into their tent or booth display, which Linda Post, director of Paradise City Arts Festival, a show organizer, claimed is a "carryover from the crafts world. Customers are willing to buy arts and crafts and pay more for them if they can picture the pieces in their own homes." A display that suggests someone's living room, and "not just a painting hanging on chicken wire mesh," allows visitors to visualize owning the artwork more easily. To that end, some artists have put down rugs ("It's nicer to walk on than cement," said Marshfield, Vermont, painter Susan Osmond), equipped their booths and tents with track lighting to spotlight works, spent more on framing and panel fabric ("My paintings look more illuminated against the long black fabric, much more so than with the shorter light bluish-gray covering I used to use," said Willow, New York, painter Marty Carey), and designed their displays more like curators than salesmen.

Beth Ellis, a painter in Glastonbury, Connecticut, who participates in half a dozen outdoor fairs annually, stated that all the frames she uses are of one type (gold leaf) and that the artworks exhibited are on one theme, such as all landscapes or landscapes with figures or landscapes and still lifes. "People shift their energy every time they go into another booth, and that can be very tiring," she said. "If your display has a lot of different types of work, that can take even more energy. I only have a small window of time to capture their attention, and I don't want to waste it on works that make people shift their energy more than once."

She added that her displays are intended to reflect the light and airy feeling of her mostly plein-air paintings. To that end, Ellis custom ordered a booth whose dome is heavy-duty transparent plastic (rather than a fully white top or one with plastic skylight) that filters ultraviolet rays while providing natural illumination of her artwork. The cost of that tent was $1,500.

Ellis believes that the extra care and expense has led to increased sales but added that "it's not a measurable thing." The fact is, no artists can claim a one-to-one correspondence between the type of tent he or she buys, how it is decorated, how artwork is displayed, or anything else and

the sale of art. What collector ever says, "I would have bought a painting at the next booth, but I liked the rug you put down"? Sometimes, Plainfield, Massachusetts, painter Larry Preston uses a Persian rug in his tent (a particularly expensive prop, since hundreds of visitors will give the rug a real beating), and he also bought gray fabric panels ("When you are outside, a white background is too bright and the paintings become hard to see") and a consistent set of frames for all his works. The tent, rug, fabric, and panels cost him a combined $3,000. Additionally, he cut down the number of paintings on display, sometimes as few as twelve if they are at the 36" × 48" size, more if closer to 12" × 16". Fewer works on exhibition are "easier to see, and each is perceived as more important," Preston said, although he noted that the drawback of not having as many paintings on display is that prospective buyers may not know that they have a choice of sizes, images, and prices. (Preston keeps other pictures on hand for visitors who make inquiries.)

"When I put a rug on the floor, so people weren't just on the grass, my booth seemed cozier and sales went up," he said. "When I changed my panels, sales went up. When I went to one style of frame and put up fewer paintings, sales went up." In past years, he sold ten or so paintings per year and now sells between forty and fifty. Another change was no longer selling prints of his paintings, which perhaps had given the impression that his display was low end: "When I took prints out of my booth, sales went up." It is possible that eliminating the prints did the trick, and the bulk of the $3,000 spent on customizing his tent display was for naught, or it may be that his artwork improved over time or that how he spoke with visitors to his tent became more polished. The components of success are difficult to disentangle, but a growing number of artists are looking to how their booth and tent displays—amidst a sea of others at fairs and festivals—might stand out and get them noticed.

"Handmade" and "Made in America"

It's good when we all speak the same language, you dig? However, every profession has its own insider jargon, which sometimes gets in the way, such as the legal profession's Latinisms (*a fortiori*—even more so; *ab initio*—from the beginning) and the sports world's slang (*juice*—steroids; *wheelhouse*—favorite area for hitting). The art world has its own insider

vocabulary where terms may seem a bit comical (*houseable*—the art-work fits in a normal-sized living room) and occasionally contradictory (objects in a museum may be on *permanent loan*). Auction houses take *chandelier bids* (bids that no one actually made or were seemingly made by the ceiling-hung chandeliers in order to get the price higher), while artists and art galleries sell *original prints*.

Most of us wish to be "green" (good stewards of the environment) and look to buy "all-natural" or "sustainable" or "organic" products. Unfortunately, those terms do not have clear-cut definitions and, in fact, tend to be defined by whoever is using them. Domino's promotes "artisan" pizzas, and Dunkin' Donuts offers "artisan" bagels, which give the impression of something individually prepared rather than mass-produced. Undoubtedly, customers would be displeased if the pizzas or bagels they bought really tasted any different than those they had purchased previously, but the term "artisan" isn't meant literally but just to suggest that someone in the company cares about the taste or quality or something.

The term "handmade" often becomes contentious in the arts and crafts field, particularly when more than one person may be involved in the production of some item (the rules of the Ann Arbor Summer Art Fair state, "All work must be the original design of the artist; the essential work required to make each finished piece must be done by the artist. The artist is expected to be the major contributor of the time required in the essential production of the work. Helpers or assistants do not replace the artist in the production of a piece. They are permitted to assist in the nonessential and more mundane processes that go into the production of a finished piece") or when elements of an item—such as beads on a necklace—are imports or just manufactured elsewhere ("Items that are mass-produced, made in "workrooms" or factories, machine-made from molds, pre-fab forms, patterns or from commercial kits are not allowed," according to the rules for entry into the Belleville, Illinois, Art on the Square show). Not every fair makes hard-and-fast rules. Rick Bryant, executive director of the annual Central Pennsylvania Festival of the Arts in State College, noted that "handmade may be an issue for some of our customers, but it isn't one of our criteria for selecting artists. Many people use commercially available materials and buy from catalogues." He added that the festival "used to require that T-shirts being sold by the artists be made in America, from cloth produced in the United States, but we no longer care."

The term *handmade* is not used in the Central Pennsylvania Festival of the Arts prospectus, but the concept remains: "All work exhibited must be original artwork produced by the artist. Work that has been produced from commercial kits, patterns, plans, prefabricated forms, or other commercial means is NOT permitted."

The online crafts marketplace Etsy takes a more expansive view of the term, according to its Dos and Don'ts page: "On Etsy, the term 'handmade' can additionally be interpreted as 'hand-assembled' or 'hand-altered.'" A company blog adds that "we recognize that artists and artisans are imaginative and resourceful with varying skills, expertise, and aesthetics. We don't want Etsy to be in the business of regulating or defining the limits of creativity. There is room in our community for a broad range of creative expression and techniques."

For most artists and craftspeople, "handmade" is a promotional term, rather than a legal concept, although the Federal Trade Commission (FTC) has rules about its use (www.gpo.gov/fdsys/pkg/CFR-2000-title16-vol1/pdf/CFR-2000-title16-vol1-sec23-3.pdf): "It is unfair or deceptive to represent, directly or by implication, that any industry product is hand-forged, hand-engraved, hand-finished, or hand-polished, or has been otherwise hand-processed, unless the operation described was accomplished by hand labor and manually-controlled methods which permit the maker to control and vary the type, amount, and effect of such operation on each part of each individual product."

The people who are most apt to bring a complaint about an artist's or craftsperson's unfair use of the term "handmade" are other artists participating in a fair, bringing their sharp eyes to bear on the booths of their competitors. "There is a lot of self-policing at fairs," Bryant said, likening participants to "children in the back seat of the family car. 'He's breathing too loud.' 'He's taking up too much of the seat.' They don't want others to have a perceived commercial advantage." At times, however, artists do correctly identify competitors as cheating, which will be brought up before a fair's standards committee and may lead to a participant being told to leave. Bringing a legal claim for deceptive advertising may be difficult, as a California district court's 2015 decision in favor of Maker's Mark Distillery reveals. Maker's Mark, which is owned by Jim Beam, had included the terms "handmade" and "handcrafted" on the labels of its whiskey, which was challenged by a group of consumers

who claimed that the process of making its bourbon "involves little to no human supervision, assistance, or involvement" and instead is reliant on a "mechanized and/or automated production process." The court concluded that no reasonable person could understand the term "handmade" to mean literally by hand and that substantial equipment was not used.

There is no case law regarding works of art, although the use of digital photography, foundries, and print studios make clear that artists increasingly are team leaders, or designers, rather than one-man bands. "I think using a foundry in Asia would make the statement 'Made in America' inaccurate," said Nicholas M. O'Donnell, an art lawyer in Boston, Massachusetts, but no lawsuits have been filed to date. Again, the issue is less how the objects are produced than how they are marketed to the public.

Another phrase that is defined by the FTC is "Made in America"—or, more properly, "Made in USA" (www.ftc.gov/system/files/documents/plain-language/bus03-complying-made-usa-standard.pdf). Probably, most visitors to arts and crafts fairs in the United States assume that items for sale were "Made in America," unless the artist or craftsperson is a foreign national. "Locally sourced matters to many people," said Karen Delhey, executive director of Guild of Artists and Artisans, which sponsors the Ann Arbor Summer Art Fair, "but it doesn't disqualify someone if what they are selling was not made or assembled in America." Similarly, Linda Post, director of the Paradise City Arts Festival, stated that "where materials are sourced is not of paramount importance to the visitors to our festivals, or to us when we select artists. We look for creativity, imagination, and technical proficiency." Artisans might only find themselves afoul of the law if they promote their creations as "Made in USA" when they were not.

According to the federal agency, "For a product to be called Made in USA, or claimed to be of domestic origin without qualifications or limits on the claim, the product must be 'all or virtually all' made in the U.S. The term 'United States,' as referred to in the Enforcement Policy Statement, includes the 50 states, the District of Columbia, and the U.S. territories and possessions."

As examples of what is and is not allowed, the FTC offers some examples, such as a propane barbecue grill that is wholly produced in Nevada with the exception of the knobs and tubing, which are Mexican imports. A "Made in USA" claim is acceptable, "because the knobs and tubing

make up a negligible portion of the product's total manufacturing costs and are insignificant parts of the final product." On the other hand, a table lamp assembled in the United States from American-made brass, an American-made Tiffany-style lampshade, and an imported base could not be identified as "Made in USA," because the base forms "a significant part of the final product."

Of particular interest to jewelry makers is the potential adoption by the FTC of new rules prohibiting them from labeling their creations as "Made in USA" if the precious stones were sourced outside of the United States and its territories. However, if jewelry is not labeled as or claimed to be "Made in USA," there could be no action for marketing deception.

Frames and Pedestals

Every job, even the most glamorous, has its boring side, and for Medford, Massachusetts, artist David Phillips it is building pedestals for his sculptures. "I could use my time better, doing something other than making pedestals," he said, "but I've made them myself throughout my career. If it needs a pedestal, I figure I'll just make my own."

In most cases, he believes that his artwork needs it, at least for the purpose of display.

A pedestal represents a day's work for him, buying the materials he needs—often plywood and paint, sometimes concrete—to form the base on which his work will sit. If he were to cost out the pedestal ("say my time is worth $50 an hour"), it might come up to $400 or $500, but he rarely adds that to the cost of his work. "Buyers generally assume that the pedestal comes with the sculpture. I'm delighted to have a sale, so I'm not going to quibble about the price of a pedestal."

Frames on paintings and pedestals under sculptures often seem to be part of the package for art collectors. "Frames, pedestals, and bases make the pieces feel more finished," said Marc Fields, owner of New York's the Compleat Sculptor, which sells pedestals and bases to artists, at prices starting at $100–$500 (for laminates and Formica) to $300–$1,000 (for Lucite or hardwoods) and $600–$2,500 (for stone, such as marble). The variation in price is based on the size requested. As boring as the process is of making another pedestal, Phillips acknowledged that it helps improve the presentation. He noted that "people have said to me,

'Wouldn't it look better at a different height?' and they have a point. The work just doesn't look right sitting low on a table."

Frames and pedestals do more than encase a painting or make a sculpture sit up higher. They provide some protection from bumps and kicks, as well as act to spotlight the artworks, separating them from the world around them and forcing viewers to look at them closely. Certainly, some contemporary artists want their work to be part of the surrounding world, rather than in contrast to it, and frames, pedestals, and bases sometimes violate their aesthetic sense. Can't satisfy everyone.

Some artists consider that they have done their job by completing the work of art, leaving the presentation part to others, such as their dealers. "There often is a push-pull between artists and dealers," said art dealer Louis Newman. "The artist wants the cheapest frame or pedestal, especially if the artist is paying for it, while the dealer wants something that is presentable." Not only does the presence of a frame make a painting seem more finished, he added, "it's one less thing for a client to have to think about. 'Honey, what kind of frame should we get?' 'I don't know, what do you think?'"

On the other hand, artist Alan Magee of Cushing, Maine, views the frames on his Photo-Realist paintings as part of the entire artwork, hiring cabinet makers to cut and mitre pieces of wood that he paints and assembles to encase the canvas. "My aim is to control the presentation," he said. "I want the shapes and colors of the frames to be unexpected, just as the painting itself should be something of a surprise to the viewer."

The cost of the specially manufactured wood comes to more than $1,000 per frame, and then Magee spends several days applying layers of paint and assembling the frames, but the cost of this is folded into the final price that a buyer would pay. Those buyers usually understand that canvas and frame are both works of the artist, although there was "one collector who discarded my frame and got another to fit the color scheme of his home. All I can say now is that that painting isn't complete."

Another artist who aims to control the presentation of artwork is Alison Sigethy, a kinetic glass sculptor in Alexandria, Virginia, who purchases pedestals for her work, equipped with lighting to illuminate them from below. Those pedestals serve a very practical purpose for buyers,

she said, solving "the problem that many people have with sculpture, trying to figure out what to do with it. The sculpture on the pedestal makes it easier for people to understand how to show and place it. I know pedestals have helped sales, based on the reaction of customers when they see it as part of the sculpture."

Sigethy added that the pedestal "makes the price of the sculpture more palatable" for buyers, and the amount she pays for the pedestal—usually around $1,000—is woven into the final sales price for her work.

Not every frame, pedestal, and base is intended to be part of the total package and may just be there to give potential buyers a sense of how an artwork might look in their homes. Krista Steed-Reyes, director of Broadmoor Galleries in Colorado Springs, Colorado, stated that sculptures are always sited on top of some base, although the gallery has moved away from purchasing pedestals and instead places objects on antique tables. Buyers seem to understand that the table is not part of the artwork but just brings the artwork closer to the viewer's eye. For two-dimensional artworks, however, frames are assumed to be part of the package. "There is only one painter in the gallery whose works we can sell unframed," she said. "With the others, we haven't been able to sell their paintings without frames." As a result, the gallery purchases frames for unframed works, either tacking on that expense to the overall price that a buyer will pay or deducting that amount from what is owed to the artist when they sell.

Peter Loughrey, director of modern design and fine art at Los Angeles Modern Auctions, also noted that frames and pedestals are crucial in selling artworks. "Personally, I like to see sculpture at eye level," he said. "So, I have many pedestals in our inventory to elevate objects to the necessary height." He added that often "small sculptures look best inside one of our glass showcases. In our May 2016 auction I custom built a display niche for three Harry Bertoia sculptures to elevate them off the floor and give them proper lighting."

At the Rhona Hoffman Gallery in Chicago, the decision on presentation usually is based on the artist's preference and "if the art calls for" a frame or pedestal, said gallery associate director Anastasia Karpov Tinari. More often, paintings will be displayed unframed and sculptures will just sit on the floor with no base or pedestal. "It is harder to see a small piece if it is right on the floor," she said. The gallery has several pedestals on

hand, but if it needs more, discussions will take place with the artist on who covers the cost of acquiring them.

The art galleries that show the figurative bronze pieces of Benjamin Victor, a sculptor in Boise, Idaho, generally use the most basic get-it-off-the-floor painted plywood pedestals that they provide. ("I don't send them pedestals," he said. "I let them do what they want.") The artist periodically receives commissions from governmental agencies and colleges, and in these instances he will work with the building architect to have a base created as part of the overall design of the space where his sculpture will be installed. Spending his own money on pedestals arises for his privately commissioned works, and Victor spends between $50,000 and $100,000 annually for wood and stone bases and pedestals from the Fort Collins, Colorado, supplier Pedestal Source. "I weigh in with the client on what I think might look best in the space where the work is going to be placed," he said. "I want to see what would match their homes, and I look at the species of wood they have in the house, the color scheme of the rooms, the design of the house, and the scale of the work that I'm making for them."

The starting price for a pedestal that he selects is $1,000, and the highest-priced pedestal he ever used was $8,000 for a 48-inch-tall maquette that was otherwise priced at $14,000. The total price for that work was $22,000. "I don't really make anything from the pedestals," he said. "I may charge a design fee."

For many artists, perhaps most, the look of an artwork is enhanced by a frame, pedestal, or base, but it is unclear how much money to spend on making that better presentation, since so often buyers are just going to discard those frames and pedestals for custom versions that they have made, "in colors or materials that suit their home décor," said Zachary Wirsum, director of the fine art department at the Chicago-based Leslie Hindman Auctioneers. He noted buyers often "leave pedestals behind" and that the auction house has "a graveyard of pedestals in our basement, which we reuse when needed. We may occasionally repaint them." A painter in his own right, Wirsum said that he doesn't frame his own work, because "I like to show the raw edges of the canvas." Understanding this, his gallery doesn't frame his paintings for its exhibitions, but he added that buyers tend to get his work framed, "because that's how they like them to look. I guess they can do what they want."

From an Exhibition Standpoint

"In general, I don't put works behind glass next to paintings," said Louis Newman, director of David Findlay Jr. Fine Arts, a New York City art gallery. Drawings and other works on paper generally "recede" in the presence of a painting whose colors are more likely to "jump out" at the viewer. When a big canvas is nearby, a drawing will often be taken as a preliminary study for the larger work, sometimes regardless of the content of the two pictures. Still, sometimes it happens that a drawing and canvas share a wall, which may take place for a variety of reasons (part of a single installation, each provides context to the other, a simple lack of separate space in the gallery, among others), and Newman stated that in this case the gallery might paint the wall blue "to neutralize the effect, basically putting both works on a neutral playing field." The benefit of painting the walls is to keep the white drawing paper from seeming to dissolve into the wall itself but stand out.

The Nancy Hoffman Gallery in New York City has also painted the walls when exhibiting drawings, even when no paintings are present, also to "offer a little bit of contrast to the paper," according to the gallery's director, Sique Spence. The wall paint is apt to be a shade of gray—"just a bit of contrast. Red would be overly dramatic." However, that kind of drama is regularly found in the works on paper galleries of major museums, where walls may be green or violet or some other color that contrasts sharply with white paper, especially since the lights are often much lower in these galleries than in the regular painting and sculpture rooms.

Hanging drawings also poses dilemmas for artists and galleries. It is not uncommon to see a single large painting on a wall of a commercial art gallery—a visitor's attention is immediately focused from afar—but "you don't want one drawing, unless it is absolutely enormous in scale, holding up a whole wall," Spence said. "The drawing is likely to get lost in scale that way." The more customary approach is to group a number of drawings together, pulling the visitor up close in order to get a better view. Drawings amidst other drawings force the viewer to forego looking for the finished larger piece and concentrate on their specific artistic qualities. The obvious drawback in this type of exhibit design, however, is that it suggests that the individual pictures are not substantial works of art in themselves and need others around them to fill them out.

Galleries seek to solve that problem by displaying drawings on smaller walls or in smaller gallery rooms. In that context, "the eye can rest on it, instead of going beyond it," Spence said. Additionally, as collectors are likely to hang a drawing in a smaller space, "they will get a better sense how the work might actually look in their home."

Finding the most appropriate mat (if there is to be one) and frame also takes considerable care. Overly thin frames might not be strong enough to hold everything together, while very ostentatious ones can be an unattractive billboard for how much the drawing cost. Jill Weinberg Adams, director of Lennon, Weinberg Gallery in New York, noted that she prefers a "straightforward presentation. I don't take a small drawing and put an enormous mat and frame around it to make the drawing look more substantial"—an approach with which most dealers agree—but there are certain mats and frames that heighten the drama of looking at the picture. Louis Newman uses a deep bevel mat, eight-ply rather than four-ply, because "eight-ply gives the image more of a presence," as opposed to the standard four-ply in which "the image looks like a poster." Fillets, or spacers (usually wood, rag board, or plastic), between the frame and glass also have the effect of deepening the image, drawing one's eye in. He avoids metal frames, which he associates with posters and finds do not enhance the image, choosing instead lightly stained hardwood frames that seem to be more commensurate with original fine art. Newman also eschews black frames as "funereal, and they pull the eye away from the work." His worst-case display for a drawing is "a thin cardboard mat with a black frame on a white wall, because this makes for a sterile presentation." In addition, he has applied fine linen or silk on the mat itself in order "to soften the color of the cardboard mat and it gives a halo effect without distracting from the image."

Mats are not always used in the framing of drawings. While their main function is to keep the drawing flat and not drifting toward the glass, many artists, dealers, and collectors prefer to show the edge of the paper itself, especially when it has a rougher, handmade quality. In these instances, the drawing is attached to the backboard and simply "floats" within the frame; fillets are often used to create the extra space between the paper and the glass that the mat would otherwise provide.

A novel use of mats has been made by Bill Richards, a New York City artist who exhibits drawings at the Nancy Hoffman Gallery. The mat

covers the perimeter of a drawing, but the mat itself is floated within the frame, that is, the edge of the mat can be seen three-quarters of an inch in from the frame. The mat is secured in place either by hinges at the top (more on hinges later) or simply by the pressure of the glass.

Mats are also a source of decoration, adding or offering contrast to the central image. At times, the mat will be a different color than the paper, and the mat may contain designs and colors complementing the drawing. Graydon Parrish, who creates drawings and oil paintings in Amherst, Massachusetts, and exhibits at Hirschl & Adler Galleries in Manhattan, uses a framer that draws in borderlines on the blue-gray mats, and some of these lines are filled with pastel-colored dry pigments, applied with a watercolor brush. There is a considerable amount of back-and-forth between Parrish and the framer, as the two experiment with different line thickness, mat, and pigment colors, and the extra work figures into the price: between $800 and $900 per frame and mat on drawings that sell on the average for $20,000. (Parrish pays for this service out of pocket, noting that "it's the one problem I have with Hirschl & Adler, they will not pay for matting and framing and just take it off the top when they sell a work.") Framing and matting charges that run 4 or 4.5 percent of the entire cost of the artwork is within the norm of the gallery world. Louis Newman's rule of thumb is "no more than 10 percent of the work's price for the frame."

From a Conservation Standpoint

On the face of it, art dealers and art conservators should have a lot in common—both groups want art to look good, if for somewhat different reasons. Badly illuminated, matted, and framed drawings will not be appealing to potential collectors, and those same factors are likely to cause long-term damage to the artwork itself. The two groups sometimes part company when it comes to the actual business of finding the right mats, frames, and lighting for drawings. The reasons certainly are economic, but also the result of a lack of a clear understanding about how to actually protect drawings. Everyone is quick to repeat the mantras of products labeled "acid-free" and "archival," which suggest proper care and an artwork's longevity, but these terms are to art what "all-natural" and "organic" are to food—well-intentioned, higher-priced, and ultimately meaningless since there is no federal standard for what these words are required to mean.

Ronald Jagger, director of the Phyllis Kind Gallery in New York City, noted that he spends "a great deal of time" thinking about frames and mats for the drawings that are periodically put on exhibition, but those thoughts often run to "how to keep the costs down." Framing and matting costs between $100 and $175 per drawing, an expense shared equally by the gallery and the artists, and there may be forty-five works in a single show. "We think about what kind of frame—metal or wood—would best enhance the drawing, we think about UV"—ultraviolet light—"glazing, and we know to use archival materials, but the fact is that most of our clients take off the frames and mats we put on. They have their own framers." Cheaper frames and mats seem to solve one problem, but they also may lead to others.

Drawings not matted and framed to exacting museum standards may result in significant damage to the artwork. The paper is stained by acids in the mat or frame (or both), even by the tape used to hold the drawing in place. The paper buckles and puckers because of moisture, perhaps even bulges out so far as to come into contact with the protective glass (which no longer protects it at that point). These types of damage are not uncommon in private homes, although quite rare in major museums where the price of high-end matting and framing small drawings starts at $500 or more. The gap between what professional conservators recommend doing and what many artists and dealers end up doing can be wide. The Lennon, Weinberg Gallery may spend as little as $75 per frame, according to Jill Weinberg Adams, who noted that she works "on a short time frame; I have to get a lot of frames in a hurry. While I look for the best balance of care, I don't always have the time and budget to get everything properly framed. I may have eight weeks and $3,000 to spend. Sometimes, I have to go with a less expensive framer just because they're the fastest."

Conservators speak not about just framing and matting, but about the entire "frame package." That package typically consists of backing material (acid-free corrugated cardboard or polystyrene-cored board, often called Fome-Cor), a backboard that may be called "conservation board" (high quality cardboard and paper made of chemically refined wood pulp) or rag board (made of cotton or linen stock), the drawing itself, a window mat (again, rag board, buffered rag board, or conservation board), covering glass (including regular glass or acrylic glazing materials, such as

ultraviolet shielded Plexiglas, Lucite, and Acrylite), and the encompassing frame (wood, metal, plastic), which can—but need not—be made airtight when sealed on the back with polyester film (Mylar), metal foil, or other impermeable materials. "Airtight" does not mean, however, that a work of art can be placed in any environment, such as a humid bathroom, and remain protected.

Many of the materials that framers use are described as acid free, but that may not offer sufficient protection to artwork. It is not uncommon to see, for instance, a brown core just under the top layer of a so-called acid-free window mat, where the window has been cut out. "If the mat board has a core that has wood pulp, it won't remain acid free," said Leslie Paisley, head of paper conservation at the Williamstown Regional Conservation Center in Massachusetts. That wood pulp core contains lignin, a type of natural glue that holds the wood fibers together but turns brown and more acidic as it ages. That acidity will reach through the surface of the mat to the paper, causing it to darken in spots.

Hazards lurk all over. A mat that is perfectly acceptable to conservators may turn acidic from backing material that contains harmful wood pulp or if it is in direct contact with a wood frame, absorbing acids from the wood. Some types of wood are more acidic than others—poplar and ash are less likely to cause conservation problems than oak, for example—but it is often the case that some buffering material between the mat and frame is needed. Artists need to go beyond claims of "acid free" to ask specific questions of those who would mat and frame their work about what these products actually contain.

Some framers simply do not carry the highest quality conservation materials. "Framers are profit driven and know that they can't charge exorbitant prices," said Karen Pavelka, a professor of paper conservation at the University of Texas Graduate School of Preservation and Conservation Studies. "So they don't use mat board with good quality fibers, for instance, or they will mount the artwork using pressure-sensitive tape, which isn't very strong, doesn't let the paper expand and contract, and is very difficult to remove. There is a lot of damage that framers can cause."

Acidity, which causes paper to become stained and brittle, is the most common long-term problem with improper matting and framing materials. A less visible but no less problematic area is adhering the artwork to the backboard, using what is referred to as hinges. (At times, drawings

are held in place with corners, made of sturdy acid-free paper or Mylar folded into triangular shapes and adhered to the backing.) A variety of materials are used as hinges, including archival (not Scotch or masking) tape and linen with a type of envelope glue; what makes them archival are the claims that they can be removed without damaging the artwork.

Those claims, however, are not accepted by all conservators, who often look beyond the issue of getting the picture matted and framed to a time in the future when the drawing will be removed from the mount. "You may be able to take off archival tape within a few minutes of applying it without any real damage, but, if it has been on for some time, it will not easily come off without taking some of the paper with it," said Margaret Holben Ellis, director of the Thaw Conservation Center at the Morgan Library in New York. Additionally, while the paper expands and contracts with changes in humidity, the tape does not have that flexibility, causing the paper to buckle where it comes into contact with the tape, sometimes leading to tears. The linen hinges have more—although not exactly the same—elasticity to "breathe" with the paper, but its glue has the potential of staining the paper, "and you have to use a lot of water to take it off. It's like steaming a stamp off an envelope, and that water can damage the paper."

The preferred method is long-fibered Japanese paper, which is adhered to the paper and the backboard through a wheat or rice starch that is applied with a brush. "It is very strong and entirely reversible with not that much water," she said.

One area in which art dealers and art conservators would clearly find themselves at odds may not matter all that much. Gallery lighting is much brighter than that used in the rooms showing drawings in museums. The dim lighting in museums preserves the paper but it makes getting a good look at the work a bit more difficult, and gallery owners want prospective collectors to see the work clearly. "If you can't see it, it won't look very good," said Frederick Baker, an art dealer in Chicago. "A dark room would make me crazy." The galleries in museums devoted to works on paper are usually illuminated to scientific measurements of between five and eight "foot-candles," Margaret Ellis said. To determine whether or not a room is brighter than that, she recommended using a photographic meter, which is built into many 35-millimeter cameras. Setting the ASA scale to 100 and the f-stop at 5.6, the indicated shutter speed will be

equal to the number of foot-candles. If that number exceeds eight, the room should be dimmed or the artwork moved elsewhere. It is rare, on the other hand, that a gallery director has any idea how much wattage is lighting up an exhibition.

"Objects are made up of molecules," Margaret Holben Ellis explained, "and light energy may cause molecules to separate. When that happens, it releases acidity, which is a product of the reactions, and that eats away at the canvas and paint, causing fading." She suggested placing drawings away from wall areas that will receive strong direct sunlight as well as away from lamps.

In addition, ultraviolet filters might be placed over the windows, or ultraviolet Plexiglas in front of the work itself, to shield it from the most harmful effects of the light. Among the benefits of Plexiglas are that it is lightweight and almost unbreakable; however, it holds a static charge that may lift the paper or bits of the drawing material. Larger pieces of paper (40" × 60") have more movement than smaller ones, and they are more apt to be pulled toward the Plexiglas, requiring a larger fillet (perhaps a three-quarter-inch spacer as opposed to the standard one-quarter inch) to keep the paper and gazing material separated.

There are also ultraviolet coatings that one can apply to windows, retarding the most severe effects of strong sunlight, as well as certain types of accordion-shaped blinds that allow a certain amount of light and heat to enter a room while reflecting high heat. Hardware and home decorating stores will have many of these products. If not, call a local museum to find out where to get them. Darkening the walls with paint, by the way, adds a certain drama to a room and may reduce some of the glare that takes place in galleries where the light bounces off the white walls. However, it does nothing about reducing either ultraviolet rays or the overall amount of light in the room.

Fortunately, exhibitions in galleries only last a few weeks, after which the drawings would go back into storage or into someone's private home where the longer-term problem of preservation actually begins.

Talking to Collectors

By now, it should be clear to all that artists really aren't discovered while hidden away in some garret (what is a garret anyway?); that artists have

to be out in the world making contacts and talking, talking, talking about their work. But what to say? Painter Bill Jensen called it "the worst thing in the world to be a salesman. It's better to be yourself," yet all conversations that one has as an artist with a prospective collector have an element of salesmanship, whether the product is specifically a work of art or more diffusely the artist him- or herself as a serious, knowledgeable, interesting person. Those opportunities to be the Artist may be few—an opening of an exhibition of one's artwork—or frequent (manning the booth at an art fair, holding an open studio event, giving a public talk or demonstration, introducing oneself professionally at a party), but they all require the same understanding of the need to find something to say. The anguish and dread of saying something wrong or irrelevant or making a poor impression has driven some artists to look for the nearest garret in which to hide. Cyberspace has become the new garret: too many artists these days believe they will be discovered through some chance Internet search, relieving them of the need to face the world in person and in words.

Conversations between artists and collectors, usually starting in the form of question-and-answer, may be straightforward ("Where were you when you painted that landscape?") or have an underlying purpose. "People want to feel your level of commitment," Tom Christopher, a painter in South Salem, New York, said. "They want to know if you're for real or just a charlatan, someone with a bit of talent out for a quick buck." Christopher paints crowded, colorful New York City streets, and he talks to would-be buyers about how he started drawing and why Manhattan's main and side streets have been his principal subject. He refuses to talk about money ("I have dealers for that") and deflects requests to paint certain locations ("Could you do 77th Street and York Avenue?"). Sometimes, the question may seem insulting ("like, 'Why don't I paint Frankfurt, Germany?'"), but he responds by expressing enthusiasm for New York City, often finding that humor is helpful. "I've been asked, 'Have you always been an artist?' and I say, 'Well, I tried other jobs, but none of them stuck,'" adding that collectors "don't really want a soul-searching answer."

Turning the conversation around, Christopher sometimes becomes the one asking the questions: "What do *you* like about New York? Where do you live? What do you see? What turns you on about the city? If you

were a painter, what would you paint? How do you like the ragged drip edges of my paintings?" Never straying all that far from his own artwork, Christopher broadens a discussion that can easily devolve into rote responses. He keeps brochures and catalogues on his work handy—they may answer a familiar question or just give visitors at an exhibition something to do—"but openings are, what, two or three hours, two or three times a year. That's not so much."

For Western artist Howard Terpning in Tucson, Arizona, the talking may go on for days at a time, such as at the Prix de West competition that lasts a long weekend ("I get a little hoarse by the end of it," he said), and the questions are always the same. "I'm asked a million times how I got started in this business. I sometimes wish I had a printed sheet to hand out" or could just tell people to read one of the books written about him to get their answers. However, sarcasm and touchiness would be self-defeating, and "I patiently explain to each and every one of them how I got started in the business, how I started painting the Plains Indian." Like Christopher, Terpning won't talk money, referring collectors to his gallery for paintings and to Greenwich Workshop for prints. Unlike Christopher, Terpning carries no business cards or brochures, relying solely on his vocal chords.

Wildlife artist John Seerey-Lester, who lives in Osprey, Florida, goes a step beyond brochures, running a video or slide presentation that describes his background in art and how he paints, and he sometimes adds commentary while the video is on. Usually, the questions that follow are a continuation of those themes: where something was painted, why he chose to paint that, sources of his inspiration. Talk that is less open-ended and more specific to the artwork on view makes the process of conversing with strangers more manageable for him. Wildlife collectors, he noted, respond favorably to "stories of where I was when I painted something, the hazards I faced, any dangerous incidents, funny stories. I've done walkabouts in a gallery, telling anecdotes about this or that work, and usually all the pieces are sold by the time I'm done talking."

Since art is a luxury rather than a necessity, what is generally thought of as sales talk may not be all that helpful in getting someone to make a purchase. Instead, the contagion of an artist's enthusiasm or information about who else has collected the artist's work ("People feel more confident paying $15,000 for a painting when they know they're not alone,"

Christopher said) may help a sale take place. Art is a commodity to be bought and sold, but as a vessel bearing the ideas and feelings of the artist, it is also a very personal product, affecting the relationship between buyer and seller. For sculptor Elyn Zimmerman, collectors sometimes become friends. "People come up to me at an opening and ask me questions," she said. "They see something in my work that touches them deeply, and a relationship builds, because we share certain fascinations."

At other times, she noted, the questions merely reflect puzzlement over what's going on in the art, requiring explanation.

The confidence artists feel in their ability to speak to strangers is proportionate to the degree to which they believe that talking to collectors is actually useful. Painter Harriet Shorr said that, during studio visits, collectors who have purchased pieces usually make their choices immediately, "and they're not particularly interested if I'm talking or not," while those who tell her they need to think about it first "generally aren't going to buy anything, and I could talk myself blue in the face." Like many artists, she prefers to be approached by a collector than to strike up a conversation with a stranger looking at her work. Like many artists, she prefers a dealer talking up her art rather than herself. However, "one time, I approached someone at a party who was talking about art. I thought, 'What the hell, I might as well let him know I'm an artist.' It was at a point in time when I didn't have a dealer. I invited him to my studio, but nothing came of it. It seldom does."

Not every collector is eager to meet artists or go to their studios, at least not right away. Edward Broida, a noted collector of contemporary art who lived in Malibu, California, said that he may "get to know the artists after I buy their work, but I dislike knowing them first, because it affects my objectivity. When I was living in New York City, artists would invite me for studio visits, but I found it very uncomfortable. They look at me and I look at them. What do I say? What do I do? I prefer to see art in an independent, third-party place, like an art gallery."

On the other side, a number of artists complained that the people who approach them frequently are looking to be allowed into their studios. "I feel close to abhorrence about strangers coming into my studio," said New York painter April Gornik. "It's very interruptive, and I don't want someone's unsolicited opinion." She added that she prefers to discuss finished pieces rather than those in progress.

It is not always clear how important it is for a collector to know the artist. Perhaps, during his own life, Rembrandt personally helped or interfered with the sale of his paintings, but nowadays his artwork stands on its own, talked about by people with doctoral degrees, and many living artists would hope that their art speaks for itself (or that a dealer will do the talking). Jamie Wyeth worries that something he might say about one of his paintings might "intrude on someone else's sense of what the work is about." Renowned for his own work, as well as that of his father (Andrew Wyeth) and grandfather (N. C. Wyeth), he noted that the problem of making a bad impression "gets worse as you get more established. People have a preconceived idea about who you are, and you find you're probably a disappointment to them in the flesh."

Renown also increases the number of people who want to talk to an artist, although it may have little to do with collecting and more about creating an anecdote they can tell someone else. "I've had people come up to me and tell me they love my work; they have a painting of mine in their living room that's changed their lives," Wyeth said. "I ask them, 'Which painting is that?' and they say, 'Uh, um, well, there is a person in it, or something.' OK, better not go down that road." At other events, he has been congratulated for painting *Christina's World* and for illustrating *Treasure Island* ("I've learned to accept thanks for whatever people want to thank me for"), coming to the conclusion that many people simply want to hear their own voices.

Hearing themselves speaking to an artist or just wanting to hear the artist's voice, people may have a variety of reasons for talking to artists that have nothing to do with the purchase of art. Just as marketers send out flyers to names on a mailing list, with the hope that 2 or 3 percent of the recipients buy whatever they are selling, artists may have countless futile conversations for the prospect of talking to an actual collector who makes a purchase. However, conversations are not flyers, and the effects may be varied. For artists, putting their thoughts into words may help clarify their thinking and understanding of their own work. Hearing an artist discuss his or her work may help a listener gain a greater appreciation of art (and who can tell where that may lead?). Listening to people describe what they found in their artwork could give artists a fuller appreciation of what happens once their work goes out into the

world. "Art is a conversation," Elyn Zimmerman said. "If it doesn't communicate, what's the point of making it?"

Juried Show Etiquette

There is no "Miss Manners" for the art world, but there is an unspoken etiquette for juried shows and art fairs, which is brought up whenever an artist is found to have broken one of the rules. Sometimes, it is the artist who is clearly at fault, knowingly disobeying a rule that the show sponsor has set; at other times, show sponsors create rules that may force artists to choose between following the stated guidelines (causing them to act against their own best interests) and dishonesty. The fact that there is no standardization among the thousands of shows and fairs annually taking place around the United States means that artists themselves must tailor their own practices (and ethics) to conform to the rules of this or that event.

One rule on which there is general agreement is that artists should not substitute another work for the piece that was submitted to a jury. The desire to make a substitution may come about when an artist sells a juried piece before the show begins. Not all collectors will allow the works they bought to be part of a show (the piece may be damaged, for instance), and this puts the artist in a bind: Should the artist hold off on a sale, withdrawing from the show, or see if the show sponsor will accept something else? Artwork is not interchangeable, however; a work that is submitted for an exhibition should be available, and sales may have to wait.

Another point on which most agree is that the same work should not be submitted to two or more different shows, taking place at the same time, in order for an artist to see which is the best show in which to participate. If the artist's work is accepted into more than one show, it means that another artist's work was rejected, and the show sponsors may also have to scramble to fill an empty space. Artists should learn about a show before they enter their work, not afterwards, and commit themselves fully to the event.

Artists should also not fudge the issue of medium, which sometimes comes up in shows of watercolors. Some watercolor shows accept acrylics and gouaches, even pen-and-ink drawings with a watercolor wash, while

others are adamant about only transparent watercolors. The Midwest Watercolor Society has been so concerned about what is called a watercolor that it tests accepted entries to see if their medium is truly transparent. Artists who are in doubt about what is allowable have every right to ask; however, they should not knowingly submit work that goes against a sponsor's stated aim.

While most show and fair sponsors earn their money from visitor admissions, concessions, and booth or entry fees, some also take a commission on sales occurring at the event. In some instances, collectors are required to purchase works through the show sponsor rather than through the artist—one example of this is the LeMoyne Center for the Visual Arts in Tallahassee, Florida, which handles purchases (including payment of sales tax) for the annual Tallahassee Watercolor Society Tri-State show—but most shows rely on an honor system: the artist tells the sponsor what he or she sold and pays a commission (of usually 10 or 20, sometimes 30, percent). Frequently, when a commission is charged, the sponsor is able to lower booth fees for artists, even eliminate jurying fees. Moving the financial underpinnings of a show from up-front money (fees paid by artists) to money earned (through sale of artwork) requires more of the sponsor to promote the event and bring in likely buyers. This shift should be encouraged by honesty on the part of participating artists.

Some gray areas in show etiquette may also arise. Certain show and fair sponsors require that participating artists donate a work—perhaps, for an auction or as a door prize or for the sponsor's permanent collection (when the sponsor is an art institution)—but which work? Should a painter contribute a painting or a print or even a sketch? Must the donation be representative of the artist's best-known work or just anything? Often, the prospectus does not indicate what the donation should be, and artists are left with an ethical decision—to give away the type of work that got them into this show or donate just something small or inexpensive (or both) with their name on it. Probably, the latter option makes the most sense, especially if a donated piece is to be used as a door prize. Some artists create a line of less expensive pieces, and one of these would fulfill the requirements of the sponsor.

The length of time between when an artist submits a work to a juried show and when it is accepted may be months, and significant changes may happen in the artist's career in the meantime. Awards may be won,

works sold, rave reviews published. Frequently, show sponsors require that artists put a price on work they are submitting for jurying; by the time of the actual show, an artist may want a much higher price, which could be accommodated in a gallery situation but is likely to cause hardship to a show sponsor who has printed up hundreds or thousands of brochures with prices noted in them. The sponsor would have to reprint the entire brochure with the correction or pencil in a change on every brochure or leave the brochure as is and hear from annoyed visitors to the show. The Massachusetts-based Cambridge Art Association, for its part, informs artists that the organization "will not permit changes in price upon acceptance." Price hikes cause hard feelings on the part of the sponsor, while now artificially low prices will irritate the artist. Sticking by one's word means adhering to the price originally set.

Not everything is cut and dried, however. Some shows require that every work on display be for sale, which may be attractive to visitors but not to artists. Artists may not want to sell works with personal meaning to them, or they may have a ready buyer (or have even sold the piece already). They may want the piece available for another show. A not-uncommon solution for artists is to give the piece a very high price ($10,000, whereas it otherwise would go for $1,500) in order to discourage sales and get around the not-for-sale problem. Other show sponsors set price limits for works on display, which is again appealing to visitors but cause hardship for artists who could charge more at other shows. Just as in the required donation problem, show sponsors place artists in an ethical bind: irritate the sponsors or hurt their own career opportunities.

In some cases, a show sponsor will request artists to indicate the value of submitted artwork, not for the purposes of listing a price but for insurance purposes (in the event of damage or destruction). That valuation should not be inflated. Artists would be wise to read a prospectus carefully, determining a course of action based on the rules the sponsor has established; perhaps they simply should not enter shows and fairs that make unpalatable demands.

Some conflicts between artists or between artists and show sponsors may not avoidable. An artist may choose to enter the same work in a great many shows, which will likely irritate other artists (and show sponsors) who are unhappy at seeing the same piece again and again. However, the public does not travel the show circuit as artists do and are unlikely to

see the work repeatedly; artists create works for potential buyers rather than for other artists.

An artist may submit a favorite work to juries for years, which may also annoy fellow artists who only send in slides of their newer work. Many show sponsors require that all work submitted has been created within the past two years, in part because they want annual shows to have a different look every year for the public. Newness, of course, is not an artistic criterion, but good etiquette in the art world is often a mixture of strong principle and the assumed needs of the market.

CHAPTER 3

Open Studios

IF ARTISTS ARE GOING TO ENJOY SUCCESS in their careers, they need to put their work in front of people, but which people? A billboard image of their art on the side of Santa Monica Boulevard in Los Angeles will certainly result in lots of people seeing it, but there not likely to be many buyers. Marketing means finding the right audience for something that is for sale, and part of an artist's task is to find the most appropriate places to display—and, thereby, sell—their artwork.

The buying and selling of art takes place in a large number of ways, in galleries or at auction, through commissions, over the Internet or by mail order, at arts and crafts shows, at art fairs, and also directly from artists during studio visits. The open studio may be the most fun for prospective buyers, since it is often done with other people and tends to have a party atmosphere (food and drink are served, there might be balloons and flowers, and even the most irascible artist tends to be on good behavior).

Open Studio Events

The Boston (Massachusetts) area seemingly is just wild about artists opening up their studios to the public. In the fall of 2016 alone, there were eleven of these community events, taking place over weekends in East Boston, South Boston, South End, Vernon Street, the Brickbottom Building, Dorchester, Fenway, Jamaica Plains, and in other areas and surrounding towns. And that's just the fall. During other times of the year, artists in Acton, Arlington, Brookline, Cambridge, Framingham, Lexington, Lowell, Medford, Natick, Needham, New Bedford, Somerville,

Sudbury, and Waltham (probably others, too) schedule their own occasions to invite in visitors and prospective buyers.

The benefits for artists are clear, if their ambitions are not overly high: according to Peg O'Connell, a photographer in Brookline, Massachusetts, and past director of Brookline Open Studios, the purpose of the event, which takes place annually in late April, "is threefold, to educate the general public through art demonstrations, to connect artists with potential collectors, and to allow artists to sell their work to the general public." More of the first two take place, she noted, than the last: "Sales vary from year to year, the ceramists and jewelers do consistently well in terms of sales since their prices per artwork are affordable. The painters, photographers, and mixed media artists do have sales, yet most of their activity during the weekend are for leads to future shows."

Most of the artists who take part in the event one year look to do it again the next. Their work gains some visibility and they might earn some money. They are not waiting for art galleries to discover them, and participation in these events rarely requires jurying or much other than the payment of a registration fee. Area businesses, such as shops and restaurants, also benefit since open studio days bring in additional foot traffic and money. Artists in certain neighborhoods and towns may do better than others. John Crowley, curator of exhibitions at Boston's City Hall who oversees open studio events in the City of Boston, noted that he himself had participated for a number of years at the open studios at the Fort Point Arts Community in the city's south end. The dense cluster of artists in this series of buildings brings out visitors with a serious interest in art. "One year, I made over $6,000 [for my paintings and sculpture]," he said.

For Nancy Fulton, a photographer in Somerville, Massachusetts, and longtime organizer of Somerville Open Studios, the aim is meeting new people, noting that "much of my mailing list has come through open studios." She sees many of the same people from year to year, over the fifteen years that she has participated, "who have seen my work and want to see new work I'm doing now." It is easy for artists to become isolated, especially someone like Fulton, whose work is not represented by a gallery, and opening her studio up to the general public allows her to gauge their reactions and level of interest. Her sales at the annual May event have ranged from "several hundred dollars to several thousands dollars."

Community open studio events rely on volume: 50 or 100 or 500 or more artists' studios all accessible and all within a few feet of one another, so that visitors may see a lot in a relatively short period of time. This favors cities or towns that have one or two buildings filled with artists' studios, but artists who don't have studios in those specific places are at a disadvantage. Such was the case for Beverly Shipko, an artist in Westchester County, New York, who for several years has been included in the annual mid-April Riverarts Studio Tours itinerary but rarely visited by anyone, because "most of the artists in the tour have studios in the same areas"—largely in the downtowns of Dobbs Ferry and Hastings-on-Hudson—"and I live far out in Ardsley." (It actually is a little more than a mile and a half from Dobbs Ferry, but that might seem like a schlep for people who otherwise are just walking from one studio to the next.)

Shipko is still part of the annual tour, but she has turned the occasion into her own individual open studio event, inviting past buyers and others who have shown interest in her work to her studio, which is located in her home. "It's the beginning of spring, and everything is becoming beautiful and people are happy to go outside," so it just made sense to coordinate her largely private event with the county's. Mid-April probably would have been the time when she would have wanted to schedule an open studio event anyway, since Easter and Passover are over, as is the NCAA basketball tournament, and April K–12 school vacations usually still are a week away.

"It's important to pick the right date," she said. "You have to look at the school calendar, and stay away from any holidays or major sports events. On three-day weekends, everyone leaves, so no one would come to your open studio." Ever conscious of collectors who are Christians and Jews, Shipko holds her open studio on both a Saturday and Sunday. "If I only open one day, people will say, 'That's my church day' or 'That's my synagogue day.' You have to accommodate everyone, but it's tiring, though."

Accommodating differences goes even further than that, as she provides snacks—desserts, largely—and beverages (coffee, tea, milk, juice, and water), and some of the visitors inform her that they are gluten-free. "I had to get gluten-free Oreos from Trader Joe's," she said.

Solo, or by-invitation only, open studio events have clear advantages over the community events, making up for the potentially smaller

number of visitors who will traipse through the studio with a more select group that has shown an interest in art, particularly the work of the artist whose studio they are visiting. These people are more apt to know what art costs, and their visit to the studio will be an opportunity to see more of the artist's work and a sense of the process by which the artist creates it. In addition, because the artist and visitors are acquainted, and perhaps even friends, artists may feel a bit less worried about inviting strangers into their studios and homes. Still, it is best not to tempt fate. Shipko hid her jewelry, prescription medicines, and liquor bottles ("just like I do when my daughter has a party with her friends"), placing some of her artworks on one staircase for show and also to block curious visitors from prowling her home's upstairs, and she put a ribbon across a second staircase also to deter people.

Additionally, she doesn't work this event alone. Her husband, daughter, and a friend are on hand to direct traffic and be watchful. "One time, we did have a strange man come," she said. "He asked strange questions, he seemed unstable. I just wanted him out of the house, and eventually he left."

Perhaps that strange man was the lone visitor from the Riverarts Studio Tours. Meg Black, a painter and sculptor in Topsfield, Massachusetts, doesn't piggyback her annual open studio at her home on anything the community is offering, and all of her guests were specifically invited for the mid-November event. A few weeks past peak fall foliage season, she picks mid-November, because "it's not too cold, it's not too warm, people often are done with leaf raking; it's before Thanksgiving and Christmas, so people aren't preoccupied with other things," she said. It is in the middle of football season, so she holds her open studio over both Saturday and Sunday, so that people who don't want to miss college football on Saturday or the pros on Sunday will have fewer excuses to skip her event.

Black, an art history professor at Salem State University, also made sure not to be alone, hiring one of her graduate students to walk around "to engage people about my art," as well as a local framer who acted as a salesman for her artwork and also had the chance to drum up some business for himself. The framer was paid $50 per hour (he worked nine hours in all), and the graduate student was paid "less than the framer." She also hired a caterer who served visitors cookies, cheese and crackers, hot hors d'oeuvres, and wine, which cost $1,000. The final expense was

specially printed postcards—the design for the postcards was done by a local graphic designer, who was "paid through barter"—that were mailed to close to 300 people, and in all the cost of holding her open studio was $2,500. (An artist's time, we all know, is free, so it is best not to try to tot up the value of Black's hours spent planning the event and promoting it on social media.)

Not everyone who was invited came, but everyone who received announcements by postcards or electronically was urged to bring their own friends or acquaintances who they thought might be interested in her work. Some of those postcards were given to invitees in order that they would mail them to people they knew.

At the open studio, Black sold six pieces, "all to people I hadn't met before," earning $5,000, doubling her out-of-pocket costs. The most awkward moment of her open studio occurred after it was over, when the Boston gallery that exhibits Black's work asked for her mailing list of invited guests, as well as a commission for sales. The open studio did not come as a surprise to the gallery owner, who had been informed in advance and raised no objections, but Black said that the conversation after the fact was "sticky. Ultimately, I had to tell her that if she wanted a commission, she should have come to the open studio and sold something."

One cannot blame the gallery owner, who likely believes that her efforts on the part of Black helped raise the artist's public visibility and stature, for which the gallery should be rewarded. Dealers often prohibit the artists they represent from selling directly to buyers, worrying that collectors will turn away from the gallery and only purchase from the artists at a discount. Open studio events are useful for some artists but create problems for others.

It is difficult to assess what makes an open studio event a success. Seeing many of the same people over the course of fifteen years, as Nancy Fulton has done, might seem like spinning one's wheels if these visitors don't turn into buyers at some point. Spending $2,500 to earn $5,000 is more break-even than profitable, if all the time, planning, and disruption to one's life are taken into account. Leslie Fry, a sculptor in Winsookie, Vermont, who has opened her studio in her home in early summer for the past several years, last July spent $800 on food, mailers, and a few helpers ("to serve refreshments and wrap up things that were sold") and

earned $1,600 through sales, "and I was very depressed. It just didn't seem worth it." Possibly, Winsookie in northern Vermont is just a bit too off the beaten trail to attract prospective buyers, or it may just be that Fry did not invite the right people. "They were people I knew, and I treated it as a party, where people could walk through my beautiful sculpture garden and see things they might want to own," she said.

Increasing an artist's visibility and generating sales are worthy goals, and artists hope that both take place. Perhaps a dealer or two will show up, inviting the artist to show at a gallery, or a visitor may keep that artist's postcard for a period of time, purchasing an artwork a year or more later. Meg Black received two commissions following her open studio (one was a private collector and the other a hospice seeking an artwork for its lobby), and Beverly Shipko was invited by the owner of Cavalier Galleries to show her work in the gallery's three locations (Greenwich, Connecticut; Nantucket, Massachusetts; and New York City). So far, one piece was sold by Cavalier, and the final reckoning of that open studio has yet to be fully tallied.

Turning Visitors into Buyers

Group open studio events primarily are an educational activity for the emerging artist, letting the public know that artists exist within their midst, providing information on the processes and materials by which art is made and that "artists aren't crazy nutty people, and that art is a commitment, a life, not a hobby for them," said Patti Brady, a painter and former chairperson of the Greenville (South Carolina) Open Studios Project.

For participating artists, too, there is often an educational component, allowing them to learn how to present themselves and their work in a professional manner. Some of the groups that organize open studio events provide workshops or possibly just recommendations on a website on how artists should promote their work, set up their studios, create a price list, or talk about their work. Open Studios, which is held annually in Boulder, Colorado, provides a marketing workshop before the event for the 140-plus participating artists that focuses on how to publicize artwork, the types of financing arrangements that may be set up, and "how to talk to people," said Gary Zeff, founder of Open Studios. "You want to get some conversation going, like 'Is this for you, or is it a gift?'

and not just 'Will this be cash or charge?'" He added that collectors are interested in "a story that goes along with buying a piece," such as how it was created or what was the inspiration. In addition, asking visitors about themselves—what kind of art they like, where they live and work, how they heard about open studios, what do they see in this painting—both creates a bond between artist and prospective buyer and is a form of marketing: artists learn who their audience is, as well as the visitors' taste in art and level of artistic appreciation.

What works and doesn't work in attracting and keeping visitors is a matter of trial and error, and not everyone has had the same results. Something as basic as shaking a visitor's hand when that person enters and leaves the studio may add a note of ceremony to the occasion. A variety of suggestions are made by organizers of open studio events, such as the following:

- Show the artistic process, for instance, through displaying various stages, which might include preliminary sketches and oil studies or the materials and equipment used. Liz Lyons Friedman, a printmaker in Aptos, California, who has been a long-time participant in the open studio event organized by the Cultural Council of Santa Cruz County, displays her printing press, inks, blocks, and paper, as well as intermediate stages in the creation of prints on view, "which really fascinates visitors. They just have no idea." This offers a number of conversation starters.

- Send out invitations electronically or by regular mail to people who have bought work in the past or just have shown interest in the artist's career, informing them of the time and place of the open studio. A postcard with a reproduction of the artist's work might be tacked to a bulletin board, lasting as a reminder longer than an easily deletable email message. The same postcards should also be available in the studio when visitors arrive, along with other printed material, such as a brief biography of the artist, a price list, and, perhaps, some information about the artwork itself (inspired by . . . , technique used . . . , commemorating . . . , for example), if it is not obvious. Visitors should be directed to sign a guestbook and include their addresses, in order that they may be placed on a mailing list for future shows or open studio events.

- Images, written materials, and elements of the artistic process generally keep visitors in the studio longer, during which time they might decide to buy something. So does food and drink. Ann Ostermann, event manager for the Cultural Council of Santa Cruz County, stated that there is "no correlation between food and sales; spending longer eating doesn't result in visitors buying art," but there may be other benefits. A bite to eat and something to drink makes people feel welcome and helps sustain them as they progress from one artist's studio to the next. Those who drop out to go to a restaurant may not return. Gary Zeff said "no alcohol for sure, you don't want the liability," but various artists spoke of serving white wine, as well as water and finger foods (nothing crumbly and keep a supply of napkins on hand). Artists should also remember to eat during the day, in order that their energy level stays high.

- Artists should try to get a good night's rest before the open studio, but they will stay refreshed longer if someone else (friend, spouse, relative) is on hand to chat up visitors, directing them to the guest-book, keeping the food moving, and cleaning up any messes.

- Signs and posters (balloons?) should be set up outside, so that visitors know where they are to go. Inside, artists might want to put out of the way dangerous materials (solvents and resins, for instance) and machinery with sharp edges, as well as clean up spills that could cause a slip. Artists with studios in their homes may consider removing valuables and prescription medicines from the bathroom vanity (toilet paper should be in good supply). Some artists cordon off rooms in their homes that they want off-limits to visitors, but not all. To get to the studio of Marie Gabrielle, a watercolor artist in Santa Cruz who takes part in the citywide open studio weekends, visitors must walk through her house and backyard, and she considers her house a major selling point, because her framed paintings are on the walls. "I have a nice house, and people like the idea of seeing what my paintings would look like in a living room," she said.

- Among the DON'TS that sometimes get mentioned are letting a dog run loose, wearing perfume, and trying too hard to sell things. While having a friend help out at the open studio makes the artist's job easier, both artists and their friends need to remember that they shouldn't just talk to one another, but focus on visitors.

- Among the open points of discussion among artists are whether or not a studio should be reconfigured for the occasion to look more like an art gallery (will visitors take art more seriously if the setting is formal or do they come to see a more rough-and-tumble workplace?), if two-dimensional pieces should be framed (are people more apt to buy if artworks can be put directly up on the wall?), and if there is any return investment on providing food (does a better bottle of wine suggest that the artist is more prosperous and successful?).

The other main purpose of an open studio is to generate sales, and a number of factors help determine an event's level of success in this area. For instance, more participants increase both the amount and likelihood of sales. Between 2002 and 2015, over 400,000 people have visited the studios of artists in Greenville, South Carolina, who have participated in the annual mid-October Greenville Open Studios, purchasing $2.2 million in artwork, while the 140 or so artists of North Coast Open Studios in Humboldt County, California, annually earn above $200,000, and the 400-plus artists taking part in in Santa Cruz's Open Studios Art Tour earn between $1.2 and $1.5 million each year. Additionally, a number of open studio organizers have instituted a jurying system for applicants in order to raise the (perceived) quality of the event to the public. The Greenville open studios requested artists to submit images both of their artwork ("We wanted professional quality work, not a free-for-all," Patti Brady said) and of their studios ("We wanted to know if they have a real studio space or just work in the kitchen," she noted).

Sales are difficult to predict, regardless of the quality of the artwork on display; in fact, if higher quality translates into higher prices, top-notch art will probably be a money loser, because most open studio visitors don't actually come to buy, and those who make a purchase usually spend very modest amounts. Laura Baltzell, a painter living in Brookline, Massachusetts, who rents a studio in East Boston, took part in both the East Boston Artists Group and Brookline open studios (in Brookline, she set up her home as a gallery), participated in the open studio events in East Boston and Brookline, creating digital reproductions of her paintings, which she sold for $50 apiece at the Brookline show, but did not sell any original paintings at either open studio. Loretta Shoemaker, a

painter and pastel artist, brought out "all my lower-end things" for the East Boston open studio, such as some 3" × 7" paintings; in all, she sold ten works for a total of $500.

Marie Gabrielle, on the other hand, regularly earns the bulk of her income at Santa Cruz's open studio weekend. One year, she took in $40,000, selling fifty watercolors that were priced between $300 and $2,000 to visitors who came by her house. She has shown her work at galleries and periodically tried to hold more private, by-invitation open studio events for her own collectors but never with as much success. "So many more people come at the community event, maybe 2,000–3,000," she said. "They look forward to open studios, and that's what I work for."

By-Invitation Open Studios

The sometimes circus atmosphere and the uneven quality and content of the work in these community open studios may begin to work to the disadvantage of artists whose work has reached a higher level of esteem. For them, selling $25 knickknacks would be a humiliating step down. These artists may continue to hold open studio events, but just for their own studio and by invitation only. Their focus primarily will be on sales, commissions, and establishing relationships with serious collectors.

"I sell so much at my open studio," said Lynn Peterfreund, a watercolor painter in Amherst, Massachusetts, who opens her studio to collectors, friends, and colleagues twice a year. "I make thousands." She noted that big group open studio events have "an exhibitionary value to artists, but my aim is to sell."

When artists take on the job of selling their own work, they need not only to be the creator, but also to take on some of the elements of being an art dealer. Dealers have price lists, for instance, indicating what each piece costs. Artists should not fumble around in a desk for a price list when visitors are right there in the studio (that looks very unprofessional), and prices that are not committed to paper but simply stated to would-be collectors might make them feel ill at ease. (Visitors might wonder if the artist is stating the real price or sizing them up for how much they look like they can pay.) Postcard images or brochures should be available for visitors to take, as well as biographical or reference material (critical reviews or an artist statement—see Chapter 4). Any purchases

should result in the creation of a written sales receipt, listing the artist's name, artwork's title, size, medium, price, and the date of sale. United States law already protects creators, but they may also choose to include on a sales receipt the fact that copyright (unauthorized copies of the work may not be created) and moral rights (alterations, distortions, and destruction of the work without the consent of the artist) for the artwork are retained by the artist.

Additionally, as noted above, it is useful to have a friend, relative, or spouse on hand to tend to the details (gauging particular visitors' interest in art and price range, guiding them to specific artworks, and making sure they sign the guest book, for instance) in order that the artist may speak on a loftier level.

Practice has made (almost) perfect for Richard Iams and Buck McCain, two painters living in Tucson, Arizona, who have been holding a joint annual open studio—actually, open house—every March since 1993. Organized and run by their wives, Donna Iams and Melody McCain, the event drew thirty walk-ins the first year and grew to the point where it is an invitation-only affair for 350 collectors. (The final number may be higher, since many invitees bring guests who they believe might also be interested in the artwork.)

From this experience, Donna Iams has learned what has and hasn't worked:

- "Start planning the open-studio six or seven months in advance," she said. That planning includes checking that no other major events are taking place that day at neighboring colleges or in the NCAA Final Four basketball tournament ("someone once asked us if we had a television"); scheduling the printing of brochures, flyers, and postcards; hiring caterers, florists, and parking attendants.
- Notify people months in advance. "When we first started, we tried telling people a month in advance, but so many people had already made other plans," she said. "They told us, 'We wish you had let us know earlier, so we could have put it on our calendar.'" Richard Iams's holiday cards (Hanukkah for Jews, Christmas for Christians) each contain a brief handwritten note about the show, followed up in late January by a postcard with information about the

open studio event on the back and an image of a painting that will be on display. One month before the event, a newsletter is mailed out, containing between four and six images, the times and date of the showing, a map, and a request for an RSVP ("The first time we had more than 300 people, we ran out of food").

- Make it one day. "The first few years, we did shows over two days, on Saturday and Sunday, from 2 to 5 p.m., but that was very exhausting," she said. "You have to set up twice and take everything down twice. We switched to a one-day show, from 10 a.m. to 7 p.m., and that's worked out a lot better. "A problem with the second day, she noted, is that collectors believe that "if they didn't come the first day, everything will be gone, so they didn't come the next day." Over the course of that nine-hour day, she found that the flow of visitors was relatively constant.

- Have a range of artworks to show. Each artist puts out approximately twenty artworks, consisting of five paintings and the remainder sketches and small studies for larger pieces. It is the less expensive sketches that are most likely to sell, especially to visitors who are just starting to collect. "For the first three years," Donna Iams said, "we tried to make the display look like an art gallery," but they switched to a far less intimidating and formal approach, putting unfinished and unframed pieces on the floor, perhaps in a corner. (Their house looked like a house again.) "People like to root through things. When they find something out of the way, they feel as though they've made a discovery."

- Provide food and drink. As the open studio became an all-day event, the foods need to change for different times of the day ("no one wants to eat a sandwich in the morning"). Before noon, the serving is similar to a continental breakfast, with cinnamon rolls and fruit, changing to carrots and celery sticks, chips and salsa, chimichangas, and fajita sticks (kept in warming hot plates) by the afternoon and evening. "Sandwiches don't work," she said. "They dry out." Guests are limited to two free drinks, including beer, wine, and juices. "We try to use top-end wines, costing generally $15–$20 a bottle. We don't want to invite people in and then give them cheap things to eat and drink. I've heard at gallery openings people say, 'Gee, this gallery must not be doing well if this is what

they serve' or 'I think this wine has been watered down.' We want to project an image that we can provide nice things."

- Make yourself available. For the first three years, Donna and Melody prepared and served all the food and beverages themselves, "and we never had time to talk to people." That talking has proved quite valuable, discussing the business side with collectors (prices, commissions, how and when to make deliveries), making sure that visitors sign the guestbook, and stepping in to continue conversations with visitors when their husbands are being monopolized by individuals for too long. They hired a caterer and a bartender, both of whom were allowed to put out their business cards. As a result, the caterer drummed up a considerable amount of business, too, and gave Donna and Melody a sizable discount (10 percent the first year, 50 percent most recently).

- "Name tags don't work," she said. "People hate them." Visitors prefer to remain anonymous to one another but are usually willing to put their name, address, telephone number, and email address in the guest book, although they may need to be shepherded over to it.

- Flower arrangements add to visitors' pleasure, while parking attendants alleviate concerns about where to park and the safety of their cars. For her own peace of mind, Donna Iams removes prescription medications from the bathrooms, breakable pottery that may be bumped by people walking through the house, and pocket-size valuables (small sculpture, for instance) that might be stolen. She also purchased additional liability coverage for her homeowner's insurance policy (approximately $50) for that one day. The entire cost of staging the open studio is $1,500, including $575 for catering; $300 for wines, beers, and hard liquor; $150 for parking attendants; and the remainder for printing and mailing.

- Every visitor takes away a packet of images—postcards and brochures, mostly, and biographical information about the artists. Donna and Melody have also set up a print stand where visitors may purchase reproductions of their husbands' paintings.

- After the event, every visitor will be sent a handwritten thank-you note for coming. At the open studio, Donna and Melody hire a photographer to take pictures of visitors, posing actual buyers with

the artist and the work purchased. These photographs will accompany the thank-you notes.

Taking Suggestions

The director of the Creation Museum in Petersburg, Kentucky, had a suggestion for sculptor Mark Hopkins, but it was a bit odd. "He wanted me to do a sculpture of Noah's Ark, including a dinosaur or two," he said. (The Creation Museum "brings the pages of the Bible to life," according to its website.) "I thought, 'that's ridiculous.' I told him, 'It will look like *Dinotopia.*' It just wouldn't make any sense, so I rejected the idea." But he said it nicely, diplomatically, "something like, 'Let me think about that for a while,' because you don't want to hurt someone's feelings."

Many, perhaps most, artists get suggestions from people—their dealers, their collectors, their (artist) friends, and spouses, someone who shows up at an exhibition opening—for new subjects. "People say to me, 'I know an interesting person you'd want to paint,'" said Jamie Wyeth. "Well, I'm not interested in painting interesting people, thank you very much. I don't say that to them. I say something like, 'Fine' or, 'Oh, great!' and just forget about it." He doesn't want to be rude, either.

Sometimes, the recommendation isn't for new things, but old ones. Dealers have told Northampton, Massachusetts, artist Scott Prior, "'This painting I could have sold ten times,' and I guess the suggestion is to keep doing the same thing." Other people come up with ideas for him, based on other interior or exterior views he has done at some point in his career: "You should paint my summer place. You'd love the view from the deck." Things like that. Prior takes a deep breath, also wanting to be agreeable, and says "something like, 'Oh, that's interesting' or 'I'll have to check that out,'" hoping that the subject gets changed.

Where do an artist's ideas come from? From dreams or their own experiences or someone else's art? Quite often all of the above, no doubt. Sculptor Petah Coyne claimed that "travel gives me so many ideas. The world is full of amazing visuals." Julian Opie, a British painter and sculptor, claimed that "I get loads of ideas from past artists, from history." Painter Tula Telfair stated that she isn't particularly interested in other people's ideas because she has so many of her own, based on themes she has pursued in earlier imagined landscapes. New ideas have to get in line.

Still, the suggestions from other people keep on coming, and at times, they get taken up. Painter Eric Fischl noted that a dealer of his work in Germany "suggested I should explore making paintings based on the bullfight." He liked the idea and pursued it.

Fischl isn't a sports or animal artist, but the subject allowed him to explore a long-standing theme in his work, the rituals of masculinity, but this time seen from a different vantage point: the toreador faces down the brute force in himself.

A different type of suggestion occurs with painter and sculptor Alan Magee, who has incorporated old dolls and household objects into his work as though these were archaeological finds. "People who know my work have given me gifts of metal objects and other things they have dug up in a field," he said. Fellow artist Lois Dodd "gave me a rusted metal cup she found under her barn, because she knows I like these kinds of things." And he does like these things. "They act as a provocation to me. They seem to be saying, 'What do I remind you of? What can you do with me?'"

Successful suggestions have to jibe with what the artist is already thinking about, interested in. Some years back, a US art dealer called Canadian wildlife artist Robert Bateman because he had a collector very interested in commissioning a painting. This "very patriotic American" wanted a painting of a bald eagle—"that's not so unusual; I've painted many eagles over the years, including bald eagles," Bateman said—flying past Mount Rushmore, and he wanted the carved images of the presidents to be clearly visible in the background. Bateman asked the dealer, "Does he want the stars and stripes held in its beak, too?" The artist "never got around to doing" that painting.

Most suggestions are meant well and reflect the fact that these viewers are connecting to the art in some positive way, something that triggers their own ideas or memories. Al Agnew, a wildlife artist in Sainte Genevieve, Missouri, tells those who offer suggestions to him that "'it's an interesting idea,' and let it go at that," and it usually ends at that. "I can't remember anybody seriously following up and checking to see if I painted it." At times, it can get a bit awkward. "I once had a dealer who kept telling me what I should do," Telfair said. "He seemed like a frustrated artist." Taking someone else's ideas and opinions is more difficult for some than for others. Painter Peter Plagens noted that "sometimes an

art world friend, my dealer, or a critic (and I do read reviews of my work) will say something, usually in passing, about something I've painted that'll cause me to think and maybe change course just a bit." More often, however, the comment is "'Oh, I like this better than that,' and I end up determined to do more of *that*."

Meeting Prospective Buyers at Museums

In many communities around the country, newcomers to town join a church, or PTA if they have children, as a way of meeting people with whom they may have something in common. Latania McKenzie, an IT manager, and her partner, Jonelle Shields, a health care administrator, both joined the Young Professionals group of the High Museum of Art in Atlanta, Georgia. The group is part social—"a party scene at times," Shields said—and part educational, which is more their interest, since they aren't looking for dates but do collect paintings by local artists and are interested in having more of a role at the museum. "I would like to be a board member one day."

Through the museum group, they have met local art dealers and artists, taken part in guided gallery visits, and listened to talks by High Museum curators about art, as well as by board members about the mission and collecting goals of the museum itself. Shields noted that the museum appears to be "grooming" them to take the next step, an affiliate group called Art Partners, which also offers a number of social events but has more of the group lectures and visits to galleries, museums, and artists' studios.

A growing number of museums around the country have established beginning patrons and collectors groups that mix the social and educational. The Museum of Modern Art, for instance, has its Junior Associates, while the Guggenheim has a Young Collectors Council, and the Kimbell Art Museum in Fort Worth, Texas, has its Curators' Council. There is the Young Collectors at the Neuberger Museum of Art in Purchase, New York; the Contemporary Art Council at the Brooklyn Museum; the Evening Associates at the Art Institute of Chicago; the Avant Garde at the Los Angeles County Museum of Art; the Contemporaries at the Portland Museum of Art in Maine; the Young Collectors Council at the Perez Art Museum in Miami; the Apollo Circle at the Metropolitan Museum; and

Whitney Contemporaries at the Whitney Museum. It is difficult to find an art museum of some size that doesn't have a similar type of group.

Members of these groups are viewed as an area of cultivation by these museums. Karaugh Brown, former senior manager for membership and patrons at the Guggenheim, noted that curators lead tours for the Young Collectors Council of exhibits in the museum, as well as of artists' studios and the private collections of the museum's patrons, in order that members gain an "understanding of what's in our collection and what's of interest to us." The artists' studio tours especially "connect them with the artists that are important to us."

Museums are not the only ones eyeing younger collectors. Many art fairs also arrange special presentations for members of museum collector groups that involve private off-hour tours of gallery booth exhibitions and panel discussions of trends in the art market. "We are aiming for the younger demographic," said Donna Davies, director of art fairs for Urban Expositions, based in Kennesaw, Georgia, which owns and operates ArtAspen, ArtHamptons, Houston Fine Art Fair, Palm Springs Fine Art Fair, and SOFA Chicago. "We don't track sales at art fairs, but feedback from gallerists indicates that lectures typically lead to sales and meeting new clients." The Armory Show, an art fair held annually in New York City in late winter, has a VIP program for members of museum groups, including private tours of artists' studios and collectors' homes, as well as offering panel discussions on "identifying an emerging artist, how to tell the difference between good and bad art, understanding the international art market—themes on collecting like that," said Irene Kim, who is in charge of the VIP program. Yet another organization that arranges dealer talks, as well as visits to art fairs, artists studios, and museum and gallery exhibitions, a private membership group called the Contemporaries (www.thecontemporaries.org), is unaffiliated with any institutions and has a membership of 3,000 "urbanites in their thirties and forties, many of whom are doctors, lawyers, MBAs who have an interest in contemporary art and culture and want to learn more," said the group's cofounder, Rodney Reid, thirty-eight, managing director of the Private Capital Advisory Group at Evercore and an art collector. "There has been a clear trend over the past decade of identifying the next generation of collectors. The demographics are shifting, and we are trying to help this younger generation of people become collectors." There

is no fee to join this group, because the gallery owners, museums, and art fairs that host catered events to which Contemporaries members are invited are so avid to meet these people.

Additionally, Sotheby's Preferred, a division of the auction house that exclusively works with museums to sell deaccessioned artworks, arrange private purchases for them, and offer appraisals of objects in their permanent collections, provides speakers on the buying and selling of art and even stages mock auctions for collector groups at these institutions.

These museum groups can be quite popular, some with hundreds of members. Edward J. Gargiulo, director of asset management at the New York–based HighBrook Investors and chair of the Museum of Modern Art's Junior Associates until he relocated in 2015 to Los Angeles ("I'm considering which museums here to join"), said that when invitations to limited-seating events are emailed, "you need to be close to your computer when the invite is issued so you can respond in time." Not all of the members of the group are looking to buy art, he noted, and a high percentage come for the food and the hope that they can find a date. Others who are interested in owning art may not have begun to make purchases yet, awaiting hints on who, what, and how to buy.

"Not everyone in the group is in a position to acquire art," said Joanne Cassullo, a trustee of the Whitney Museum who acts as liaison to the Whitney Contemporaries, "but over time, as they advance in their careers and become more involved with the museum, many of them will become collectors, and we hope that they continue to move up into other membership groups at the museum."

The grooming isn't just about sticking with the museum, giving more money, and taking on some volunteer activities. Those talks by board members and curators focus on the artists and art trends that the museum is following. Joanne Cassullo "nurtures us. She goes with us to events and shares information on the direction the museum is going," said Kipton Cronkite, a member of the executive committee of Whitney Contemporaries. "You learn what museum acquisition committees are interested in, and I keep those artists on my radar. I try to buy early in their careers."

Art dealers are invited to museum collector group get-togethers to discuss some of the artists they represent, as well as tips on where and how to buy artwork. Not all of the High Museum's more than one thousand Young Professionals members attend those talks—some just want

the social part, hold the education—but those who do are getting a lesson on how to become collectors, with an unstated but clear tilt toward art that the museum prefers. The High Museum of Art, like many other museums, is playing a long game, encouraging art-interested people to buy art that is favored by the board and curators and that may be donated to the institution years into the future. "We're trying to start a relationship that makes members more knowledgeable and benefits the museum in the long term," said Ashley Chandler, the High's coordinator of the Young Professionals group.

If museums are hoping to influence young collectors in these groups, they are not the only ones. Group members themselves look to establish prospective clients for one or another professional activity. Kipton Cronkite, for example, is an art advisor who hopes to "meet future clients. Maybe they aren't ready to collect right now, but when they are in a few years and are looking for someone to help them they'll think, 'Oh, yeah, there's a guy I met named Kipton.'" Another member of the Whitney Contemporaries' executive committee, Patrick McGregor, who owns KP McGregor Consulting, a "communications and marketing consultancy, specializing in the luxury, fashion, lifestyle, and art categories," viewed the museum group as "a great networking opportunity. You meet dealers, curators, artists, and other members who may become clients at some point."

There has been discussion in years past at the Museum of Modern Art's Junior Associates about whether or not to allow "people in the art commerce side of things to become members," Gargiulo said. Ultimately, it was decided that it was OK for private dealers, gallery owners, art advisors, and artists to join. "Everybody wins that way. You just can't be too pushy. You just have to conduct yourself properly."

Artists are members of many of these groups for the same reasons everyone else is, looking to meet people socially and professionally, as well as to learn about trends in the art world and to support a particular institution. Life would be much easier for artists if there were published lists of art collectors and instructions on where to meet them, but museum groups may be the closest thing to that. When painter Grant William Thye moved to Chicago in 2007 "to pursue art full time," he became a volunteer at the Art Institute of Chicago in order "to meet like-minded people and also get a little bit of social interaction, as I quickly realized

I would spend all of my time in the studio and could sometimes go days without even seeing another human." He also joined the museum's Evening Associates, its membership group for younger collectors. Over time, Thye joined the board of Evening Associates, steering it away from being "nothing more than a giant singles bar" to developing "art-based activities for members to take part in." His time at Evening Associates has made him a number of friends, and "I have made some good contacts by being on the board and have gotten connected to a few opportunities for commissions—murals. There probably are not many serious collectors on the board, although some have purchased pieces from me."

On the other hand, Annika Connor, a New York City artist who is "supporting myself through painting sales," hasn't sold any of her artwork to art buyers on the Guggenheim Museum's Young Collectors Council, of which she is among the members of its acquisitions committee, but noted that "I make connections for art sales at every single function or event I attend." Similarly, Mary Bays, a clothing designer and professor at LIM College in Manhattan, joined the Metropolitan Museum of Art's Apollo Circle in order to meet people ("I have met one of my best friends through the group, artists, collectors, as well as other designers") and also to have a closer affiliation with the museum's Costume Institute. "I started my career as an eveningwear designer and always had to come up with new embroidery designs for my dresses," she said. "So the textile collection was a great research tool."

Some dealers and art advisors join more than one of these groups at the same time in order to increase their chances of meeting future clients. Kipton Cronkite also has memberships in young collector groups at the Guggenheim, Museum of Modern Art, and the Louvre. Acquaintances turning into buyers cannot be guaranteed, however, and it can be expensive to join. Yearly membership in the Young Collectors Council at the Pérez Art Museum is $750, $760 for Museum of Modern Art's Junior Associates, and the Dallas Museum of Art's DMA Forum, which "gathers budding collectors and young families for unique educational and social events, intended to deepen their relationship to the DMA, the Dallas arts community, and each other," costs $1,000 annually.

"A lot of artists are members of the Modern's Junior Associates," said the Armory Show's Irene Kim, who herself is a member. "It's a great networking opportunity."

CHAPTER 4

Exhibiting Art in Non-Art Spaces

"GALLERIES WERE NOT WELCOMING TO MY ART." Well, we've all heard that before: rejections cause some artists to give up, others to change their work to something they hope dealers might like better, yet others to search harder for galleries that will take them in. Sculptor Don Howard of Winter Park, Florida, decided to look for other places to show his work, masks with exotic faces, but art galleries were not among them. "A lot of places that show art aren't art galleries," he said, adding that he has sold many of his wall-hung sculptures to clients: bars, libraries, restaurants, a copy center, and even a tattoo parlor. "There is a lot of waiting around in these places, and, while they're waiting, people look at the walls around them. Sometimes, they stare seriously."

Art Doesn't Have to Be in a Gallery to Be Real Art

It probably helps sales that Howard, a retiree with a pension and social security income, prices his work quite modestly, charging $250–$300 and sometimes as little as $125 for each sculpture. "I sell a lot, because my prices are so reasonable," he noted. "If I were in a gallery, I'd have to charge more and probably would sell a lot less."

Like love and marriage, art and art galleries seem to go together, but sometimes it is not an easy pairing. Some artists may not have enough work to satisfy a gallery owner, and they may not be ready (yet? ever?) to view their art as a saleable commodity or even know if anyone is likely to want to buy it. Putting artwork up for display is essential for any artist's artistic and personal development, but venturing into commercial art galleries usually comes after a process of exhibiting pieces elsewhere.

That elsewhere may consist of a wide variety of alternative spaces that may or may not have any relationship with art. "We used alternatives as a stepping stone, building a résumé and gaining experience," said Kate Burridge, wife and business manager of Arroyo Grande, California, painter Robert Burridge. "We did it at the beginning of his career, and it helped get him ready for galleries, where people now buy his work."

During that time, the late 1980s and early '90s, Burridge's work was exhibited at coffee shops and restaurants, hair salons, libraries, and wineries. Sales were brisk, but usually on the low end, between $75 and $350 apiece, although once he did sell a $1,000 painting at a wine tasting. Perhaps the lesson of all this is that artwork needs to go where people with money go; art galleries only attract a small fraction of those with disposable income, while everyone goes out to eat.

Restaurants and cafés are probably the largest sponsors of informal art shows in the United States. These exhibitions create, to Terry Keene, owner of the Artichoke Cafe in Albuquerque, New Mexico, a "win-win situation for us and for the artist. The artist gets to display work and make sales, and we get a free, ever-changing source of décor."

At times, the artwork becomes a very integral part of the overall dining experience. At Café Tu Tu Tango, which has six locations (Atlanta, City of Orange, Hollywood, Miami, Orlando, and Toronto), the interiors are all designed to look like an artist's loft in Barcelona, Spain. Not only are there completed paintings and sculptures around the restaurant, but also works in progress that artists are completing on the premises, working at easels or on a sculptor's table. "Metal sculptors sometimes use a spot welder," said Mark Amidon, general manager of the Miami restaurant. "The heavy work is done elsewhere and brought in to be assembled."

The interior of the Big Sky Cafe in San Luis Obispo, California, has an art gallery motif, staging six two-month shows annually. "We have music there, too," said Christina Dillow, one of the restaurant's managers and a fine art photographer. "It's everything that makes people happy—music, food and art." Her own work was on exhibit this past summer, with six photographs selling ($75–$100 unframed, $275 framed). She has thought about seeking out a regular commercial art gallery to show her work, but is "unsure. There are time issues, I mean, can I really keep up? I have a full-time job at the restaurant. I also don't know the art gallery business, how it works."

Another art-oriented restaurant is the Gallery, with locations in Santa Barbara and Montecito, California, which started out in the mid-1980s as a bookstore that showed artwork but has become in equal measure a bookstore, restaurant, and exhibition space. The art sales, however, now bring in the lion's share of revenues, according to Jeremy Tessmer, one of the Gallery's sales representatives. "You have to sell a lot of books to make what you can from the sale of just one painting," he said. The profitability of the art hasn't led the Gallery's owners to turn the space over exclusively to exhibitions, however, which Tessmer attributed to "the culture of Santa Barbara. There are innate reservations about art spaces in Santa Barbara. People have expectations when they walk into an art gallery, and they think of art galleries as so formal. A bookstore and café is much more informal; everyone can afford a book or lunch." He noted that "people may not take art as seriously in this setting as they might in a strictly art gallery, but I don't think it has hurt sales at all."

The arrangements that artists make with restaurateurs vary widely. At some restaurants, the manager selects the artist and the artwork; at others, the owner picks what will be shown. The 212 Market Restaurant in Chattanooga, Tennessee, relies on an outside art consultant to choose artists whose work will be on exhibition throughout the dining rooms for three months; other restaurants rotate shows on a monthly basis. Terry Keene noted that he used to put up twelve month-long, one-person shows a year ("customers liked some, didn't like others") but decided to simplify the process by turning all of the exhibition space over to one painter, Santiago Pérez of Tijeras, New Mexico. "He's a very popular artist around here. My customers really love his work, and they notice when something new is up," Keene said. "As things sell, he brings in new works, and he changes paintings that have been around for a while. It's easier for me and more profitable for him."

Keene does not charge any commission on sales at the restaurant—some others do, ranging from 10 to 40 percent—but, in a written agreement with Pérez, the owner absolves himself of any liability in the event of work being damaged or destroyed. The same is true for any stolen pieces—one smaller painting by the artist was stolen this past spring—which Pérez has to accept as a part of doing business in this manner.

The possibility of damage and loss, or people simply not treating artwork with the respect more customarily found in commercial art gal-

leries or museums, at more informal settings for exhibitions is an ever-present concern. At a local library, a child pulled the tongue out of one of Don Howard's masks, and a smoker put out a cigarette in the mouth of another at Orlando's Blue Room Bar & Lounge. Twice in the past two years, customers have walked off with small paintings on display at Salt Lake City's Oasis Cafe—in the first instance, the artist brought a lawsuit, and, in the second, the value of the artwork was less than the restaurant's insurance policy deductible (that artist received nothing)—and Kate Burridge had to scramble to retrieve fifteen of her husband's paintings locked inside a local restaurant that had gone out of business. "I drove by wanting to see how many people were there at lunchtime, and I found the doors locked," she said. "I waited until some workmen came by—they were there to take out the stove—and I just went in and took my husband's work out. No one asked who I was or what I was doing, thank God."

Ad hoc art spaces may reveal other drawbacks for artists, as well. Artworks may not be properly hung or labeled; a librarian, for instance, may not be able to answer a question about who the artist is, the cost of a work, or how to get in contact. (Café Tu Tu Tango takes a 5 percent commission on sales, payable to the waiter, "in order to encourage them to sell the work," said owner Bradley Weiser, but other art-filled restaurants offer no incentive to promote actual sales. Prices of artworks are usually low, and revenues to the eatery through commissions are small.) Burridge noted that the tasting rooms at wineries, where artwork may be on display, are usually dimly lit, which may add ambience to the experience of sipping wine but makes seeing the art more difficult. The heat generated by food at a restaurant or hair dryers at a salon may cause damage, as will smoke at a bar. Various smells also get picked up, which stay with the art and are difficult to remove. Protecting the artwork, when it is incidental to the main function of the establishment, is not likely to be a high priority to the owners, but artists may discover that the cost of obtaining their own insurance coverage for these works—especially at a restaurant, where rates are set based on the likelihood of fires—is prohibitive.

Putting up artwork in a bookstore, café, pool hall, or car wash ("We've tried everything once," Don Howard said) is the goal of no one's artistic career, but it may lead to more and better things. Art dealers may stop

in for a meal, look around, and ask an artist to show at their galleries; customers may want to buy what they see at the café or something else in the artist's studio or even commission the artist for a new piece. Intrepid artists bring their work to the places that wealthy people go, knowing that art collecting can start or take place anywhere.

"Art increases business," Weiser said. "It becomes part of the entertainment of the restaurant." At times, that may not work to the benefit of the artist, if their creations simply become window dressing for some other moneymaking enterprise. "Some places try to trick me, and use my stuff as décor," Howard stated, but he also has a trick to use. "At one bar in Orlando, called Antigua, I told them I was going to take my pieces out and put them in a show in another place. Right then and there, they bought five of them to keep permanently."

Art in Health Care

Art has long been thought of as good for the soul, but it has been seen increasingly as good for one's health, as well. Based on studies of the beneficial effects of having art around, a growing number of hospitals have created art galleries in their public areas, purchased artworks for a permanent collection, and employed artists to hold regular workshops with patients. "For patients, art is a diversion and a resource to deal with their affliction or problem," said John Graham-Pole, a pediatrician and codirector of the Arts in Medicine department at Shands Hospital of the University of Florida at Gainesville. "It is also a way in which we rehumanize the connection between patient and caregiver."

Shands Hospital has two art galleries, offering a changing series of exhibits of the work of patients as well as of professional artists in the area, and an artist-in-residence program that employs up to eighty artists per year (part- and full-time). These artists work with patients individually or in groups on art projects; on occasion, they work with the families of patients.

Retirement and nursing homes, libraries, and especially hospitals have been establishing and building art collections, sometimes based solely on donations, but other times with separate budgets for purchases. The aim is to improve the physical and therapeutic environment for patients, their families, and staff. "Studies have shown that artwork helps to reduce

stress and boredom, reduces blood pressure, and increases white blood cell count, all of which are factors in the healing process," said Jessica R. Finch, art program manager at Boston Children's Hospital in Massachusetts, which has been building a collection, now reaching five thousand pieces, since 1996.

Holding workshops for patients is a very different experience from other types of teaching. Dona Ann McAdams, a New York City photographer who teaches at Hostos Community College in the Bronx and at Empire State College, as well as to schizophrenic patients every Friday since 1983 at the Brooklyn Day Program in Coney Island, noted that her mental patient students "are more interested in the final image than in the technique. I take the pictures, process the film, and make prints; they set up scenes and hand color the prints." Employed through Hospital Audiences Inc., a nonprofit organization that pays her $32.50 per hour plus transportation and the costs of some of the materials used, she said that the patients are "not working for a grade or to finish a semester. It's not just a means to an end, but a part of their life experience. I'm very much a part of their lives, so I come every week."

Professional artists working with patients are not expected to know or practice art therapy, although at times it may appear that there is a certain overlap in roles, since they frequently work with the same types of patients with similar materials. "The artists we employ don't have psychological training," said Elizabeth Marks, director of Hospital Audiences. "Our mission is to provide cultural access to the arts to everyone other than as a form of therapy. We believe in the healing power of the arts. We don't use art as a means of emotional outlet, and we shy away from purposeful interpretation, which you find in art therapy."

In addition to gaining full-time employment, McAdams used the experience to photograph her Brooklyn Day Program students, which resulted in an exhibition and a book, entitled *The Garden of Eden*, which was published in 1998. Other artists have been able to exhibit their work in hospitals or sold pieces to the institutions. In 1980, Tracy Sugarman, a Westport, Connecticut, "reportorial artist," approached the director of the hospital in the neighboring town of Norwalk about creating "a series of reportorial drawings of each department, showing what goes on in the hospital in a warm, unbuttoned way." In all, Sugarman turned in more than 100 black-and-white line and wash drawings. Ten years later, the

hospital invited him back to create a mural for its then-newly refurbished pediatric wing. He painted a series of seventeen full-sheet (22" × 28") watercolors, which were then enlarged by computers and affixed to panels that became the murals—the original watercolors themselves were hung in pediatric patient rooms.

By chance, the architect for the renovation of Elmhurst Hospital in Queens, New York, happened to see Sugarman's mural and recommended the artist to the president of Elmhurst Hospital. Again, the artist created a series of watercolors, and the images were blown up for a mural in the corridor.

The building of a new hospital, or the renovation of an existing facility, is a particularly apt time to sell artwork, as decoration is often a part of the budget. When the hospital is a city- or state-run institution, percent-for-art laws may apply. Dorothy Holden, a fiber artist in Charlottesville, Virginia, sold a wall-hung quilt to the University of Virginia when its medical center was built, and the piece was purchased through a percent-for-art program. The medical center has a permanent collection with its own exhibition space—brochures provide information about the works and the artists for visitors' self-guided tours—and there is also a gallery for temporary exhibits near the elevators. Whether en route to visiting a patient or waiting to see someone, visitors have an unavoidable opportunity to look at the work of local professional artists. Holden has had a one-person show in the gallery and participated in a group exhibit. "I've had tremendous exposure through the shows," she said. "A lot of people have told me that they saw my work. Someone who was visiting a patient in the hospital stopped into the gallery and ended up buying a piece."

Another visitor to the hospital's gallery, a patient whose architect husband was currently designing Charlottesville's City Hall renovation, "recommended my work to the city of Charlottesville, which commissioned me to make two quilts for city hall," she said.

When a hospital does not have an arts program, artists who look to work within or exhibit in or to sell work to the institution should contact the president or chief executive officer. Many hospitals also have volunteer auxiliary groups, one of which may be involved in decoration or cultural activities. In most cases, hospitals, especially those that are municipal or state facilities, work with local artists.

Art in Sports Venues

This is not your father's football stadium. (Or ballpark or basketball arena, for that matter.) Air-conditioned VIP reception entrances, concierge attendants, and private escalators fit fans who want their crowd experience to be a bit less crowded. Comfortable sofas in climate-controlled lounges, wet bars, and refrigerators, as well as huge, high-definition screens, appeal to those who are just as happy watching the game at home. The Minnesota Vikings' window wall and translucent roof—part of the $975 million stadium it opened in 2016—will "offer a picturesque view of a scenic downtown skyline," for those whose eyes need a break from the game. Increasingly, sports venues are about amenities as much as about some game, and one of those amenities these days is fine art.

"We believe that the art enhances the visitor experience," said Charlotte Jones Anderson, executive vice-president and chief brand officer of the Dallas Cowboys, whose $1.3 billion AT&T Stadium, which opened in 2009, contains sixteen commissioned site-specific artworks, as well as forty-two other works that are on view throughout the facility. Many of these works are by internationally known artists, such as Doug Aitken, Jim Campbell, Olafur Eliasson, Jenny Holzer, Anish Kapoor, Matthew Ritchie, and Lawrence Weiner and have no thematic relationship to football or any other sport. It was not a given that renowned artists would want their work associated with a sports arena, and Mary Zlot, the art advisor who commissioned and acquired pieces for the Cowboys stadium, first contacted the galleries representing these artists to find out if they would be interested in creating work for this venue. Eliasson was the first artist to sign on, "and once you get a really fabulous artist like him to on board, it made it easier to attract others," she said.

Part of the appeal to these artists is that the artwork would not be sports related, which fit into the goal of the Cowboys. "It is important to us that our venue be more than just a sports venue, that it would attract people beyond the world of sports," Anderson said. And, in fact, far more than just sports fans come to the stadium in the course of a year. "We have something going on every day," she said, which may include more than one event per day, such as weddings, corporate functions, conferences, high school proms, bar and bat mitzvahs. The Academy of Coun-

try Music held its televised awards show at AT&T Stadium in 2015. "The collection is built for every type of event."

This isn't just happening in Dallas. The ballpark of the Miami Marlins, which is owned by New York City art dealer Jeffrey Loria, features large-scale works by Daniel Arsham, Red Grooms, Roy Lichtenstein, Joan Miró, Larry Rivers, and Kenny Scharf, among others, while the Santa Clara Stadium (where the San Francisco 49ers play) and the Staples Center (which the Los Angeles Lakers, Los Angeles Clippers, Los Angeles Sparks, and Los Angeles Kings all call home) both have two- and three-dimensional artworks installed throughout the venues. As opposed to the Cowboys stadium and the Marlins ballpark, those latter two sports venues highlight the work of more regional artists, a tack also taken by both the Atlanta Falcons and Minnesota Vikings, which are in the process of building new stadiums and have put out calls for artists to submit images of their work for possible commissions and purchases.

Atlanta and Minnesota have followed in the path of the Kansas City Chiefs, whose Arrowhead Stadium, renovated and expanded at a cost of $375 million and reopened in 2010, has been building and installing a collection of artworks since 2013. "The Cowboys were a helpful resource at the outset, in terms of the process they undertook," said Sharron Hunt, director of the team's art program, noting that she hired a local art gallery owner (Paul Dorrell of the Leopold Gallery) as advisor and set up an art council—including the president of the Kansas City Art Institute and directors of both the Kemper Museum of Contemporary Art and the Nelson-Atkins Museum of Art—to help in the selection process. Also, just as with AT&T Stadium, it was understood that Arrowhead Stadium is more than just a place to watch eight home games per year (perhaps one or two more if they make the playoffs), but a "multiuse facility that serves the community," where two hundred events of all kinds take place throughout the year. The opportunity to host these events would not be possible without the renovation of Arrowhead Stadium, enhanced through the Arrowhead Art Collection. "However," she said, "we ultimately took a different direction from that of the Cowboy's, giving the art a more regional focus."

According to Dorrell, "The point, from my perspective and that of Chiefs, was really to invest in and help grow regional culture, as opposed to importing art from larger cities on the east and west coasts. Our

region is sufficiently sophisticated, with abundant talent of the professional level, to fulfill art programs of this nature working only with artists from this area."

In 2012, the Chiefs announced a call for artists, eliciting hundreds of submissions, paying an honorarium to those artists asked to submit specific proposals for commissions. Matt Dehaemers, a sculptor in Mission, Kansas, was one of those selected, and his Plexiglas-and-painted-wood *To the Power of Twelve* was picked for the collection and is hung twelve feet off the ground in a lounge on the club level. (Arrowhead, like many new or renovated sports facilities, has three categories of seating for ticket holders—general admission, club level, and private suites. With the exception of one sculpture, installed outside of the stadium, all of the artworks in the collection are sited on the club level.) "Initially, I did worry that the work might get damaged by someone spilling beer on it or throwing something at it," Dehaemers said, "but it's high enough off the ground in case of some beer spills, and no one can climb on it."

Hunt stated that most of the artworks are sited on the club level because the people admitted there are less likely to be disorderly and that there has been no damage, graffiti, or vandalism to date. "Even on the rowdiest of days, win or lose, our fans have been very respectful of the art," she said.

Nedra Bonds, a fiber artist who was born and still lives in Kansas City, also had some worries about the potential of damage to her commissioned piece, a 6" × 6" quilt called *Connecting Threads* that reveals three women figures (a Native American, an African American, and a Caucasian) all working on the same quilt. "There are so many bars at that area of the stadium, and people can slosh their drinks or get rowdy in other ways, but they resolved that problem by having my work covered with Plexiglas," she said.

Her quilt has no relationship to sports, and Bonds noted that "I don't do sports art. I'm not a football fan. Mine is semihistorical work about folks in the community all working together."

The selected artworks were picked, Hunt said, not for their connection to football or any other sport but for their quality, and artists generally were free to do what they wanted to do. (One artist, a Saint Louis painter named Tim Liddy, was asked to do a series of ten images of vintage sports board game covers, which are hung together as a group.) "I

don't have a sense that whether or not the art has a sports theme matters to visitors on game day or on any other day," Hunt said. In fact, it is more likely that the artwork is looked at most carefully on nongame days, for instance, by guests of a wedding, corporate function, or bar mitzvah or some other event. "We think of the entire community as our audience." Area museums have booked guided tours of the stadium's artwork for their members, and Kansas City public schools also bring children on field trips to Arrowhead to look at the art. "During a game, there is a lot of getting to your seats, finding snacks and beverages, finding the bathrooms, meeting your friends, so many fans may not pay much attention to the art," she said. Some fans may stop while en route to somewhere else in the stadium to look at the art, although the presence of the artwork does not appear to lengthen the amount of time they stay in Arrowhead. The art may enhance their experience in some way, but the collection was not acquired in order to justify the high cost of tickets or to turn fans into season ticket holders or ticket holders into buyers of luxury suites. As a marketing tool, the artwork makes a facility that only has eight firmly scheduled games per year more attractive to high-end party planners. A spokesperson for the Miami Marlins also noted that "art gives the ballpark more polish and definition."

What may be most unusual is a sports venue competing for conventions and party events with hotels, convention centers, and museums. Historic homes and art and natural history museums regularly promote themselves as ideal spots for weddings and other activities, trading on their collections and cultural settings to woo event planners. With the emergence of significant art collections at sports arenas, one sees for-profit enterprises jockeying for the same business with nonprofits, both using artwork as a sales tool. The Cowboys stadium made itself even more like an art museum by creating a free, downloadable app for its art collection, providing information on every work on view and opportunities to hear the artists themselves talking about their art.

The interest in art on the part of sports venues comes as no surprise to Tracie Speca-Ventura, founder of the California-based Sports and the Arts, which acts as an art advisor to sports franchises (including the Los Angeles Lakers, Orlando Magic, New Jersey Devils, and San Francisco 49ers) and professional athletes. "Stadiums are huge spaces with great big walls, ideal for art," she said. "Stadiums are the museums of today.

Fans may not go to art galleries and museums, and you can educate them without hitting them over the head or making them feel stupid. For the franchises, an art collection opens up marketing opportunities and very good press."

She and others at Sports and the Arts attend gallery exhibitions in search of "artists we can work with," and artists contact the company, sending in images of their work. "I have a roster of a couple hundred artists, and I'm always looking for more."

For the artists commissioned by Arrowhead Stadium, the upshot has been positive—they were commissioned, paid, had their work seen by a far larger and more diverse audience than usually looks at art, been written up in the *Kansas City Star*, and have another line to add to their CVs—with the one exception: none of the exposure and positive write-ups have led to additional commissions and sales so far. The art is sited where people of means watch a game or attend a party, but those people haven't become collectors themselves, at least of this art. Karen Kunc of Lincoln, Nebraska, who was commissioned by the Chiefs to create a group of six prints (*Aqua Alta Series*), said that all the favorable attention and all the people who saw her work "has not led to anything else," and Tim Liddy stated that "I've received a number of emails from people who say, 'I really love your work. How much are they?' I write back and don't hear from them again." Perhaps those people assumed art costs the same as a football ticket.

Art in the State Capitol

The state capitol building in Santa Fe, New Mexico, is often a very crowded place, with over one thousand people—lobbyists, school groups, legislators, bureaucrats, and tourists—passing through on almost any given week. That's more than most art galleries and even tops attendance at many of the state's art museums. Perhaps some of those regulars and visitors to the capitol will pay particular attention to the artwork on display, because there is a lot of it, over four hundred paintings and sculptures (mostly) by contemporary artists who are state residents, and the number is growing.

Since 1990, the Capitol Art Foundation of the State of New Mexico has been acquiring examples of the work of the state's noted and emerg-

ing artists in order to show "the cultural heritage and the artistic vitality of New Mexico," according to Cynthia Sanchez, director and curator of the foundation. "Exhibits in the rotunda typically draw the most attention and inquiries," she said. It is not uncommon that visitors to the capitol ask about the artists whose work they have seen, and Sanchez offers a brief printed biography or even contact information. Where that information leads she doesn't know, adding that exhibits elsewhere and even sales "could well result."

New Mexico is not alone in its determination to acquire and display resident artists' work. Most states have a program of exhibiting art in their capitol and government office buildings. (The federal government has its own version of this program, called Art in Embassies, which is run by the US State Department and places work by contemporary artists in embassies and consulates around the world on three-year loans.) Sometimes, that art is of an historical nature, such as the collection of fine and decorative art from the eighteenth through the early twentieth centuries administered by the Maryland Commission on Artistic Property, but more often it includes contemporary work. Recipients of visual arts fellowships in a number of states have work displayed in their respective state capitols, for example, and the Governor's Gallery, a room near the office of Florida's governor, has a series of temporary exhibitions of artwork on the theme of Florida by state artists. In addition, there are five other gallery spaces within Florida's state capitol complex dedicated to the display of resident artists' work.

Similar to New Mexico, Florida established a permanent state art collection for the capitol back in 1997 and has acquired twenty-five pieces so far. Artists in both states who would like their work included in the respective collections submit slides for consideration by a panel that includes members of the state arts agencies and outside art experts. Also, like New Mexico, Florida budgets no money for the purchase of this art but actively solicits donations from artists. Wyoming, on the other hand, which inaugurated its Capitol Art Collection in 2000, appropriates funds for the purchase of art, paying up to $2,500 per piece ("The legislature has learned through this that artwork doesn't just magically appear—it costs money," said John Coe, administrator of the program).

The benefits for artists having their work included in a state art collection tend to go beyond hard cash. "It's an opportunity to have their

work continually on view," said Sandy Shaughnessy, arts administrator for Florida's state arts agency, the Division of Cultural Affairs, which runs the program. "Nothing is in storage." She added that artists who donate their work to the state collection are featured on a page on the agency's website and that the Division of Cultural Affairs is regularly contacted by "curators and collectors" who are interested in a particular artist's work.

Donating work with an eye to finding dealers and buyers is no sure bet, however. John David Hawver, a painter in Islamorada, one of the Florida Keys, donated a $5,000 painting entitled *New Intensified Low Tied* to the state's art collection in 1998, following a show of thirty-five of his works in the Capitol Building. The donation was a form of thank-you for the exhibition, "and it certainly looks good on my résumé, 'in the collection of the State of Florida,'" but he noted that "no one has tracked me down after seeing the work in the state capitol." Sarah Bienvenu, a painter in Santa Fe who in 2001 donated a $3,600 watercolor entitled *The Field in Spring* to the New Mexico state art collection, noted that since the piece has been on display in the state capitol "I have had so many calls from people." Those people, though, are friends congratulating her, rather than buyers or gallery owners. Similarly, Berkeley, California, painter Elizabeth Hack, whose work was selected to be part of the Art in Embassies program, has had little response from collectors, perhaps because the embassy is located in Fiji.

Custom Artist

There is no one way in which artists work or show their art. Some produce alone in their studios, while others work collaboratively with others. Some create works for exhibits at galleries, while others prepare for juried shows or look for commissions. Custom or decorative artists generally work in homes and offices, hired to paint a mural on a wall or ceiling, perhaps even a tabletop, and their work is seen by the people who live, work, or visit there.

"Almost all of my work is in powder rooms, lavatories—bathrooms without showers," said Jeffrey Damberg of Cos Cob, Connecticut, noting that the steam from a shower would damage his paintings. One of his powder room wall creations was a picture of an outhouse with a forest

around it. Another was a mural of a group of men, all well dressed. "You don't see their faces, only their backs," he said. "The homeowner wanted me to paint it that way, as though the men were turning their backs to give her privacy."

Judith Eisler, a New York City artist, also has been hired regularly to paint bathrooms and bedrooms. "People feel they can go wild in their bathrooms," she said. "They feel hidden there, and so they let loose and want lots of different colors that they'd never allow elsewhere in the house." However, she has painted murals in every other room of a house, as do most decorative artists, Damberg included.

A growing number of homeowners are becoming interested in bringing artists into their homes to create custom works, according to several interior designers. "Clients are getting more cultured, more knowledgeable about art, and they like to tell an artist what to do," said Lourdis Catao, an interior designer in New York City. "It makes them feel like artists, too."

One of Damberg's clients, Marian Hvolbeck of Greenwich, Connecticut, commissioned him to create a composite of famous landscapes, including Thomas Cole's *Oxbow*, Vincent van Gogh's *Cypress Trees*, and Claude Monet's *Water Lilies*, as well as images from Corot, Cézanne, and some others. Damberg was an ideal choice for this project as he specializes in art copies, and most of his murals are replicas the work of other artists, such as Grandma Moses, John Singer Sargent, Albert Bierstadt, and various nineteenth-century French painters. "I have a whole lot of art books," Hvolbeck said, "and I opened to pages in my books and told Jeff, 'Put that in, and this one, too.' Jeff made photographs of the paintings in the books and enlarged them, so he could work from them." The ability to direct an artist made Hvolbeck feel as though she were collaborating in the process. "Paintings are interesting. I enjoy paintings and have a number of paintings in my living room, but here I was part creator. The final work is very personal to me because, while some of the copied paintings are well known, some are not, and I am the only one to know the reference."

Decorative artists encompass a wide group of talents and techniques, some straddling the fence between fine and purely decorative art, while others are more like artisans. Some, such as New Yorker Raymond Bugara, specialize in trompe l'oeil, creating realistic images that fool the

viewer into believing they are three dimensional, such as bookshelves filled with classic tomes. Others, "faux artists," create simulated finishes on surfaces, such as the look of marble on a staircase or gold leaf on molding on clouds on the ceiling. Yet others add pigment to plaster or give a wall the look of Italian-colored stucco. Certain artists do both murals and wall finishes.

Decorative artists are generally found through interior designers or architects (many architectural firms have in-house designers) or by word of mouth. All of Damberg's newer clients have come through past ones, "as someone comes into the house and sees my work and asks 'Who did that?'" Bugara, whose jobs all come through interior designers, on the other hand, said that "word of mouth isn't all it's cracked up to be. People don't want the same painter in their house as their friends; it's like two women wearing the same dress at a party. They get competitive and want a different artist."

It is rare that an artist places an advertisement in a magazine or newspaper ("an ad might bring me too much business," Damberg said), although some are listed in the Yellow Pages. However, many artists and craftspeople have joined the American Society of Interior Designers (608 Massachusetts Avenue NE, Washington, DC 20002–6006, 202-546–3480, www.asid.org) as "industry partners," a category of membership for people providing products and services that interior designers can use.

When a homeowner contacts an artist individually, it is usually to paint a mural in a particular room of the house; however, when an interior designer hires the artist, the mural is part of a larger redecorating job for which the artist is one of the subcontractors. Some artists enjoy the one-on-one relationship with the homeowner, while others prefer having a designer handle the financial and technical arrangements with the client. Frequently, it is the designer who suggests to the client the idea of bringing in an artist to add accent colors or an entire mural. "Artists are basically problem solvers," Catao said, "and the problem here is how to fill a commercial or residential space. In a small room, the question is how can an artist give the sense of three dimensions."

"I like to have the designer as a buffer," said Katie Merz, a New York City artist who creates cartoony imagery for homeowners. "It's a nightmare to deal with the owner all the time. So many of them want to make suggestions while I'm working. Some clients have a kind of neurotic way

of communicating—they feel that the only way they can talk to me is to find something wrong with what I'm doing."

Merz noted her greatest fear, once the mural has been completed, is that the client doesn't like it ("You hold your breath until you hear someone tell you it's OK," she said), but the process of determining what will be painted on the walls usually includes sample designs and renderings for the client's approval. Eisler, who is both contacted by homeowners directly and hired by interior designers, meets repeatedly with the client to ensure that they have same imagery in mind. "Someone will say to me, 'I want it to be sand colored, you know what I mean?' and I say, 'No, I'm not sure I know what you mean.' I ask people for visual clues as to what they want in a picture. I tell them, 'Let's find that color on a Benjamin Moore color chart.'"

She added that interpreting what potential clients want from their descriptions can be trying, as they themselves may not be certain. "You have to be a psychiatrist sometimes," she said. "One woman told me at the end of a job that she didn't really like what I had done. I told her, 'You approved the samples,' and she said, 'Yes, but that's because I didn't want to hurt your feelings.' I told her that this is a service industry—it's not about feelings." Clearly, this defines the difference between a gallery artist, who creates personally motivated artwork for a more generalized audience, and a decorative artist who is being commissioned to create a very specific artwork for a particular client. The final artwork may be the same in terms of imagery and style, but there are far more personal entanglements in the decorative arts field.

Graduates of art schools, both Eisler and Merz are active as gallery artists, occasionally selling their paintings to the same people who hired them as muralists. Charles Gandy, an interior designer in Atlanta, Georgia, noted that many of the artists he uses are "right out of the galleries here, and some of them sign their murals." Gandy added that he regularly looks in at art galleries to find artists who might be suitable for custom work in someone's home.

Not every gallery artist will find the transition to decorative work so natural, according to Laura Richardson, president of Miller-Richardson Galleries in Washington, DC. Some of the challenges are technical ones, such as painting on a wall instead of on a canvas (requiring different preparation and media), and the scale is usually larger. "Some artists feel

constricted by a commission, because of the desire to please, and they may not like to make changes," she said. "You're also not painting in your studio but in a public area, with an audience all the time. A lot of artists aren't aware of what they're in for."

The letters of agreement or contracts that artists and homeowners sign are similar to those for public art projects, with paragraphs detailing the requirements of the homeowner (specific wall, for instance); the medium, palette, and artist; the creation of a maquette; and the nature of the approval process, the manner in which the final work will be delivered or installed, the cost of the project, and a payment schedule.

Many artists charge for their renderings (between $100 and $700, on the average, depending upon the intricacy of the maquette), although the price will be subsumed into the overall cost of the project if the client accepts. Artists establish fees for an entire project in a variety of ways. Some charge by the square foot, while Damberg prices murals by the job, estimating the amount of time it will take, multiplied by a $55-per-hour wage. His average mural costs $4,000. Both Eisler and Merz charge between $350 and $600 per day (Bugara's fee is between $400 and $800 per day), and they also estimate how much time the work will require. All of the prices include the cost of materials. One of Eisler's biggest jobs was painting murals on the walls of an entire Manhattan apartment, a project that went on for several months and for which she charged $25,000. As most other contractors, decorative artists receive a deposit of either one-third or one-half at the outset and the remainder at the completion.

Prices are often higher when middlemen are involved, as gallery owners who arrange commissions take a percentage of the artists' fees (between 10 and 30 percent), and interior designers customarily include a 15–25 percent additional charge.

Public Art Loan Programs

The problems that Chicago-based sculptor Wayne Kusy was experiencing is probably well known by other artists. "My work is too big for most galleries," and his studio was filling up with completed large-scale pieces. ("My work does not fit into the backseat of a car. It takes two people to move, and, once I get it out of my house, it has to stay out. Not coming

back.") What's more, the principal buyers of his pieces tend to be museums, whose curators may not be available to visit some gallery somewhere during a four-week exhibition. A solution to all those problems was a yearlong exhibition at the town hall in Algonquin, Illinois, courtesy of the town's public art commission, which since 2005 has operated an art loan program that invites twenty artists annually to place their work in town-owned sites.

"Having a nice place for folks to come and view it for a year is more than worth it to me," he said. "My big pieces are advertising for my commission work," and in fact Kusy received two commissions, which undoubtedly was abetted by a segment on ABC World News.

Certainly, there is a novelty element in the work of Wayne Kusy that seems made for TV, as his work is built from toothpicks. However, two- and three-dimensional artists of all types have taken part in a growing number of programs developed by public art agencies and some universities around the country that borrow artworks, rather than purchase them. "The idea for our program developed in 2009, at the time of the recession," said Karen Gerrity, cultural affairs manager for the city of Broomfield, Colorado. "The city froze money for our percent-for-art program, since they were laying off people at the time and it didn't make sense to buy sculptures when you are doing that." Broomfield's percent-for-art program was restarted in 2011, but, by that time, the art loan program (called Art for Awhile) already had been in operation for two years. There are currently three municipal buildings in the city's downtown that are sites for borrowed artworks, and as many as nine pieces are displayed in any given year.

Every loan program is a bit different. The one in Algonquin "helps" artists cover the costs of installing their work, Algonquin City Planner Ben Mason said, although the amount is "small," and the city provides no insurance to cover damage, theft, or liability. The city does not promote sales of these pieces, although the municipality's online page does contain information on the participating artists and links to their websites. If a sale takes place, Algonquin does not ask for any commission.

The art loan program in Evanston, Illinois, which began in early 2016, offers a $150 honorarium to participating artists ("It's wrong not to compensate artists, because the people benefiting the most is the general public," said Cultural Affairs Coordinator Jennifer Lasik), and the city insures each borrowed artwork for damage or loss up to $10,000.

In Colorado, on the other hand, Grand Junction's Art on the Corner loan program provides a more generous $500 honorarium to participating artists in order to help pay for transportation and provides accommodations for out-of-town artists in a local hotel for the opening night preview. The city's all-risk insurance policy covers the artworks. "Not every year, but most years" since the program began in 1984, the city purchases for its permanent collection one of the pieces loaned to the city, according to Robin Brown, event management director for Downtown Grand Junction, and the city receives a 25 percent commission for any pieces that are sold during the year. "The money helps keep the program going."

Broomfield's program pays artists a $1,000 stipend, provides insurance, and has bought one work from the lending artists every year since it began. One of the artists whose work was purchased is Scy Caroselli, a bronze figurative sculptor in Denver, who has gone on to lend her work to other municipal art loan programs in Gillette, Wyoming, and Hutchinson, Kansas. The loans widened her market and led to commissions at a women's health center in Gillette and a hospital in Denver. Mostly sweet, but a little sour. "There is a cost to loaning your work," she said. "You are without your money for a year, and the work may not sell." Additionally, there was one instance of vandalism, in which the handle of a wagon was broken off, but repairs were made at no cost to the artist.

Things can happen. In Algonquin, a two-dimensional work fell off the wall, damaging the frame and glass more than anything else, and one large-scale sculpture that Robert Craig of Des Moines, Iowa, had loaned to a college was used by skate boarders. In the 32 years since Grand Junction began its Art on the Corner program, three works have been stolen, two of which were recovered shortly thereafter, although they had sustained some damage. "There was a bronze pig with a slit on its back, and it looked like a piggy bank," Brown said. "It was solid bronze, and you couldn't put any coins into it if you wanted to, but someone took it out into the woods outside of town and cut it in half looking for money." That work was repaired and reinstalled, as was a large bronze medallion with a human face on the front that was taken out into the desert and used as target practice. That piece was returned and put back up, "and no one, not even the artist, minded the dings."

A criterion for selection for outdoor-sited works by the Broomfield Public Art Committee is their ability "to withstand Colorado weather,"

Gerrity said. "High winds, subfreezing temperatures, moisture. Two works have broken because of the elements since 2009."

Public art loan programs satisfy a number of needs. They are a relatively inexpensive way for cities, towns, and universities to install works of art for the benefit of their communities; and because they are temporary placements and haven't been a financial drain, there is far less rancor if people don't like it. "No one wants to be tied to a work in perpetuity," said Tom Eccles, executive director of the Center for Curatorial Studies at Bard College and former director of New York City's Public Art Fund, which installs public artworks for periods of months.

For artists, lending produces additional, long-term opportunities for exhibition. Robert Craig noted that "your exhibition record is the first thing people look at in terms of your credibility, and it is important to show that you are actively exhibiting." As a result, he has pursued these programs at various locations, sometimes moving the same piece from one site to another after the loan period has ended. One piece in particular, titled *Fiddler*, had been displayed on the campus of Washburn University in Topeka, Kansas, for five years before being moved to a downtown Topeka site for another year. Since 1989, he said, approximately ten pieces have been loaned to twenty different loan programs at colleges and cities around the country.

Similarly, Conway, Arkansas, sculptor Bryan Massey has lent more than two dozen works to municipalities with loan programs over the course of his career, and "at least ten of them have been sold, either to the city or to private buyers who saw them," he said. "I always look for more opportunities to loan my work, because so many of them end up as sales."

He also always looks to see if the loan program insures works against damage and theft—"I've had one instance of each"—and whether or not the coverage also covers artworks while in transit.

It isn't just living artists who benefit from loan programs. The managers of artists' estates, including Roy Lichtenstein and George Rickey, regularly place works on long-term loan at museums, universities, and other institutions in order to keep them in the public eye and also to generate sales. In the past fourteen years, the Roy Lichtenstein Foundation has produced posthumous editions of the artist's sculpture *Brushstrokes* series, a number of which have been lent to cultural institutions around the country, including the Philadelphia Museum of Art and the Wallis

Annenberg Center for the Performing Arts in Beverly Hills, California. One other work from that series, *Five Brushstrokes*, was originally on five-year loan to the Indianapolis Museum of Art before it was purchased by the institution.

Philip Rickey, son of the artist and board member of the George Rickey Foundation, noted that loans of his father's artwork are arranged both through the foundation and the Marlborough Gallery, which represents the estate. "It is the foundation's requirement the organizations receiving the loan pay for installation and insurance; in effect, all of our costs are covered, but we don't ask for any additional payment, as some artists and foundations do." The aim of the loans is "to get the work out, keeping George in the public eye and cultivating interest, especially when works become available for sale." Sales sometimes do result from loans, he said, noting several pieces that were lent to the Atlanta Botanical Garden and to the New York City Department of Parks and Recreation's Art in the Parks program and then purchased.

Certainly, not every artist reports sales, commissions, or opportunities to exhibit elsewhere based on participating in a loan program. Deerfield, Illinois, printmaker Rita Price, who has lent pieces to the art loan program in her town, has "received positive comments" but no offers to buy, and marble sculptor Richard Cody Janes of Fox Lake, Illinois, had even less to show for his participation in Deerfield's program. "There was no significant feedback. No one is trying to buy it." However, another Deerfield participant, Janet Austin, who creates mosaic murals, installed a floral-themed piece at the city's public library, "and I got a call almost immediately from the library saying they wanted to purchase it." In addition, she has been contacted by public art programs in Chicago, Evanston, and Skokie, Illinois, that wanted her to lend pieces. "One or two of those loans have turned into purchases," she said.

Exhibiting and Selling in Another Country

Some years ago, Bronx, New York, sculptor Frederick Eversley recalls not being paid by a gallery that exhibited his work. Yeah, yeah, a lot of artists have been in that position, but the difference in this case is that the gallery was in Germany, a country where Eversley doesn't know the laws, doesn't speak the language, and had no plans to visit. "What was I going

to do? Hire a German lawyer? Where would I even find one?" he said. "I decided it wasn't worth it." So, he swallowed his losses and moved on.

That was only once—if we don't count the time another European dealer did pay him, just very, very slowly, or the occasion when some unsold work came back damaged because it hadn't been packed properly—and Eversley has relished the opportunity of broadening his market by exhibiting on another continent.

Seasoned artists know that one needn't travel abroad to experience frustration and disappointment dealing with galleries. Minimalist artist Peter Halley, who lives in Manhattan but makes three-quarters of his sales through galleries in Europe, stated that "it's not any different from sending your work to a gallery in the US," except, he noted, that it can be somewhat more difficult finding out if a dealer in some other country is dependable and trustworthy, and the cost of shipping and insuring works is higher. (In addition, fine art entering any of the twenty-eight European Union nations from an outside country is assessed a 5 percent value-added tax.) Those higher costs may lead to other problems. "Consigning works for a show in Europe can be an ordeal," he said. "If pieces don't sell, artists can have trouble—maybe a little trouble, maybe a lot of trouble—getting their works back, because it is so expensive to return works to artists in the U.S." Dealers make excuses for delays, "saying, 'Let me hold onto it for another year. I'm sure I can sell it.'" Halley's preferred practice is to have his European galleries buy his work outright, reselling it to collectors, which makes "everything cleaner."

Having one's work an ocean away can be nerve-racking enough, especially if there is no plan to visit the gallery while the exhibition is taking place. "Almost all the galleries I have worked with abroad I never visited in person, so there is always a question of what do they really look like and how they operate," said Alexandra Pacula, a New York artist who has relationships with a number of foreign dealers. "I feel that every time I decided to start working with a gallery abroad I took a leap of faith, but so far I have had no major problems."

Just as in the United States, American artists who look to exhibit their work abroad would want to find gallery owners who have a reputation for being dependable and trustworthy. Halley noted that an artist's "due diligence" in this area largely consists of "talking to other artists who have exhibited there," as well as asking art dealers in the United States

about a foreign dealer's standing in the art field. "The art world is small. People know each other."

Getting back unsold works and receiving payment in a timely fashion are the two issues that a number of artists have mentioned. Larry Bell, a painter and sculptor in Taos, New Mexico, had eleven of his paintings disappear "when a gallery closed in Switzerland, and the owner died," according to his studio manager, Lois Rodin. Some years later, those works "were found in storage and returned to us." His glass sculptures have come back damaged as a result of being "badly packed" or after being left too long in a storage facility. The cost of repairing or remaking these sculptural works is too high, she added. More losses to swallow.

Money is no less an issue when sales do take place. Stephen Schultz, an artist in Idaho, claimed that his dealer in Paris did not pay him for sold pieces "for over a year after my show. He finally paid only because of wanting to participate in another exhibition I was having in Greece." Otherwise, Schultz would have needed to bring a lawsuit, requiring him to hire a lawyer in a country where he barely knew anyone to begin with. It was all "frustrating to be at such a distance and to be unfamiliar with the legal process let alone subtleties of the language."

How artists will be paid for sales is one more adventure that should be worked out in advance. Halley noted that "all business in the international art world is done in English" and that "business in the art world is conducted in dollars," but that may not be the experience for every artist. Portland, Oregon, sculptor Kate MacDowell noted "communication difficulties" she has experienced with a few galleries and museums in Europe that suggest that everyone's English may not be top-notch. Additionally, the difference in time zones between Oregon and Europe makes the ability to reach people by telephone in Europe a bit chancier, with email becoming the primary mode of communication. She claimed, "for example, I write to a curator that a collector may be willing to lend a piece for an exhibit but needs more information about how the artwork will be insured and shipped, and the curator appears to read it as the collector has agreed to the loan and perhaps misses the request for additional info." Speaking directly by phone might have cleared things up more quickly.

One of her communication difficulties involved one gallery in Europe that was "very slow to pay and gave me incorrect information about where

a piece was located and if it was sold or not. I'm still unsure about the status of that payment." Over time, she has gotten the impression that European galleries regularly allow buyers more time to pay for their art purchases than takes place in the United States, which could explain why it takes longer for her to receive payment after a gallery reports a sale.

MacDowell noted that she and the European galleries work out the retail price of her sculptures in the local currency, and she is paid based on the exchange at the time "when the payment goes through as opposed to when the price is set or the piece is sold. This plus some small loss in exchange fees makes it difficult to directly predict the eventual price I get back for the piece, although it is usually within an expected range." The most preferable form of payment to the artist is a direct deposit of dollars wired from the gallery's account to the artist's bank account in the United States, with the gallery owner paying any and all conversion costs and transfer fees ("In two cases, galleries paid for the transfer," Schultz said).

European—or Asian or South American, for that matter—art dealers have no better or worse reputation for fairness and honesty than their counterparts in North America. ("I have not had any problems or concerns with my European art dealers who treat me very well," said California artist Mel Ramos, "but this is not to say that I have not had problems with dealers in the USA.") For American artists who show and sell their work both in the United States and abroad, there is more inventory, shipping information, currency exchange rates, and sales receipts to keep track of, requiring that they be organized and attentive to the business side of their art careers. For Ramos, "my daughter Rochelle is my studio manager, and she is incredibly competent when it comes to keeping track of my work." That helps.

CHAPTER 5

Alternative Galleries

AT THE HIGHEST VANTAGE POINT OF THE art trade, artists are well taken care of. Gallery owners arrange for framing, crating, shipping, and insuring of artwork, pay for exhibition catalogues and advertising, promote artwork actively to the media and collectors, and calm any fears artists may have that not everything is being done to publicize and sell their work. All that is asked of artists is that they produce artwork. Below that rarefied perch is a hierarchy of relationships artists have with dealers: artists get the show and the catalogue, but they have to pay for their own framing and shipping; artists get the show but no catalogue or advertising unless they agree to pay half or more of the costs; artists get a show, a mailing of postcard invitations, and a white wine and fruit plate opening (everything else they must pay for); artists get a show if they contribute to the costs of running the gallery.

Is This Vanity?

A generation or so ago, there was more of a boundary line between commercial art venues and what are sometimes called "vanity" galleries. Nowadays, there appears to be more of a continuum in which artists expect less and pay more. A strong sense of right and wrong has been replaced increasingly by a belief in being pragmatic, doing whatever works. Certainly, the stigma attached to paying to show has lessened, following the experience in other art forms, such as musicians who produce their own audiotapes and CDs to sell at performances (concertgoers don't seem to mind), dramatists and actors who rent out theaters to stage a theatrical production (audiences don't care as long as the show is good),

filmmakers who bankroll their own movies (Spike Lee's *She's Gotta Have It* and Michael Moore's *Roger and Me* made them both famous), and writers who publish their own books (readers are more likely to blame publishers for rejecting new talent).

The pragmatic artist judges every situation differently, based on his or her expectations and goals. Perhaps achievement is measured less by sales than as a psychological boost. Rachel Von Roeschlaub, a painter in Port Washington, New York, paid Manhattan's Agora Gallery $2,000 to be included in a group show in which she only sold one work ("the least I ever sold at a show," she said) but considered the experience a success because she is now "able to say, 'I had a show in New York,' which impresses people who look at my résumé." Similarly, Portland, Oregon, painter Kyle Evans was willing to pay $2,000 ("I can deduct it as a business expense," he said) for a show at Montreal's Galerie Gora because "since Gora is in Canada, suddenly I'm an international artist."

There is more than just vanity to their view of themselves as artists. In the three years that Evans has been represented by Gora, five of his paintings have sold (selling for between $900 and $1,000 apiece), which, after the 40 percent gallery commission is paid, puts him at the break-even point. Von Roeschlaub has had three other shows since exhibiting at Agora—at the Broome Street Gallery in Manhattan, the Port Washington Library, and the gallery of the American Association of Applied Science—which may not be directly attributable to having her art displayed at Agora, but "a board member of the library said she saw I had had a show in New York."

For artists, New York is Mecca, but the process of getting one's work shown in a commercial gallery there (or in any major city) is never easy. Gallery owners and their assistants see too many hopeful artists carrying portfolios, and their brush-offs are seldom even polite. Seventy-four-year-old Eleanor Gilpatrick, a painter who lives in Manhattan, was told by one gallery owner "that I was too old and my art wasn't political enough. I didn't assume I would be discriminated against." However, having retired as an economist in the health care field in the late 1990s, she did feel too old to start a new career from scratch—this time as an artist ("I can't look too long into the future, I may not live that long," she said)—and sought to shortcut the process of getting a gallery show, joining New York's Jadite Gallery in 2002. Jadite has three gallery rooms, the

largest one renting for $4,000 per month while the others go for either $1,000 or $700 per month, and it shares the costs of other expenses. "For more established artists, no expenses are split," said Katalina Petrova, the gallery's assistant director. Gilpatrick has done well at Jadite, selling ten paintings and three drawings, putting her in the plus side of the ledger even after the gallery's 40 percent commission is figured in.

Not every artist will be satisfied with a pay-to-play approach to their careers, especially if they haven't built a collector base and expect that a for-rent gallery space will pull in art reviewers or prospective buyers. "Agora was a big disappointment," said photographer Mike Gabridge of Augusta, Georgia, who had paid $1,000 for a show back in the mid-1990s. "I got zero, nothing, out of that venture. The artist takes all the risk." He had "expected that a 'show'—and I put that word in quotes— would lead to gallery owners, buyers, and interior designers stopping by, but attendance was very disappointing." Artists who take part in this type of venture need to recognize the difference between one type of gallery and another. The business that Agora, Jadite, Gora, and other like art spaces are in is not selling art, but giving artists the chance to show their work, regardless of whether or not the owners of the gallery care for the artwork. Artists are most likely to find success at these galleries if they already have a group of collectors ready to buy but need a place to display the artwork. "If you just sit back and wait for someone else to do all the work, you really can be screwed," said von Roeschlaub. She noted that Agora's opening reception was "very bare bones, no food," and that the invitations to the show's opening "weren't very good. They told me they could do better invitations and quoted me an outrageous price; I did my own. They asked me if they could frame my work and again gave me an outrageous price; I did my own there, too."

The art world does not have an easy relationship with this realm. Commercial art dealers and gallery owners tend not to look favorably on exhibitions that artists paid rent in order to participate, and art critics look down on for-rent art galleries, cooperative art galleries, artist-curated exhibitions, and much else that is removed from high-end traditional commercial galleries and museums: "When an artist has gallery representation, it suggests the beginning of a commitment to the work by someone other than the artist him- or herself," said *Los Angeles Times* art critic Christopher Knight. "Because art evolves as informed dialogue

and conversation, it is significant when another person—a gallerist—has begun the conversation by saying, 'I believe in your work.' A vanity gallery cannot offer that; it cannot offer more than the sound of one hand clapping." That view was seconded by *Philadelphia Inquirer* art critic Edward Sozanski, who stated that "I do not have a formal bias against vanity spaces, because the primary concern for me is always the quality of the work being shown and whether it might be of interest to readers. That said, I usually consider such shows of lesser interest, simply because I prefer to spend my time on shows that have been vetted by someone, even if only a gallery dealer. Experience has taught me that self-curated shows are usually disappointing."

It can be difficult to separate the expensive opportunities from the seeming rip-offs. Complaints have been raised by artists against the Florence Biennale in Italy (each of 800 artists are to pay $2,000 in order to take part) and the Batik Art Group of Barcelona, Spain ($400 for six feet of exhibition space), as well as against *NYArts* magazine and *Artis-Spectrum* magazine, two publications consisting principally of artist-paid advertisements whose distribution claims are not easy to verify. "These promoters are leeching on people who are going nowhere," said Robert Coane, a painter who operated the website Art Alarm. "They offer come-ons with false or exaggerated claims, asking for huge amounts of money that lead only to more come-ons that involve a lot of money."

In most (if not all) cases, artists are "found" for these galleries, exhibits, and magazines through web searches that are indiscriminate. Both von Roeschlaub and Kyle Evans noted that they were contacted online by the directors of Agora and Gora Galleries, respectively, stating that they "loved my work and really wanted to show my work," von Roeschlaub said.

Opportunities for artists to "invest" in their careers are legion. Magazines such as *ARTnews* and *Art New England* periodically publish "Artist Directory" pages consisting of one after another slide-sized advertisements ($500 in *ARTnews*, $400 in *Art New England*) bought by artists who hope that a tiny image and contact information will lead to something (it rarely if ever does). Critics for prestigious art magazines regularly take on writing assignments, penning essays (at between one dollar and two dollars per word) for promotional catalogues for artists whose work they would never write about in those magazines. Coane, however, stated

that these publications and writers are more legitimate, because they do not make false claims—*ARTnews* has a paid subscriber base of more than 84,500 art collectors, dealers, and museum curators, regardless of whether or not they bother to look at the "Artist Directory."

One man's meat is another's poison, the saying goes, for the difference between what is questionable and acceptable in the art world is sometimes a matter of perspective. Coane criticized the Manhattan-based Phoenix Gallery for overcharging the artists it represents. The gallery charges a membership initiation fee of $300, as well as quarterly membership dues of $750 (or $3,000 per year) for those living in and around New York City, $975 ($3,900 per year) for those living farther away. With approximately twenty artists represented by the gallery, an individual is likely to get a one-person show once every two years. Between joining and exhibiting, an artist may pay between $6,300 and $8,200. However, those charges are not so out of line with those of other membership galleries about which Coane had no complaints. For instance, New York City's oldest cooperative gallery, A.I.R. Gallery, demands a $500 initiation fee and $240 per month dues (or $2,880 per year) for its members, with opportunities to have a solo exhibition once every two years. As a result, the price of exhibiting for new A.I.R. member works out to $3,380, less than at Phoenix but still a considerable amount.

"The amount of money is not an issue to me," said Saint Paul painter and art gallery owner Joseph Brown, adding that his one show at Phoenix Gallery did not result in any sales. "My work doesn't sell there or here, but I think it's still worth it. I relate more to New York than to Minnesota."

The Artist as Curator

"If an artist can't show his work to the public, then he doesn't exist. How long can you go without existing?" said Philip Sherrod, a New York painter, who has actually shown and sold his work quite a lot. Still, a lot is not quite enough for him, since he organizes—or curates—other shows, including an annual exhibition of what he calls "street painters" at the Cork Gallery at Avery Fisher Hall of Lincoln Center, viewed by the very *un*street people coming to see the philharmonic, opera, or ballet. The show includes his own artwork and that of a dozen or so other artists.

"We're artists who went to the street and try to match the energy and sense of time in the city with technique."

And so, to present and promote his work in the context of a theme shared by a particular group of artists, Sherrod became a curator. He's not the first artist to come up with the concept of staging his own show rather than waiting for a gallery or museum curator to put together a display—the French Impressionists, the Ashcan School, the Blue Rider group, the Surrealists, and even some Pop artists all staged their own exhibitions and events, bringing attention to otherwise ignored developments in the arts—but part of a growing trend. Instead of passively hoping for someone to discover them, leaving their careers in other people's hands, more and more artists are looking to take control of how, where, and when their artwork is seen. They are contacting the managers of arts centers, as well as sites that are not nonprofit or arts focused, such as hospitals, naval yards, and office complexes, to offer a presentation of artwork for public display. "There are a lot of nonprofit art galleries in North Carolina," said Jim Moon, a painter and president of the Asolare Foundation, based in Lexington, North Carolina, whose whole purpose is to stage exhibitions of the work of emerging artists. "It's not difficult to get shows in them. They don't schedule very far in advance, and most don't have curators on staff."

These nonprofit art centers also exist primarily to show the artwork of emerging artists. Since they do not need to sell art to pay their rent (like commercial galleries) or bring in large numbers of visitors to generate revenue (like museums), they offer an opportunity that is more concerned with exposure than commerce. "As an artist, you're always looking for new venues, you want to be seen," said Chicago sculptor Terry Karpowicz, who has curated more than thirty exhibitions in various nonprofit art spaces since 1982. "And, it's not just about showing your work but defining your aesthetic to the community. I do that by choosing other people's work that I respond to."

Karpowicz and Sherrod both identified the goal of these shows as being shown and getting seen rather than selling art, because, while sales do occur, they are not predictable. The New York City–based Organization of Independent Artists sponsors a series of artist-curated exhibitions every year, holding them in various locations, including public spaces at the New York Mercantile Exchange and at New York Law School.

According to organization president Geraldine Cosentino, "Often, there are more sales at the law school, where people don't have much money, than at the Mercantile, where they do have money." In both locations, she added, hundreds of people walk by the displays every day, and artists "all think they're going to hit the jackpot. When they don't, they can get pretty unhappy. I try to give them a realistic picture beforehand, that it's about exposure and experience; don't expect to make a bundle."

Nonprofit art centers are generally not competing with commercial art galleries, although they may serve as a substitute when no galleries are nearby. They are places "to explore and experiment with things that aren't necessarily commercial," said Laurie Lazer, codirector of the nonprofit Luggage Store Gallery in San Francisco, referring to installations, wall drawings, and other less saleable objects. As a result, artists have not been overly disappointed if there aren't any or many sales. However, Lazer said, expectations are changing; they are making "work to sell, and they want sales." More than once, prospective buyers have approached her about works on display, asking about prices and discounts. "I have a hard time dealing," she said. "If you went to a commercial gallery, they deal."

Selling may not be the point for artists curating or participating in these shows. Artists in academia need periodic shows of their work in order to obtain a raise or a promotion, or perhaps an exhibition of current artwork is a stipulation of a grant-funded project. "Shows can bring you academic success, not necessarily commercial success," said Paul Hertz, a digital artist and faculty member of the art department at Northwestern University in Evanston, Illinois, who has organized and curated several shows that included his work and that of his peers. "The goal is to provide documentation of artwork and artists who are underrepresented."

Sales only take place occasionally at the Boston Center for the Arts, and most of the artists whose work is exhibited there "are more concerned with press coverage," said gallery director Laura Donaldson. "They get upset if they don't get enough coverage, or what they think is the right kind of coverage." Otherwise, artists look at exhibitions as a stepping-stone toward other chances to have work exhibited. A different byproduct of these exhibitions is that artists meet other artists, which may lead to other opportunities to show work or just help find a community of like-mindedness.

However, art buying does take place at some of these shows. Karpowicz reported a handful of sales, as well as commissions to create site-specific work from shows he has curated at the Chicago Pier and the Ukrainian Institute of Modern Art. ("Gallery owners won't put time and energy into promoting large-scale pieces," he said, "but the artists will.") Painter Sally Lindsay, who has curated exhibitions at both the Cork Gallery and Marymount College in Manhattan, has sold between eight and ten works to collectors she did not know beforehand. "They're sales that might not have happened otherwise," she said. Lindsay also invites past collectors to these shows. "I don't have a gallery right now, and people want to see my work somewhere."

How sales are handled varies from one nonprofit center to another. Some will act as galleries, arranging for purchases and charging a commission, while others only provide would-be buyers with contact information for the artists. As a result, their ability to identify the actual number of sales or commissions taking place is limited. If any of the artists are contacted by galleries or museum curators, they are even less likely to know.

There are a number of benefits and a few drawbacks to being an artist-curator. Putting together an exhibition allows artists to create a context for their own artwork—such as the use of similar materials or the pursuit of similar themes, which a gallery owner may not choose to see, for example—and to install the show in a way that more clearly suits the artists themselves. Even some artists represented in commercial galleries find that they become restless to show their work more frequently than the once every two or three years that is common gallery practice. Taking the lead in arranging additional exhibits maintains the momentum that the gallery shows may have begun.

Curating an exhibition is a lot of work, and that effort helps to build an artist's skills in a number of areas. Artist-curators need to be able to find appropriate artists and to work with them. The curator develops an idea for the show—something that links the artists—and presents that idea in a proposal to the director of the gallery space (research may be required to determine how to write a proposal). Other talents may also come into play, such as writing press releases and grant proposals. Karpowicz's show on the Chicago pier required him to raise $125,000 (most of which came from Sears, the rest from private contributions). The artist-curator must

research which art spaces welcome proposals of artist-curated shows, and which types of works or artists they favor. The Skylight Gallery of the Center for Arts and Cultures of Bedford Stuyvesant in Brooklyn, for instance, works primarily with African-American artists, while the Cork Gallery of Avery Fisher Hall at Lincoln Center focuses on groups of artists involved in community service. The selected artists may need to be prodded to submit their slides, résumés, or curricula vitae and artists statements by a certain date. Egos also get involved, as the participating artists want the best site in the gallery to put their work, and it takes considerable diplomacy to resolve problems and satisfy everyone.

Some spaces that look ideal for an art display may be problematic for other reasons, such as the lack of climate controls or security. Sherrod stated that a number of artworks at a show he curated at Brooklyn (New York) Law School were vandalized by one or more students, and another couple of works were stolen at a show he organized at an office building in midtown Manhattan ("There were too many doors and windows").

Not all nonprofit spaces welcome artist-curated shows, and some that accept proposals for artist-curated shows do not permit the inclusion of the curator's own artwork, believing that this raises a conflict of interest. Artspace in New Haven, Connecticut, half of whose exhibitions are proposed and curated by artists, refuses to permit artist-curators to show their own work ("We don't want artists to call themselves curators just to show their work here," said gallery director Denise Markonish), and the Newhouse Center gallery at Snug Harbor Cultural Center in Staten Island, New York, will "discourage it," said gallery director Craig Manister. "Ordinarily, it's not something you want to see," adding that there is no strict prohibition. The Boston Center for the Arts created a new policy in 2005, ending the ability of artist-curators to include their work in exhibitions. "We want to separate curatorial ideas from the desire to show one's own work," Donaldson said. Not trusting artists even to be objective about other artists' work, Joy Glidden, executive director of the DUMBO Arts Center in Brooklyn, said that "artist-curating disrespects the idea of what curating really is. Curators spend a lot of time studying art, and they try to put together shows that reflect a larger idea of what is happening. Shows put together by artists seem more like vanity, flavored by what their personal interests are, without any attempt at objectivity." It is not clear who actually objects to seeing artwork by the curator in

exhibitions: visitors to the gallery haven't registered protests, and critics haven't complained in their reviews; the directors of the nonprofit art centers themselves, many of whom also act as curators of their exhibition spaces, are the ones quickest to find fault.

The directors of alternative art sites may claim the right to reject any work they feel is inappropriate or not at a sufficiently high level ("I don't pick the art, although I may veto something's that really awful," said Jenneth Webster, who runs the Cork Gallery), and they frequently take partial or full control of the show's installation. A number of gallery directors mentioned instances in which the artist-curators placed their work in the most central locations, assigning other artists' work to less convenient areas, or the curators installing several of their own works and just one by the other artists. Some directors spoke of exhibitions that were uneven in terms of quality, the result perhaps of cronyism: curators putting their friends in the show. Sherrod's New York City dealer, Allan Stone, noted that he is not interested in showing the work of the other "street painters" in his gallery.

Some nonprofit art centers provide an honorarium to the curator—even if that person's work is included in the show—although the amounts are usually not large. The New Art Center in Newtonville, Massachusetts, offers a stipend of $1,000, which artist-curators may use as they wish, while P.S. 122 in New York City provides "$100 or less," according to director Susan Schreiber. "We're very low budget; it's a labor of love." The Newhouse Center gallery used to offer a stipend, but "there's no budget for that these days," said Manister. However, the gallery pays for insurance and transportation of the artwork, the costs of installing the exhibition and having gallery sitters, printing and mailing announcements, as well as a catalogue. If there is an opening reception, the gallery also covers the food and drink. Yet other nonprofit centers simply make their spaces available for shows, neither paying anything to the curator nor contributing to the costs of mounting the exhibition. The Cork Gallery at Avery Fisher Hall requires any artist group to provide a sitter in the gallery when the space is open. If there are any costs involved in installing or promoting the exhibition, Webster stated, the group putting on the show "will absorb them. For our part, Lincoln Center doesn't charge for the use of the space." Add to the other burdens of curating an art show prodding the participating artists to chip in money to pay a

variety of telephone, printing, and mailing expenses (one's time is seemingly free).

Publish One's Own Catalogue?

Artists are told regularly that they must take an active role in the development of their careers, that they must invest their time and energy in this endeavor, rather than waiting for someone else (dealer? patron? MacArthur Foundation?) to do it for them. Many of these opportunities involve artists spending their own money, which brings up the question of whether or not self-pay garners the same art world esteem as when someone else is the underwriter. (I can say, for example, that what you are reading is a great book, but it is probably more meaningful for readers that this publisher chose to publish it.) For some time, the ground has been shifting, moving the line between what is and is not considered acceptable for artists to pay for. Being the subject of a coffee table art book is a great benchmark in an artist's career, but the publishers of these books regularly are subsidized by the galleries of the artists and/or by the artists themselves ("One of the factors in the decision to produce a book is whether the artist is willing to contribute to the costs of publishing," said Carol Morgan, publicity director for Harry N. Abrams, the art book publisher). The means of financing these books are not revealed publicly, and readers don't inquire: they simply assume that the artist must be a big deal in order to merit the book, which is what the artist and dealer wanted in the first place. Throwing a veil over how the operations of the art world are actually paid for may help maintain older (needed?) illusions for collectors, critics, and artists, but even what used to be called blatant self-promotion does not seem as out of bounds as it once had.

A growing number of artists have taken to self-publishing catalogues of their work, complete with high-quality reproductions of their work and essays by noted critics, that look for all intents and purposes just like those created by galleries and museums.

"Artists are looking for grants, new galleries, museum shows," said West Palm Beach, Florida, artist Bruce Helander, "and they need professional evidence to show that they've not just another artist in a sea of wannabes." He has produced catalogues three times to accompany shows (twice at galleries, once at a museum), claiming that the costs of creating

them—averaging $12,000—were more than made up for by increased sales that the catalogues generated. "A catalogue gets more reviews from critics and more attention from collectors," he said. "The basis of a catalogue is to transmit visual information to a consumer with a high level of design and quality. Readers then put two and two together and are more likely to form a more favorable opinion about the artist."

The first catalogue Helander published was in 1995 for his first one-person exhibition at New York City's Marisa del Rey gallery, which had no promotional plans beyond printing and mailing a postcard. He hired a designer to create an attractive presentation and commissioned Henry Geldzahler, former curator of twentieth-century art at the Metropolitan Museum of Art, to write a 1,000-word essay about his work. (Part of that expense included round-trip airfare to his studio for Geldzahler.) For its part, the Marisa del Rey gallery kicked in $2,500, which went toward mailing the catalogue to collectors, critics, and other people on the gallery's mailing list. Sales were strong, and "by the end of the opening, the catalogue had paid for itself," Helander said.

The link between increased sales and a catalogue is not always direct or clear—might (some of) these sales be attributable to the prestige of the gallery itself or other behind-the-scenes work done by the dealer?—and artists may have to take on faith that the catalogues they produce is money well spent.

In 2001, Manhattan artist Barbara Rachko self-published 5,000 copies of a sixteen-page catalogue of her pastel paintings, which she used as promotional material, sending out the catalogues around the country to museums, curators, galleries exhibiting contemporary art, "any single person who had ever expressed interest in my work," and art consultants and critics (names and addresses, purchased from mailing lists). The costs broke down to $14,000 to produce the catalogue ($1,000 apiece to two designers, $1,000 apiece to two critics who wrote essays, and $10,000 for printing), $4,500 for an assistant who typed mailing addresses and stuffed catalogues into manila envelopes along with cover letters, $150 for mailing lists, and several thousand dollars for postage.

Her catalogue did produce results: several galleries took on Rachko's work, and ten others have scheduled exhibits. The new galleries have generated a few sales, which considering prices for her artwork—$7,500 for smaller pieces and $24,000 for larger ones—indicated to the artist

that "I've already recouped the costs. The value of my paintings justified the cost." However, Rachko has not had a larger quantity of sales overall since publishing the catalogue than in preceding years, which she attributed to "the economy, which has been horrible." The catalogue may have helped offset a downturn in sales, or she might have generated those same additional sales through a less costly form of promotion: Who knows? "It's very difficult to quantify the dollar value of your efforts," she said. "Welcome to the art world."

Any artist who self-publishes a catalogue trusts that there will be benefits seen at some point in the future. "You do a project like this, and you don't get results in the first six months or a year, that doesn't mean it's a flop," she said, noting that "a curator or gallery owner may contact you a year or so later. You never know." Helander claimed that he does know, however: in August, 2003, he met a senior curator of the Whitney Museum of American Art, who bought one of the artist's collages for the institution's permanent collection, "and on that curator's desk was a stack of material about me, and on top of that stack was my catalogue of the Marisa del Rey show."

Self-published catalogues serve various purposes for artists. Topping that list are expanding an audience and generating sales; as much as increasing their visibility in the art world, potentially leading to exhibition opportunities, artists need to recover their costs through sales. As a result, artists need to move slowly into this realm, developing an idea of how much a catalogue will cost, how much they have to spend, and how they will distribute the catalogues (and pay for that distribution). The total costs were more than twice what Rachko had budgeted, largely because she began to produce her catalogue and "learned what it was really going to cost me along the way."

Susan Hall, a landscape painter in Point Reyes Station, California, self-published two thousand copies of a hardbound book of her artwork in the beginning of 2003, which cost $30,000 ("I didn't start out with a budget," she said, "and found out what it would cost along the way"). Her plan has been to sell copies of the book—at $45 apiece—through local bookstores (she and her husband both went to store owners to convince them to carry the book) and mail order (based on brochures about the book sent out to a mailing list). Her paintings sell for between $1,000 and $6,000, and Hall hoped that the book was "a way for people who

can't afford my work to have something of mine." For long-time collec-
tors, the book presents a career overview, while for those new to her art
it offers "a way for people to be introduced to my work."

Almost one-quarter of the books have been sold, and, perhaps, more
important, the number of her paintings sold since publication of the
book has increased by 30 percent, Hall noted. As with Rachko and
Helander, the exact link between book and painting sales is difficult
to identify, but Hall claimed that the book "starts a process," with the
end result being the sale of original art. At the current rate of sales, the
book's publication costs will be recouped "within two years; it could
even be sooner."

Among the decisions that need to be made are whether or not to tie
a catalogue to a particular exhibition and who should write an essay (or
if one should be written at all). It is obvious to anyone reading a cata-
logue that the essays in it will be positive, even laudatory. Some artists
just include their own comments—an artist statement, for instance—and
otherwise let the artwork speak for itself. The usefulness of an essay writ-
ten by the artist or by someone else is to provide whoever is looking
at the catalogue with some essential facts or interpretation that may be
quickly gleaned. "The main people who read catalogue essays are critics
on deadline," quipped Phyllis Tuchman, an art critic for *Town & Country*
magazine and the author of numerous artist catalogue essays. While an
artist's own say-so may be valuable in understanding the creative process,
an outside observer as essayist is more likely to lend greater authority and
credibility to the work—it's not just the artist who appreciates it. Carey
Lovelace, a critic and copresident of the US chapter of the International
Association of Art Critics, however, stated that a catalogue essay is "not
just validating the work for the viewer. It's not just like *Consumer Reports*.
Art is about ideas, and the critic looks to find the idea that is important.
That creates a bridge to the work for the reader."

Hiring a noted critic or curator also may be seen as elevating the
stature of the artwork being discussed—"it adds what I call the Pope's
nod," said Bruce Helander. A known critic's essay may be more likely read
than that of an unknown writer, according to a number of critics who
write and read these commentaries. "I guess I'd perk up if an essay is by
someone I know," said Eleanor Heartney, a critic for *Art in America* and
the other copresident of the International Association of Art Critics. She

added that artists may also "go for the big name, because they'll assume they'll get a quality essay."

Critics, museum curators, and art historians regularly are approached by artists to write catalogue essays; for some of them, it is a lucrative sideline, since the going rate is one or two dollars per word and essayists often require a minimum of 1,000 words (critic Peter Frank claimed there also may be "an extra charge if the writing needs to be turned around quickly"). The New York City–based artist career development company, Katharine T. Carter and Associates, has formalized this process, placing on retainer a number of New York–area art critics who, for two dollars per word, 600 words minimum, will write catalogue essays. "It has been helpful in my career to have written these essays," said Karen Chambers, one of Katharine T. Carter's critics for hire who separately wrote an essay for one of Bruce Helander's catalogues. "It gets my name out. People see that I've written about artists, and they want me to write about them." In fact, it was after Helander had read Chambers's essay in a self-published book by Seattle, Washington, glass artist Dale Chihuly that he contacted her to write about his collages.

Artists need to keep their hopes and expectations in check, when hiring a noted critic. Just because Richard Vine, former managing editor of *Art in America* and another of Katharine T. Carter's critics, wrote about a given artist does not mean that artist had any "in" with the magazine—in fact, none of the artists he has written up as part of his association with Katharine T. Carter has ever been reviewed or profiled in *Art in America*. "You have to realize that you haven't bought this person body and soul for the price of an essay," Eleanor Heartney said, adding that "all of us who write these catalogue essays are trading on our reputations."

Both Barbara Rachko and Susan Hall produced their catalogues and books independently of any specific exhibition, which makes them less time bound but also removes a potential marketing event in which excitement and sales may build. Both women have needed to create all the momentum on their own, lengthening the process of generating sales. Helander, on the other hand, produced his three catalogues at the time of particular exhibitions, even placing a gallery's logo, address, and telephone number on the catalogues as though to suggest the dealers published them. Had he produced his catalogues with no exhibition taking place and no gallery to list on the back, the publication would lack

"cachet. It would be too much of a commercial venture," he said, "just a naked piece of promotion," produced by "a poor artist that no gallery or museum wants." He added that "it's no one's business how an artist is trying to market his work." Perhaps the real issue is whether an artist may look in control of his or her marketing and sales or if some veil over the actual operations of the art world is still needed in order to appeal to older sensibilities.

Publish One's Own Prints?

"If all the stars lined up, and I painted a little gem," said Kerry Hallam, "all I could do is sell this work once, and that's that." That might be enough for many artists, but Hallam, who lives and paints full time in Nantucket, Massachusetts, found that merely painting and selling was not getting him ahead in the world; it just paid the bills. Back in the 1980s, he began to notice how certain artists, such as Simbari and Leroy Neiman, "were making gigantic amounts of money selling silkscreen prints," and the idea of creating an edition of prints from his original paintings began to take hold.

A lot of artists, galleries, and print publishers were thinking a lot about print editions in the 1980s, catering to a growing art market that saw prints as both an entry into art collecting—acquiring works for a far lower price than originals—and an investment. Perhaps too many artists, galleries, and publishers decided to get in on this trend. Certainly, print edition sizes ballooned to—in some instances, thousands of copies—and resulted in a glut on the market. By the end of the decade, print prices were in a free fall (and many prints were simply unsellable); many of the galleries that primarily sold prints went out of business, and publishers retrenched in order to stem their losses.

Making and selling multiples based on paintings never faded away—although some of the frenzy did—as many artists continue to try to widen their audience, increase their exposure, and generate more income from the sale of prints. In 1989, Kerry Hallam "raided the cookie jar" for money to rent a booth at Art Expo, the annual late-winter fine art print show held at the Jacob Javits Convention Center in New York City. He brought along twenty-five of his paintings, hoping to attract the attention of a print publisher. A number of publishers expressed interest, and

Hallam signed a contract the following year with Chalk and Vermilion Fine Arts, the Greenwich, Connecticut–based publisher with whom he continues to work to this day.

Wanting to earn more money is a perfectly good reason for an artist to look into the print market, but as the experience of the 1980s showed, success in this venture takes more than greed. Sylvia White, an artists' career advisor in Los Angeles, noted that "artists most suited to making a line of prints need to satisfy three requirements": the first is a strong market for the originals, "when one specific painting could have been sold ten times. A lot of artists think, 'I'm not selling my paintings, so I'll try to sell prints.' That's a backwards way of looking at it; you need to have a market for the paintings first." The second requirement is that "the original paintings have appreciated in value to the point that the artist is losing former buyers." In that case, offering prints allows these past collectors to continue to purchase the artist's work "at a lower price point." The third requirement is that the art is "targeted to a particular niche, so that the very people you want to buy your work know about your work."

Creating print editions based on paintings today offers more choices to artists than in the past. Twenty years ago, the principal options were offset lithography (a transparency made from the original is scanned and transformed onto a printing plate) and photoserigraphy or silkscreen printing (a photosensitive film is placed on the screen), producing paper prints. Digital technology has more recently allowed photographs of paintings to be scanned into computers, where colors may be changed and enhanced on the monitor and then printed by large-scale printers onto a variety of substrates, including watercolor paper and canvas, which offer the look of the original painting rather than a photographic version of it. These are usually called digital prints (or Iris prints) or giclées. Meeting the competition, many newer offset lithographs and serigraphs have been produced on canvas, adding to their production and selling costs but again providing the look of original art.

Digital prints generally cost more to produce than the lithographs and serigraphs. However, the entire edition of lithographs and serigraphs are customarily printed at one time, requiring artists and publishers to determine in advance what size the edition should be and perhaps creating a storage problem of dozens, hundreds, or thousands of unsold prints.

On the other hand, just one digital print may be produced at a time to test the market (it does not add significantly to the cost to print the remainder of the giclée edition, since all of the information is stored within a computer).

In 2001, Sally Swatland of Enfield, Connecticut, whose paintings sell for between $7,000 and $9,000, tested the market for prints by producing offsets on paper and giclées on canvas for three different images. The production costs for each paper-based print were between $100 and $150, and they were priced between $250 and $700 framed; the same images on canvas cost $175–$200 apiece to produce and were priced at $800–$1,500, also framed. She found that there was much greater interest in the digital prints "among buyers who can't afford an original but want the feeling of canvas. They were willing to spend more for the print if it seemed more like an original painting." Canvas-based prints generally need to be mounted and framed, whereas in many instances those on paper may only be shrink-wrapped and stacked with other paper prints, allowing them to get "lost in the crowd."

Other artists have also found that they can earn more for prints that seem like original paintings. The paper-based prints of Kerry Hallam's paintings are priced at $1,150, while the same images on canvas cost $2,600. Hallam also adds to these canvas prints' look of originality by lightly painting on top of certain sections; another painter who creates prints from her work, Barbara McCann of Bradenton, Florida, produces editions of giclées that are priced up to $2,000 apiece, $2,800 if she "enhances" them with some brushwork. This practice has become so widespread that a number of print publishers have artists on staff to add hand-painted highlights.

These higher-end prints have proven popular with many private collectors and companies, especially those businesses that operate on a strict budget but want to purchase a lot of artwork for their money, such as hotels and motels that look to decorate hundreds of rooms. "I've been told by one corporate manager, 'We have one dollar per square foot to spend on art,'" said Cecily Horton, a corporate art consultant and a trustee of the Museum of Fine Arts of Houston. "It doesn't sound like much, but they have projects of 160,000 square feet." Some companies may seek original works, perhaps even commission artists to create specific pieces, in their lobbies and reception areas (Horton calls these works "trophies

to impress the world at large"), but less publicly accessible areas—such as hallways, conference rooms, and cafeterias—are ripe for multiples. She noted that there are some areas where it does not make sense to place original art, because of a lack of protection against theft or the unlikelihood that anyone will check that the art remains in good condition. However, corporate buyers have shown greater interest in giclées and canvas transfer prints than the poster-type offset lithographs: "I could sell giclées up the wazoo," Horton said. "In an increasingly technological world, the touch of the human hand is more and more valued, and anything that approximates that will be more sought after."

The purpose of creating the prints is to provide an artist with an additional (sometimes called "passive") source of income, and the multiples may also increase the number of potential collectors who become aware of the artist and eventually seek to purchase the original paintings. A problem may arise, however, if the prints seem so much like originals that buyers only opt for the less expensive multiples. Curtis Ripley, a Los Angeles painter whose originals (priced in the $2,000 range) and multiples (priced between $500 and $600 apiece) are sold through a nearby fine art publisher, noted that an increase in sales for his prints has come at the expense of his paintings. As a result, he now believes that artists may need to have their originals and prints sold at different venues. "Iris prints have replaced one-of-a-kind things," he said. "It's a double-edged sword."

Artists who are considering creating prints must also decide whether they will make open or limited editions of images—open editions generally mean a lower price, while limiting edition involves researching the market and strictly obeying the print disclosure laws in effect in many states around the country. In addition, once artists decide to go into prints, they also need images to print from, requiring them to make high-quality photographic images of their originals. "I have slides of every painting I've ever made," said Linda Kyser Smith, an artist in Santa Fe, New Mexico, who is under contract with the El Segundo, California, print publisher Marco Fine Arts, "and they are all available to the publisher."

Various options are available to artists looking to create prints from their work. Among these are self-publishing and seeking a publisher, and there are benefits and drawbacks to each. Publishing one's own edition

allows an artist maximum control over the quantity and quality of the prints, as well as the marketing, promotion, and advertising of them, and it puts all profits in the wallet of the artist; however, it also entails considerable costs (production expenses, advertising, postage and shipping, mailing tubes for unframed prints and crating for framed ones, storage, market research, framing, and dealing with possible returns) and a lot of time attending to all these administrative tasks that take away from actual creating. Relying on a publisher removes the non-art jobs from the artist, yet it also means that the lion's share of profits goes to the middleman-publisher rather than the artist and requires the artist to vigilantly watch over the publisher.

Publishers are distinguished from printers in that they may simply contract out the printing; however, they do take charge of distributing the prints to a network of galleries, as well as pay for advertising, promotion, shipping, framing, and other expenses. Some printers have marketing consultants on staff who advise self-publishing artists with basic information on what to do with the prints they are ordering. "When and how should you enter the print marketplace, and should you enter the print marketplace at all, are three separate questions that I frequently find myself talking about with artists," said Sue Viders, the marketing consultant for Color-Q printers, which is based in Cincinnati, Ohio. "It can cost a lot of money to make an edition of prints, and it doesn't do the artist or Color-Q any good if the artist then can't sell them."

Sheila Wolk, a print consultant in New York City who works with Katherine T. Carter and Associates, an artists' career advisory agency, noted that "there are a lot of minuses to publishing yourself, unless you have guts of steel and big bucks," but some artists fit that description. The biggest bucks, however, are not generally spent on printing an edition but on shipping and especially advertising, which also involves the additional expenses of four-color separation and (frequently) the services of a designer. "People don't contact the artist unless they see an ad," she said, and those advertisements may need to run a number of times before readers begin to remember the name of the artist and the look of the artwork. In addition, these ads should be placed in a number of different publications that one's targeted audience reads—all of which can add up to the tens of thousands of dollars.

All publishers are not alike, and ten artists represented by one publisher may sign ten very different contracts. Some, such as Somerset House Publishing in Houston, Texas, and Wild Apple in Woodstock, Vermont, limit their endeavors to producing and distributing print editions, although Somerset has a licensing division. Chalk and Vermilion Fine Arts, on the other hand, takes on the job of managing an artist's entire career, marketing and selling both multiples and originals. "I can't sell a doodle on a restaurant napkin without them giving me permission," Hallam said. He noted that the publisher also suggests particular subjects for him to paint and the particular mood that the picture should convey. "They have a better overview of the market than I have."

"We put a lot of effort into our artists," said Eric Dannemann, chief operating officer of Chalk and Vermilion. "We're the publicist, marketing arm, production arm, agent, salesman. The word 'publisher' sounds like we only make an edition of prints. The word should be 'manager.'" A number of publishers are moving in this all-encompassing direction. Marco Fine Arts is somewhere in between Somerset and Chalk and Vermilion, since it publishes print editions of Linda Kyser Smith's paintings and also has contracted to purchase ten of her paintings every year ("at market value," she said) that are resold to the galleries carrying Marco prints. While these galleries also sell her originals, "the paintings are there to promote the prints," Smith said. A difference between Hallam's agreement with Chalk and Vermilion and Smith's contract with Marco is that Smith may sell her other paintings however she chooses, and she has arrangements with six other galleries.

Print publishers find the artists they sign to contracts in different ways. Most of Wild Apple's artists came to the company's attention through unsolicited submissions, according to Julia Brennan, the marketing manager, where a four- or five-member art development team evaluates slides, photographs, or email submissions once a week or more. Chalk and Vermilion, on the other hand, "rarely signs" artists that the company has never heard of before, Dannemann said, preferring to recruit painters whose work they see by going to galleries or looking through art magazines: "We sign a new artist every one or two years."

There are various sources of information about distributors, suppliers, printers, framers, and publishers: the classified sections of art magazines generally include advertisements for these companies and occasional calls

for submissions; the annually published *Artists' Market* (F&W Publications) contains detailed listings of companies; *Art Business News* (Advanstar) contains numerous advertisements by publishers and suppliers, as well as articles on trends and practices in the fine art publishing industry. Every year, *Art Business News* publishes its *Buyers Guide*, which contains reference information for the print publishing industry, and Advanstar hosts the five-day-long Art Expo, where artists, publishers, and suppliers rent booths and show their products.

Art Expo is the top of the line for fine art print shows, attracting much of the trade and thousands of fine art collectors. It is also one of the most expensive shows for exhibitors, costing thousands of dollars for a booth. For artists without considerable experience in producing and selling prints, it may make more sense to visit the show in person (admission is free to members of the art trade and twelve dollars for other visitors, including artists), visit the show's website (artexponewyork.com), or buy the Art Expo catalogue (costing $30 and containing one or more full-color displays by each of the show exhibitors, 888-322–5226 and the *Buyers Guide* (available through the $65 subscription to *Art Business News*, One Park Avenue, New York, NY 10016) than to spend thousands of dollars to rent a booth. There are also numerous other arts fairs around the United States where artists can sell their originals and prints, and information on these may be found in a variety of art publications.

Whereas Kerry Hallam entered the print world at Art Expo, Carl Hoffner of Fayetteville, New York, worked his way up during the 1980s and '90s, installing a booth at between eighteen and twenty-four fairs and festivals per year (the booth fees averaged $250–$400) and using the remainder of his time to print, frame, mat, and ship his work as well as keep up with the paperwork of applying for admission to all these shows. "It's hard work to do these shows," he said. "It takes a lot of stamina to stand around talking to people and being friendly, listening to them, and seeming interested in what they have to say." Sales skills are rarely taught in art schools, and Hoffner learned by doing and by listening to audiotapes that describe how to sell to people while he is driving to one fair or another. After enough of these fairs, Hoffner became comfortable talking to strangers, learning how to be his own advocate while responding collectors' questions. "They're all looking for something for their homes. You simply have to identify what their needs are and satisfy them."

By the mid-1990s, Hoffner decided to concentrate on the high-end shows, such as the annual Art Expo in New York City. "I worked for a year and a half to make the work for the 1995 New York Art Expo," he said, producing eighteen editions of 110 prints each. "The cost of doing that show and the cost of printing the work for the show came to $50,000. It's like betting your house: The 10' × 10' booth was $4,000 alone, and then there's the hotel and food costs, but the years of doing the festivals had taught me to have confidence and to invest in myself." The show turned out to be a positive experience, as Hoffner sold almost 60 percent of his work from his booth. By the end of 1995, he had sold 90 percent of his work. In subsequent years, he said, he has done "even better."

Working Small . . .

In the art world as in other arenas, size matters. Some artists prefer to work small, but their dealers tell them that large is priced higher and is taken more seriously by critics, collectors, and curators. Other artists choose to work on a larger scale, but their dealers inform them that few collectors have room in their homes for such big stuff and that they need to make art that is more affordable and portable. Quite often, art is judged by non-art criteria.

There are many reasons that artists create works in different sizes or, perhaps more pertinent, make small pieces when they are best known for larger ones. William Beckman, a painter in Millford, New York, may "spend months on one big painting, but I can do a small one in a day." During that day, he may go outside to paint a landscape; a large canvas is apt to be blown about by the wind, so by necessity he must limit the size to under two or three feet. "If you're carrying it around outside, it also has to be able to fit under your arm," he noted.

Working smaller also affects his attitude toward the work. "I don't ponder every brushstroke, so I feel freer when I'm painting." Changing his technique allows Beckman to experiment, and the results eventually may wind up on a larger painting, or maybe not. "I don't think of my small paintings as seriously. They're expendable; I call them 'throwaway paintings,' because it doesn't matter so much if they don't work." Works that he produces in his studio—and he only creates three large paintings

129

per year, on the average—"I think of more as commodities. They're more expensive, and they have to be right."

Other artists also note that smaller works feel different than larger ones and "allow a lot more freedom to make mistakes, and also some happy accidents that lead to exciting new developments," according to Burlington, Vermont, painter Peter Arvidson. For Scott Prior, a painter in Northampton, Massachusetts, his method doesn't change when moving from big to small, but he "may try out different subject matter" that will be expanded at some other time on a larger canvas. In that regard, the small painting could be seen as a preliminary artwork, except that there hadn't been a larger one in mind when he started.

Completing one large work and then moving on to the next large work can make art seem like an endless chore. "Big paintings are hard work," Prior said. "They're a leap of faith when you're beginning, because you look at the canvas and see days and days of work ahead, and you have to hope that it all comes out alright. After I have finished one and step back to look at it, I'm impressed that I have accomplished this thing, but I need a break before I begin the next one." With a small painting, "I can finish it in a day and think, 'Hey, I can take tomorrow off.'"

What smaller works may lack in finish they perhaps make up in a level of intimacy, both for the viewer and the artist. One generally backs up to take in a larger work of art, limiting the ability to see all at one time what the image is and how the artist created it. There is none of that with smaller works, which usually are viewed at arm's length. It is not always the case that smaller works take less time than larger ones (although "most galleries price works by size, which means that smaller is always less valuable, which is really unfair," Beckman said) or that artists change their techniques based on scale. More often, the subject may be simplified—fewer figures in a painting, for instance, or a head instead of a full body—but the small scale requires the artist to focus more intently.

"There is something magical about a small work," said New York City painter Jacob Collins. "It seems very modest because it's so small but guilefully announces itself the more you look at it. Big paintings are never really modest. They announce themselves immediately as big paintings."

Big artworks also announce an artist's career, while smaller pieces simply let people know that something is for sale. Very few artists are known

for their diminutive pieces, regardless of how much larger a percentage of them may be sold than more floor-to-ceiling works. In fact, a giantism has taken out whole segments of the contemporary art world: big really seems to be better. "Typically, I recommend that my artists work larger," said Manhattan art dealer Kathryn Markel. "My clients have large walls, and they won't be able to see a work if it's only twenty by twenty inches." The fact that larger works cost more than smaller ones is another reason that dealers press artists to work on a larger scale. Sarah Hatch, a painter in Decatur, Georgia, was told by her New York City art dealer, the late Monique Goldstrom, that "it wastes her time having to deal with smaller pieces, she can do the same amount of work to sell larger pieces."

For many dealers, in fact, it takes more time to sell smaller and less expensive works than larger ones. San Francisco art dealer John Pence noted that "when people want a big work, they can afford it. There's no scraping of pennies and thinking of what they might have to give up. With smaller works, the client is often not so wealthy and will have to think long and hard whether or not he or she can really afford it." With gallery rents reaching tens of thousands of dollars per month in a number of major cities (Pence's gallery costs $50,000 per month to run), artists would need to produce a lot of work and dealers would be required to sell them in significant quantities when the individual pieces are small and modestly priced.

Large, sprawling artworks—huge canvases, monumental sculptures, room-sized installations—sometimes provide an inaccurate impression of an artist's actual body of work. Far more of Mark di Suvero's tabletop (28' × 16') and medium-sized (from four to ten feet in height) sculptures sell in any given year than the larger outdoor works that are assembled with cranes and for which he is better known. In fact, di Suvero told one of his studio assistants, Zachary Coffin, who lives in Atlanta and is a full-time sculptor in his own right, that "the key to keeping everything flowing is to have small works to sell." Coffin has also gained a reputation for his massive public art pieces, weighing up to ninety tons and costing $200,000, but he, like di Suvero, additionally produces smaller works of only thirty-five to forty pounds that cost $5,000 to $25,000. Dealer prodding pushed him in that direction. "Gallery owners have told me, 'People love your work, but we can't move it,'" Coffin said. "'Collectors want the work in their houses; our customers don't own sculpture parks.'"

At times, however, galleries may seek smaller works by an artist, or at least a balance of small and large, in order that potential buyers are given a choice. Smaller and less expensive pieces provide a safe entry point for new collectors and those who are being introduced to an artist's work for the first time. "Smaller works are easier to sell, ship, and store," said Julie Baker, an art dealer in Grass Valley, California. She noted that one of the artists represented by her gallery, the San Francisco painter Nellie King, is known for her eight-by-eight foot paintings, whose average sale price is $6,000, but "I've specifically asked her for smaller pieces." King has brought in both "painting strips" that measure nine inches by eight feet and twelve-by-twelve-inch paintings that are priced at $600. Those have sold well, Baker said, to both budget-conscious collectors and others who "don't have to worry where an eight-by-eight-foot painting is going to go. People love her work, but many don't want to spend $6,000. They get the flavor without making a huge commitment."

This area of the art market has been accorded its own forum with the AAF (affordable art fair) Contemporary Art Fair, which takes place annually in New York City in late October and features art priced under $5,000. Almost every two-dimensional piece in the fair could be carried out under the arms of the buyers. Approximately 13,000 visitors came to the 2003 fair, making 2,500 purchases whose average price was $1,300. According to the organization that sponsors the fair, half of the buyers were new to the galleries that had set up exhibition booths; most of them were also new to art collecting. Lower-priced artwork doesn't need its own event for dealers to have pieces on hand, however. "It's nice to have things that sell for $200 or $300," Kathryn Markel said. "Gifty, presenty things."

Collectors may not be the only reason that a dealer suggests the artist create smaller pieces. "We can't show paintings that are bigger than six by nine feet," one New York City gallery owner stated. "Larger than that, the painting won't fit through our front door or in the elevator. With sculpture, too, there is a storage problem, especially for very large works."

... Or Leaving Behind Art-as-Object Making Completely

No one says that the traditional business model for being an artist—you make something, try to exhibit it, and hope to sell it—is an easy way to

make a living, but at least we all can comprehend how, if successful, artists theoretically could support themselves. What then do we make of Sean Starowitz, an artist in Kansas City, Missouri, and a bread baker when not engaged in art projects, who in 2014 teamed with Saint Louis–based artist and museum programmer Alex Elmestad on a project called "Bread for Work" for the Cowry Collective Timebank in Saint Louis? Loaves of bread (referred to as "bread tokens") that he baked were distributed to participants in this project who, in exchange, provided other goods and services to low-income groups. A participant would come to the Timebank and say, for instance, "'I'm Bill. I am a tax advisor. I'll help someone do their taxes,'" Starowitz said. "We would turn that information into the Cowry Collective, who would then match people in need with those services or needs." With a business plan like that, Starowitz seems destined to be baking bread loaves for a while longer.

Except he and his collaborator did get some money for their concept and project, not in terms of a sale but in the form of grants, in this case from both the Pulitzer Foundation for the Arts and the Sam Fox School of Design & Visual Arts of Washington University.

Project grants are not new. However, the idea that an entire artistic career might be based on grants and that the end result would not be art objects that have some permanency but largely serve some cultural, social, or political end is a more recent development in the history of art.

There are various names for this type of art, including "social practice," "community engagement," "contextual practice," and "socially engaged artmaking." Some draw distinctions between one type or another, but "social practice" tends to be the umbrella term for this field, referring to projects that generally are collaborative rather than emanating from an artist working alone in his or her studio, involve artists working within a community to develop creative solutions to local (social, political, cultural, environmental) problems, and frequently require funding from some outside source. If it is difficult to get a sense of what social practice art looks like, it is less a style than a message of some sort.

A growing number of nonprofit cultural and community development organizations around the United States have developed opportunities for artists to work with various populations in a process referred to as "creative placemaking." For instance, the Lower Manhattan Cultural Council places artists in residence at senior centers, and Peter & Paul

Community Services in Saint Louis brings them in to help the homeless create books of artwork and writing. The New York City–based Local Initiatives Support Corporation has hired artists to help transform poor and struggling neighborhoods in cities around the country through starting enrichment after-school arts programs and coming up with ideas to brighten up a business district, according to Erik Takeshita, director of creative placemaking. Springboard for the Arts, in Saint Paul, Minnesota, has hired artists to create projects for the city's Asian Economic Development Association in order to "make visible the cultural identity of the place," said Springboard's executive director, Laura Zabel.

More and more municipalities have looked to engage artists in the social practice realm in order to make use of their talents in issues of importance. An example is Mary Miss's 2007 project in Boulder, Colorado, "Connect the Dots," which involved the placement of 600 large blue metal dots affixed to trees and municipal buildings throughout the city that identify the high-water marks of floods that have inundated the city in 1894, 1914, 1919, 1921, 1938, and 1969. The intent of the art project is to remind residents of the need for preparation. "Because of its location, the nature of the steep slopes and long approach upstream the city is highly susceptible to flooding," the artist, who otherwise is not represented by any gallery, claimed. "The city is considered to be a high hazard zone where the question is not if there will be a flood but when it will happen." The art is intended to start a larger conversation rather than to be bought and sold.

In a similar vein, Jackie Brookner creates what she calls "biosculptures"—"sculpted ecosystems" composed of mosses, ferns, and other plants growing on stone or concrete shapes of her devising—that are used to filter runoff rainwater from buildings. In 2005–08, Brookner installed natural filtration sculptures for storm water runoff for a community center in San Jose, California. One part of the project, titled *Urban Rain*, contains a stainless steel sculpture of spiral forms that aerates the runoff water as it drops into a rock basin where is it filtered before flowing into a bioswale that further removes pollutants. These biosculptures become natural water treatment systems. It is not Brookner's claim that her biosculptures are having a significant impact on the environment, although some larger projects for wetlands, rivers, and streams involve the collaboration of scientists, government officials, architects,

and members of the surrounding community. Rather, it is the hope that those who see her work might be intrigued enough to see what is going on and what they could do to counteract water pollution.

Like other art styles and movements, social practice didn't originate in colleges and universities, but these days it is being taught there as class content, concentrations, and entire degree programs. One of the first things art students in these programs are taught is its history. There is no standard text on the subject, and what that history is depends on whoever is teaching the course. Daniel Tucker, graduate program manager at Moore College of Art, which offers a limited residency MFA in "community engagement," identifies early Soviet Union agitprop, the mural arts movement in Mexico in the 1930s and '40s, the Black Power movement of the 1960s, and the AIDS Coalition to Unleash Power of the 1980s as progenitors. Suzanne Lacy, chairman of the MFA program at Otis College of Art and Design, which was the first college or university to offer a graduate degree in social practice in 2005, spotlights the feminist, antiwar, and labor movements; performance art and social media campaigns; and community organizer Saul Alinsky (1909–72) as leading influences on artists. The focus of social practice art shifts with the concerns of the day. "Food and food scarcity is the issue du jour," Lacy said. "In the 1980s, it was homelessness. These days, you see more focus on violence against women, and water and ecology are coming up."

Hugh Pocock, a sculpture and video professor at the Maryland Institute College of Art who founded a sustainability and social practice concentration within the Bachelor of Fine Arts program, stated that "fine art is one of the last fields to be engaged in social responsibility and ecological awareness," as students traditionally have been taught to express themselves without regard to the larger societal context in which their work exists. "Art students regularly ask themselves, 'What is my art for? Why am I making art?' Is it simply to have my art follow a trajectory from studio to art gallery to buyer?' In this program, we are looking to raise the bar and bring into the conversation issues of social, political, and ecological justice."

Is this concentration itself sustainable? Will graduates be able to earn a living based on their training? However, that question is often met with hostility, regardless of what students pursue in art school. Pocock said that he has seen an increasing number of art students at the college

wanting to learn "how to make their work have direct and relevant impact on the world around them and how to do this in an ethically responsible manner."

More and more artists are establishing careers in social practice. One of the leading practitioners in the food realm is Fritz Haeg, an architect by training who lives in Los Angeles and whose art projects have involved installations of gardens or animal dwellings. "I want to make art that addresses our relationship to our environment and how we live," he said. "That is historically what artists have done." In 2013, Haeg created a project called "Domestic Integrities" involving the planting of a garden in a dug-up area of the parking lot at the DeCordova Sculpture Park and Museum in Lincoln, Massachusetts, and growing corn, peas, squash, and tomatoes. When ripe, the vegetables were picked and put on pedestals inside one of the DeCordova's galleries. As vegetables are harvested and brought into the gallery, they are fresh until they "start to rot and then are replaced by other things," Mr. Haeg said. "Yesterday was different from today, and tomorrow will be different. This is a live broadcast of a particular place." Food as kinetic art.

Perhaps the brightest star of this field of art is Mierle Laderman Ukeles, who creates what she calls "maintenance art" (combining art and everyday activities, such as cooking and cleaning) and has been since 1977 the unsalaried artist-in-residence of the New York City Department of Sanitation. Among her artworks was a choreographed ballet of backhoes titled *Romeo and Juliet* and her *Touch Sanitation* that involved shaking hands with all 8,500 workers in the sanitation department while saying "thank you."

Art that inspires a sense of community identity—think of Michelangelo's *David* in Florence, Italy; Soviet social realism; or Eero Saarinen's Gateway Arch in Saint Louis—has a long history, and no one expects art to solve ecological or social problems. The aim of social practice is, at best, to point up potential solutions and raise awareness. Social practice is not for introverts who prefer to be in their studios, and the skill set requires the ability to write grant proposals, negotiate competing visions and differences within communities, and understand how to interview and listen to different people, as well as how institutional hierarchies work, how to create partnerships, and how to do research. That is quite a different order of skills than those usually offered in college and

university art programs, where art students go in order to develop their artistic skills, learn new techniques, try out different media, and create a body of work that could get exhibited and, they hope, sold. One cannot imagine Picasso exhibiting something that didn't include his signature, but nothing in Mary Miss's *Connect the Dots* screamed "look at me." Mary Miss noted that "I've sold a drawing once in a while," but her principal sources of income have been the Ford Foundation, the National Endowment for the Arts, the National Science Foundation, the National Oceanic and Atmospheric Administration, and the Rockefeller Brothers Cultural Innovation Fund. Fritz Haeg also claimed to have only sold one object in his career, a large eagle's nest he created for the 2008 Whitney Biennial ("there was this one collector who kept asking and asking, and eventually I said 'OK, I'll sell it to you'"), but otherwise his projects are supported by commissions from institutions, such as Tate Modern in London and the San Francisco Museum of Modern Art. Brookner's *Urban Rain* was paid for by the city's Percent for Art program, and her projects generally are financed by a mix of grants from arts and science agencies (both the Ohio Arts Council and the Environmental Protection Agency, for instance, provided partial funding for her 2002–09 *Laughing Brook Salway Park Wetland and Stormwater Filtration Project* in Cincinnati).

"I'm not interested in putting up another monolithic, iconic art object, like Claes Oldenburg or Dennis Oppenheim," Miss said. "My goal is not to put my thumbprint on a place but, rather, to integrate my vision into the environment and let the content come forward."

CHAPTER 6

Practical (and Perhaps Ethical) Considerations

AS ANY EXPERIENCED ARTIST KNOWS, NO ONE becomes rich and famous simply by creating superlative art. The artwork has to be put out into the world for people to see, and this requires the artist to gain expertise in marketing (finding the proper audience), promotion (creating press releases and brochures), and sales (developing relationships with prospective buyers).

Photographing Art

The artist may also need to become an expert in photography, since the first introduction to one's art for many of the art world's middlemen (critics, curators, dealers, art show jurors) is through photographic images. Their first impression of someone's artwork may be formed while holding a slide up to a light bulb (perhaps on a light box or through a projector onto a screen) or, if the image has been digitized, on a computer screen. A great work of art, if not photographed well, might be rejected as second rate. "A poor slide tilts in favor of declining the work, if there are any questions," said Frank Webb, a painter in Pittsburgh, Pennsylvania, who has frequently served as juror in many art competitions.

There are myriad problems in badly photographed slides: the artwork is crooked, colors are off, glare from too much light or shadows that obscure portions of the piece, background distraction, the whole thing is out of focus. These problems are not always apparent to the artist, who "lives with his work in his head" and may not see it as objectively

as a professional photographer, according to Edouard Duval Carrie, a painter in Miami. "An artist and a photographer may have very different concepts of what the work looks like. A professional photographer only sees the work through the camera viewfinder, and he photographs just what he sees, not how he imagines the work looks like. I may like the fact that one part is more lighted than another, but it looks terrible when it is reproduced."

Carrie had shot his own slides in the past, but his Miami dealer, Bernice Steinbaum, told him that he had to hire a photographer in order to create better images to send out to the press or to show collectors. The artist agreed and now only photographs his work for his own archives. "I don't have all the equipment to take photographs properly. I'm usually too rushed or too rattled to do it the right way."

There are three main ways in which artwork is photographed: the artist does it; the artist hires a photographer; or, the artist's dealer hires the photographer. Painter Jack Beal's New York City dealer, George Adams, arranges for someone to photograph the artist's work—he does that for most of the artists represented by the gallery—bearing the expense himself. ("I don't have the equipment, I don't have the know-how, I don't have the time or interest," Beal noted.) Bernice Steinbaum, on the other hand, often brings a photographer into the gallery to shoot images of the artworks on the walls, passing on the cost to the artists. "Artists under contract to the gallery are obligated to provide two transparencies for every work," she said.

There is no association of photographers of artwork, but many are listed in the Yellow Pages or, through a search engine, on the web. Word-of-mouth references also lead artists to photographers, and some hunt up a photographer whose work they have seen in a catalogue or book (through the publisher, for instance). The costs for this service range widely, depending upon the size of the artwork, the number of pieces to be photographed, the number of exposures of each work, and whether the photographer will shoot the artwork in the artist's studio or if the art needs to be transported to the photographer's own studio. Some photographers set their rates by the hour—Peter Shefler of Gibsonia, Pennsylvania, for instance, charges $70 for the first hour and $60 per hour after that—while others charge per image. "It costs us between $47 and $100 per image to hire a photographer," said Patrick Weathers, director of

Bryant Galleries in New Orleans, Louisiana (the artist is likely to reimburse the gallery for the full amount, unless the gallery wants to reproduce the image for a catalogue or print).

Hiring a photographer has its drawbacks. Carrie spends hundreds of dollars for each photo session, and "it's a hassle to get a photographer to come when I want him," he noted. "I don't like to wait around." Still, the results now are uniform and good. In addition, photographing his own artwork "wastes my time and materials. I'm not really saving money doing it myself."

The art of photographing art can be a time-consuming and expensive pursuit, and it may also take up a fair amount of space in one's studio or home. Many artists who regularly photograph their own work dedicate some area solely for this purpose—Frank Webb, for instance, uses a third-floor room in his house exclusively for shoots—for a good reason: the setting up of a photographic shoot tends to take the most time; once lights, background, camera, and tripod are in place, different works may require only small adjustments in the equipment before they are photographed. (That is why, unless an artist works in a variety of media and at vastly different sizes, paying by the hour is often a better deal than per image.) It makes sense, therefore, to keep the photo studio permanently set up, rather than clearing out a portion of a room again and again, arranging afresh all the equipment for a shoot.

There are certain (almost) universally recommended rules of photographing a work of art. For two-dimensional pieces, the camera lens should be placed parallel to the work (in order to reduce distortion and blurriness), aimed at the center of the piece, and the alignment should be checked by a small level on both the camera and the artwork. When looking into the camera, the photographer should ensure that the artwork fills the viewfinder, eliminating extraneous material, such as the wall of a living room where it was hung or the easel on which it was photographed. Usually, the artwork is flat to a wall: wire-hung works often lean forward slightly, but a shim between the bottom and the wall can compensate for this; if the work is in a frame, screws may attach the entire piece to the wall, and works on paper may be tacked. A somewhat different approach is taken by watercolor artist Tony van Hasselt of East Bay, Maine, who places his painting on the floor, attaching his camera to a shelf and pointing it downwards. "I like to shoot the picture as soon as

SELLING ART WITHOUT GALLERIES

I'm done," he stated, noting that "I don't want to wait until the next day, because I lose the mood." He added that "if I hung up the painting, the watercolors might drip." Laying the artwork flat on the ground solves the dilemma.

Whenever possible, protective glass should be removed from in front of the artwork, because it reflects natural or artificial light as a form of glare; mats and frames also should be removed, because they add a rim of shadow around the artwork and may present a distraction. Because duplicate, or second-generation, slides are often not as clear as the originals, artists often take between three and six frames of the same artwork; some also take close-ups as details.

The list of possible accoutrements goes on: when shooting indoors, one needs at least two lamps designed for flash (strobe) or incandescent (tungsten or halogen) bulbs, placed at 45-degree angles from the piece and aimed at the center of the artwork. Bulbs need to be treated very gingerly—handle them only with a clean rag or cotton gloves, since the oils from one's skin may cause the bulb to heat unevenly—and one also better work quickly. These bulbs have a life span of six or eight hours of use, and the spectrum of light they produce diminishes as they near the end of their life. Because artificial light may create glare, polarizing screens or filters for the lens can be necessary. All natural light should be eliminated from the room so that the setup is the only light source, requiring curtains over any windows. Even better is shooting at night.

While cameras contain their own built-in light meters, measuring reflected light (light bouncing off the object being photographed), a separate handheld light meter placed next to the artwork determines the relative brightness of the light shining on the piece, or incident light. A Kodak product called a gray card, which will reveal the average mix of light, shadow, and color on the artwork, should be held up to a corner of the piece, and the camera's light meter set to the reading on the card. For background, one can purchase a roll of plain photographic paper (available at most photographic supply stores) or black velvet (sold at fabric stores), which eliminates any distractions and absorbs light.

"It's definitely more expensive to take photographs indoors," said Robert Burridge, a painter in Arroyo Grande, California, who generally places his artwork outside in direct sunlight when taking a picture. He places a painting onto black velvet glued to a board, angling the board

45 degrees from the sun, making slight adjustments in that positioning if there is too much glare.

The cost of equipment is not the only factor involved in determining whether to photograph artwork indoors or outside. "Sunlight is the perfect color temperature to use with film," said Chris Maher, a professional photographer (of artwork), craftsperson, and artist website designer in Lambertville, Michigan. However, he noted, "variability is the problem, because the light is changing all the time. You may find that it is impossible to repeat what you have done." Where an artist lives may also affect the ability to take photographs of their work outdoors on a regular basis. Southern California has a lot of sunny days, while the northwest is often overcast and rainy. Wintertime snow on the ground would likely reflect a considerable amount of light onto the artwork, creating the problem of glare. As a result, some artists set up photo studios inside where they work for the times that they cannot take pictures outside.

Artists may simply need to find out what works best for them: Some prefer the more diffused sunlight at ten in the morning or four in the afternoon, shooting in direct light or in the shade, while others become frustrated that outdoor light is naturally filtered differently at different times of the day—there is more blue in the morning and red in the evening. Alexandria, Virginia, painter Nancy McIntyre takes photographs of her work at midday on her patio, but only when there is "a little bit of sun and haziness. Overcast with light sun works perfectly with me." (Made-to-order climate conditions are not easy to come by, but, perhaps, Alexandria has a lot of that type of weather.) Some artists report that slightly underexposing their photographs creates more saturated colors, while others prefer a faster shutter speed.

"Artists need to try things out to see what works for them," Maher said. "The difference between an amateur and a professional photographer is that a professional makes tests, while an amateur will just assume that everything will work out the first time."

Are Artists Responsible for Their Art?

Art is long and life is short, according to the old Roman saying, but sometimes art doesn't hold up its end of the bargain. The canvas warps, the metal bends, the paper turns brown: new artworks may look like old

works in a short period of time, leaving their buyers perhaps feeling as though they have been had. One such collector brought back to New York City gallery owner Martina Hamilton a painting she had purchased there by the Norwegian artist Odd Nerdrum that looked as though the "painting was falling off the canvas," Hamilton said.

Art doesn't come with warranties, and state consumer protection statutes only cover utilitarian objects, such as automobiles and toasters, rather than art, which is sold "as is" by galleries or directly from artists. Still, dealers hope to maintain the goodwill of their customers, and artists don't want to develop a reputation for shoddy work. It is not fully clear, however, what responsibility artists bear to their completed work, especially after it has been sold. It is particularly the case for artists who purposefully use ephemeral materials in their art (bee pollen, banana peels, lard, leaves, mud, moss, and newspaper clippings, to name just a few examples)—isn't it the buyers' responsibility to know what they are getting?

Nerdrum, who is known for formulating his own paints (and constructing his own frames), was contacted by Hamilton about the deteriorating painting, and he directed the dealer to offer the buyer her choice of other works by him at the gallery in the same price range. The collector, however, didn't want any other Nerdrum painting in the gallery, so the artist rehired the same model he had used originally and painted the entire image anew. The entire process took a year to resolve.

Nerdrum is not the only artist who will try to make amends for work he or she created that doesn't hold up, although few others have gone to such lengths. Many others simply look to do restoration work. Painter Susan Norrie, who is represented by New York's Nancy Hoffman Gallery, was "absolutely willing to restore the piece," gallery director Sique Spence noted, after wide cracks appeared in the work, the result of incompatible drying times of the paint layers. All was not totally well with the collector, Spence said, as some buyers view a restored painting as having a "stigma." As a result, the gallery offered the buyer a credit for any comparably priced work in the gallery by any artist. When Norrie finishes her restoration, the gallery will own the painting and not ask the artist for its money back. "The artist bears some responsibility to his or her art," Spence said, "but we bear more responsibility to the client."

If they are alive and physically able, should artists be counted on to repair damage—caused by their own workmanship or a collector's

mishandling—or is the job of creation and that of conservation so disparate that no one person should attempt both? Artists look to correct problems, such as repainting a section of a canvas, whereas conservators aim to slow the process of deterioration, repairing holes, filling in cracks, but not using any materials that could not be completely removed by another conservator. It is more often the case that collectors will take damaged artworks to a conservator, perhaps directed to someone by the dealer from whom they purchased the piece, and the conservator may or may not contact the artist. "I always contact the artists," said independent conservator Len Potoff. "I ask them if they want to be involved in conserving the work, what they would recommend I do, what they think about my plans for conserving the piece and also their feelings about the work—what were their intentions when they created it." He looks to know what artists did and how they did it, "but I may not follow their formula. I don't want to recreate the problem that caused the work to deteriorate."

Some artists, however, welcome and solicit the conservation role. Long Island City, New York, artist Tobi Kahn stated that he wants to maintain an ongoing relationship with his work, even pieces from twenty or more years earlier, "and I tell my collectors, 'If there is any problem with the work, bring it to me and I'll be your restorer.' I want the painting to look exactly as it did when it was first painted." He added he sees how many paint layers he had done and "will recreate that exactly. When someone brings me an older painting that needs repairs, I'm not Tobi Kahn the painter, I'm Tobi Kahn the restorer."

An artist's sense of obligation to his or her work sometimes may be time limited, contractually at times—public art commissions usually contain a clause in the agreement stipulating the artist's responsibility for "patent or latent defects in workmanship" for between one and three years—or based on evolutionary changes in the artist's life and work. Artist Frank Stella said that he may be willing to help repair one of his works if "it's not more than two or three years old." He uses different materials for specific works and, "after two or three years, I don't have any of the materials left over. I don't have the expertise to deal with it; if I were to attempt a repair, I'd make a mess of it."

Stella refused to take part in the restoration of a twenty-five-year-old sculptural painting that had been brought in for repairs to Len Potoff,

who had contacted the artist as a matter of practice. "He said that he couldn't do it," the conservator said. "He's not where he was twenty-five years ago, and he couldn't put himself in that zone. At the time, I was really pissed, but now I find that point of view commendable."

Potoff stated that his change of mind was a result of seeing artists take their work from decades earlier and make brand-new pictures out of them. "Artists evolve over time," he said. "What they were thinking about, how they handle a brush, how they mix a specific color changes over time. There is one artist I can think of who took a 1950s painting, which was historically important and artistically great, and made a 2000-something painting out of it. The picture was altered for the worse and looks like a reproduction." That is a matter of personal opinion and taste, of course, but extensive reworking raises the question of veracity, if it is still dated from the 1950s. Tobi Kahn noted that when his restoration work is extensive, he has considered redating a painting something like 1983–2004 in order to make clear his ongoing involvement. (The approach, however, suggests that he worked on it for twenty years, not that it ever needed to be repaired.)

An example of this issue from the field of photography occurred after New York's Museum of Modern Art in 1996 purchased the complete set of Cindy Sherman's 1979–80 untitled film stills, some of which had been processed carelessly (resulting in severe color shifts and fading). "When people bring in an early work that's technically all wrong—it's turned silver or something—we print out another one," said Janelle Reiring, director of Sherman's gallery, Metro Pictures. For the Museum of Modern Art, Sherman herself had a photo lab reprint from negatives the entire set on better quality paper and with more conscientious processing. While the newer prints may look better, the older ones are considered "vintage" and worth more.

The question of which artwork expresses the original inspiration becomes even more poignant in the art world category of digital art and new media, in which operating systems and programs are bound to change. "We tell artists that works must be upgradeable, compatible with newer technology," said Tamas Banovich, coowner of Manhattan art gallery Postmasters. New media, which is viewed as antiobject, suddenly becomes very material when seen as updatable hardware and software.

Artists are not chemists and may not be knowledgeable about the chemical properties of the materials with which they are experimenting. Nowadays, they are unlikely to learn anything about mixing their own paints, or even what is inside a tube of paint, in art school. Still, many artists will experiment with their materials to the potential detriment of their work's ultimate longevity. A large number of Andrew Wyeth's paintings developed considerable flaking, for instance, because the artist made mistakes mixing gesso and egg tempera. There have also been many problems with paintings by Willem de Kooning because of the artist's mixing of safflower oil and other materials with his paints. De Kooning wanted to make his medium buttery and sensuous, but that combination made it difficult for the paint layers to dry.

In addition, many artists do not see themselves as creating works for posterity, which is more a concern of the marketplace than the studio. The work reflects the moment of experiment and creation. Mexican muralist David Alfaro Siquieros and French cubist Fernand Léger both painted on burlap sacks. Chagall made designs on bed sheets, and Franz Kline, chronically short on cash, used house paints and occasionally worked on cardboard. Their intention was to achieve different textures without regard, it seems safe to say, for future conservators and collectors. Robert Rauschenberg is one who "didn't take any particular pains with a lot of his earlier pieces. He just stuck things on with glue," his biographer, Calvin Tomkins, said. "At that time, he felt that the work itself is ephemeral, and that it's the process that is important. I don't think he feels that way now. He has a lot of people working for him now who make sure things are put together right." Among the more problematic Rauschenberg pieces are a silkscreen painting called *Sky Way* (created originally for the 1964 World's Fair and currently in the Dallas Fine Arts Museum), whose screening has flaked off, and the stuffed goat in the inner tube called *Monogram*—probably his most famous piece—which has attracted (among other things) lice.

Experimental use of materials and haphazard techniques tend to be the province of younger artists; eventually, those with longer careers look for more stable processes of artmaking. "It is not very pleasant to always be confronted with clients coming back with artworks needing repairs," said conservator Christian Scheidemann. He noted that part of his work on contemporary art involves visiting artists' studios to learn how they

have worked and to "consult with the artist to improve his technique, if he is interested."

Two issues face artists and dealers in exhibiting drawings, and they are sometimes treated as mutually exclusive: the first is how to use frames in such a way as to present drawings as substantial and complete-in-themselves works of art—like paintings—which can become a particularly perplexing problem when these often pale and delicate works are displayed in the same room as frequently larger and more colorful paintings; the second is how to mat and frame drawings in a manner that will protect them from moisture, excessive light, and a host of airborne pollutants.

Giving Artworks a Name

In 1871, James McNeill Whistler painted what would become his most famous work, which he titled *Arrangement in Grey and Black* and submitted the following year to the Royal Academy of Art in London for its 104th exhibition. Both members of the Royal Academy and the British public were unhappy with the work—the Academy came close to rejecting the painting (Whistler never again submitted a work for approval to the Academy), and the public was uneasy with a portrait described solely as an "arrangement" of colors, wanting more of an explanatory title. As a result, Whistler appended the words *Portrait of the Artist's Mother* to the *Arrangement* title just for this exhibition, although that name stuck, and the painting has come down to us by the more popular *Whistler's Mother*.

It is rare that an artist is so demonstrably thwarted in the attempt to describe and title his work ("Take the picture of my mother, exhibited at the Royal Academy as an 'Arrangement in Grey and Black,'" the art-for-art's-sake Whistler wrote in his 1890 book *The Gentle Art of Making Enemies*. "Now that is what it is. To me it is interesting as a picture of my mother; but what can or ought the public to care about the identity of the portrait?"). However, the incident shows the degree to which a name matters to people who will see and perhaps buy the piece.

Most titles tend to be quite straightforward. "I name the subject matter, if it's a still-life or a landscape," said painter Sondra Freckleton. "Its name is what it is. It's like naming puppies: you see how they behave, and that's what you name them." Most representational artists do the same with an occasional exception of a title that alludes to some event

(for instance, Manet's *The Execution of Maximilian*, which was indebted to Francisco Goya's earlier *The Third of May, 1808*) or line from a poem (the titles of African-American artist Whitfield Lovell's paintings are often fragments from jazz songs, which may have inspired them) or one that is witty, such as Debra Bermingham's 1992 painting within a painting of two human figures with a landscape in the background amidst images of a butterfly and a postcard titled *You Might as Well Choose Your Wife with a Buttercup*. "I always try to impart to the viewers something more than just a literal transcription of what they can see," Bermingham said. "The title asks them to free-associate."

Representational art would appear to have far less need of a descriptive title than most forms of nonobjective art; there seems little need for a landscape to be titled *Landscape*. From an aesthetic point of view the title seems redundant. However, viewers generally seek some idea of what is going on from the title in ways they do not when the work is abstract. "If the title is obscure or there just is no title, people often ask what they are looking at," according to Bridget Moore, director of New York's D. C. Moore Gallery. Abstract art, on the other hand, often employs a wider range of title possibilities, from *Untitled* and numbering (Robert Ryman's *Classico III* or Sam Francis's *Untitled, No. 11*) to a physical description of the artwork (Dorothea Rockburne's *Drawing Which Makes Itself* or Ellsworth Kelly's *Orange and Green*) and titles that may mean something only to the artist (Brice Marden's *The Dylan Painting* or Frank Stella's *Quathlamba*). Regardless of the style or subject matter, the length, obscurity, or descriptive nature of a title does not seem to make a difference to collectors, Moore stated. "It's how it looks on the wall that counts."

Titling art establishes an artist's control of it, yet giving a name to a work of art is, historically, a relatively recent phenomenon, and it is even more recent that artists provide the title. For instance, Giorgio Vasari, in his *Lives of the Artists*, published in 1568, makes reference to a variety of paintings and sculpture by their creators, subject matter, location, and patrons, but the actual artworks have no separate names. Titles may not have been deemed necessary when biblical or mythological scenes were depicted—*Madonna and Child* or *The Resurrection*—that everyone knew, or when the work was a portrait: Leonardo da Vinci never referred to *La Gioconda* or, as it better known in the English-speaking world, the *Mona Lisa*.

No one actually knows when titles by artists became standard practice. It may be assumed that artists would begin furnishing their own titles when they started producing artwork independent of patrons or sold by art dealers, a situation that developed in seventeenth-century Holland. However, according to several European art curators at the Metropolitan Museum of Art in New York, there was basically no such thing as giving titles to their works in Holland at this time. Inventories gave descriptions of what the compiler saw, and the titles of secular works were usually generic (such as "still-life," "merry company," "landscape with figures"). An exception is Vermeer's *The Art of Painting* that was called so by the artist's wife shortly after his death.

Some titles refer to the location of the piece (Van Eyck's *Ghent Altarpiece*, for example) or are simply descriptive, such as Alfred Sisley's *Still Life: Apples and Grapes*, which he painted in 1876, four years before Claude Monet painted his own *Still Life: Apples and Grapes*. Neither artist ever recorded such a title in his letters or diaries, so it is unclear where these names came from; it is very likely that a dealer or collector provided the title.

San Francisco art dealer John Pence noted that he will regularly "interject suggestions" when artists bring in untitled pieces. "Certain words come up when I see a painting." He added that "sometimes 'untitled' is a perfectly good title, but in general I don't think it's a good solution. And, if artists use it too frequently, it can be a serious bookkeeping problem for the gallery in keeping track of what has been sold to whom."

At times, Pence will suggest a change in a title where the artist has used words improperly or unwisely ("it shows ignorance") or add to a title when it might be more specific. Instead of just saying "Portrait," Pence recommended naming the subject; in a landscape, the particular locale would be mentioned. "It doesn't hurt to say Yosemite rather than just a geyser." Again, he claimed that the value of specificity was to the artist and dealer, rather than to the collector, who generally doesn't care what the work is titled.

Artists are also creatures of habit who may pursue the same or similar subject in a number of works but need titles that differentiate between them. "Jacob Collins uses the same titles again and again," Pence said. "I tell him, 'Maybe you should call this one *Vanitas 3*.'"

Permits and Licenses

There are a variety of licenses and permits that artists may need to obtain when operating a business and, especially, when putting objects for sale in public spaces. The most basic of these is a business license, especially if the business is likely to attract notice, such as by increasing traffic (collectors, employees, suppliers) or noise (machinery) and if it is located in a residentially zoned area. A town's planning or zoning office will determine whether or not the business violates zoning restrictions and, if so, that a variance might be granted, assuming the business does not disrupt the essential character of the neighborhood.

State departments of revenue offer seller's permits (sometimes called certificates of resale) that stipulate the sales tax to be charged and how it will be recorded and remitted.

Ordinances regulating the size, location, lighting, and character of signs exist in many municipalities; these should be checked in advance of someone designing and installing a sign.

If flammable materials are used in the business—a torch for welding, a kiln for potters—a permit from the fire department may be required, or unannounced work site visits may be mandated. Additionally, if materials are burned or substances are discharged into the sewer or other waterway, approval from the state environmental protection office may be required.

Sidewalk Ordinances

In the movie *Mary Poppins*, everyone was charmed by Bert, the chimney sweep, kite seller, and sometime artist whose sidewalk chalk pictures opened up into adventures. Real life artists, however, often find that the world offers them and their work a quite different reception when sidewalks are involved. Drawing on a sidewalk generally is viewed as a form of defacement, comparable to graffiti and punishable by fines and imprisonment. (A sample ordinance by the City of Pineville, Louisiana, states that "it shall be unlawful for any person to write upon, paint signs upon, advertise upon, or in any other manner whatsoever, deface the sidewalks or streets within the city"—art and advertising are viewed as one and the same.)

Artists who look to sell their work on sidewalks or in parks may find that the world is only slightly more tolerant and often just as willing to threaten fines or jail terms. (For instance, the ordinance in Hattiesburg, Mississippi, states: "It is hereby declared to be a public nuisance and it shall be unlawful for any person to solicit, accost or canvas persons on the streets or sidewalks of the city for the purpose of selling any books, wares, merchandise or articles of any description. Such practice is hereby declared to be obnoxious to the personal rights, convenience and privileges of the public and is further declared as impeding orderly traffic the streets and sidewalk.") In some instances, storeowners are the ones who complain the loudest, saying that they have to pay real estate taxes and should not have to compete with sidewalk vendors who don't. Some city leaders liken street vending and performances to panhandling, disturbing the peace, and generally blocking traffic. In Portland, Maine, the main objections to artists selling in plein air appeared to be safety—an easel, table, or display rack could hamper pedestrians, forcing walkers onto traffic-filled streets—and liability, in the event of someone tripping over an easel. Some artists were fined, while painter Ian Factor was told by Portland police to "move along." He actually had not been selling work but had set up his easel on a sidewalk outside his studio in order to paint a scene of some nearby street musicians when police confronted him with, "'You have a permit for that?' I said to them, 'This is a joke, right?'" It was no joke: city fines for placing a table, chair or—in this case—an easel on city property, such as a sidewalk, without a permit range from $50 to $500, and the cost to obtain such a permit is $225.

Selling artwork on a sidewalk or in a park is not for every artist. "Given the choice, artists would prefer to sell their work in a gallery than on the street," said Andy Frankel, executive director of Philadelphia Volunteer Lawyers for the Arts, "but it is an option that does come up." It is the preferred manner of selling for New York City mixed media artist Robert Bery, who noted that "selling on the street is sometimes equivalent to a good outdoor art festival. Sometimes, you can be at a good festival, but no one is buying anything." He noted that his income from sales is good, "I pay taxes, I have an accountant," and he doesn't need to split the selling price with a dealer.

The issue of whether or not artists need permits to sell their work on the streets has been popping up with increasing frequency all over the

United States, including Boston and Cambridge, Massachusetts; Saint Augustine, Florida; Salt Lake City, Utah; Hollywood, San Diego, and San Francisco, California; Portland, Oregon; and Seattle, Washington. Dozens of "street artists" were arrested in New York City during the 1990s as part of then-Mayor Rudolph Giuliani's campaign to improve the city's quality of life, but a number of them—including Robert Bery ("I was arrested quite a few times")—brought lawsuits against the city. In 1996, the US Court of Appeals ruled in his favor, claiming that the constitution's first amendment not only protects the right to create art, but the right to sell it. "Furthermore," the court held, "the street marketing is in fact a part of the message of appellants' art. As they note in their submissions to the court, they believe that art should be available to the public. Anyone, not just the wealthy, should be able to view it and to buy it. Artists are part of the 'real' world; they struggle to make a living and interact with their environments. The sale of art in public places conveys these messages." The court also found that New York City issued new permits to street vendors rarely, requiring applicants to get on a waiting list that was backlogged fifteen years or more, resulting in a restraint of trade.

The Maine affiliate of the American Civil Liberties Union, which took on the cause of Ian Factor and other Portland artists, also has called the requirement for street artists to have permits unconstitutional. "Selling art is different from selling hot dogs," said Zach Heiden, the civil liberties union lawyer. "There are legitimate health concerns in the sale of food, like hot dogs, requiring licenses and inspections. However, there is no reason ever for an artist to get a license. The courts have clearly held it to be a restriction on first amendment rights." However, while the decisions in those courts—in New York City, as well as in Hollywood, California, and Saint Augustine, Florida—may prove influential, their rulings only apply to the specific municipalities and provide no precedent elsewhere. The large number of artists residing and working in New York City, and the degree to which their presence adds to the city's overall economy, may well have prodded a judge to rule in their favor, according to Sean Basinski, director of the Manhattan-based Urban Justice Center's Street Vendor Project. "Most cities are far behind New York on this issue," he said. "They consider unlicensed vending by artists a crime."

Artists who seek to challenge civic codes requiring them to obtain a permit would have to be prepared for the time and expense of a multiyear-long legal process, the outcome of which is uncertain. Many of the street vendor statutes around the country were enacted back in the nineteenth century, and they contain language ("pushcarts," for instance) that suggests they are still planning for hurdy-gurdy men. As a practical matter, Basinski noted, artists should look to obtain whatever permits are required of other vendors. "If there is nothing on the books, you should probably get written permission from someone, because the police may just decide to hassle you," he said.

The cost of these permits and where they may be obtained is different in every city, and there could be more than one agency per municipality that issues licenses. The parks department, for instance, may be in charge of public parks, while the police control vending on city streets. Those wishing a permit to sell nonfood merchandise in Richmond, Virginia, are required, first, to obtain approval for a specific site by a tax enforcement officer of the city's department of finance; second, purchase a $300,000 liability insurance policy that names the city as coinsured; and third, pay a $225 fee to the city's license and assessment division. In the city of Syracuse, New York, permit applications must be sent to both the department of public works and the police department (the cost is $20 for one day, $50 for one month, or $100 for one year), while the offices of the city clerk in Lincoln, Nebraska, and the town manager in Brandon, Vermont, receive applications for sidewalk vending, and each charges a flat $100 fee. In general, city hall is probably the wisest starting point for information on where to obtain an application, the cost, and restrictions on vending sites and activities.

Artists looking for information may also contact the municipal arts agency, nearest chapter of the Volunteer Lawyers for the Arts organization, or a local arts organization. "You want to find out what other artists are doing," said Jamie Bischoff, a lawyer who works with Philadelphia Volunteer Lawyers for the Arts. "Maybe there is a law on the books that works to the disadvantage of artists, but no one enforces it. Maybe there is a law that needs to be changed, so artists might want to join forces and find a lawyer who will take the case on a pro bono basis or even contact the ACLU."

Municipalities may legitimately restrict street vending to a certain section of the town and specify the hours of the day that the activity is

permitted to take place—usually, no earlier than seven in the morning and no later than eleven in the evening (licenses often define acceptable behavior by the permit holder). The municipal code in Anchorage, Alaska, limits vendor sites to no longer than ten feet and no higher than six feet from the sidewalk, and they must be separated from any other vendor by at least ten feet; the permit from the city and a certificate of insurance must be visible at all times. In addition, the vendor cannot set up within fifty feet of "a business that traditionally sells the same goods or services that may be offered" by the vendor. For most municipalities, because of concerns of crowding, the number of permits that a city allows may be limited, and the determination of who receives a license may be decided by lottery or on a first-come, first-served basis.

Most sidewalk vending ordinances divide permits in terms of food and nonfood sellers, and it is the rare regulation indeed that identifies artwork specifically as an acceptable type of goods. City officials may not determine which artist vendors receive permits based on the content of their work, although art deemed offensive or disturbing is likely to be barred with little reference made to who might find the work disturbing. As an example, the relevant ordinance of Salt Lake City refers to the problem of artists "creating visual blight and aesthetic concerns," while any sound system used by a street vendor in Phoenix, Arizona, "shall play only pleasing melodies." (Call out the American Civil Liberties Union again?) Trickier still is the issue of what types of art will be allowed. Usually, municipalities prefer original art—paintings, sculpture, and handmade crafts, for instance—and shy away from graphic or photographic prints, posters, and images on T-shirts. However, two New York City graffiti artists, Christopher Mastrovincenzo and Kevin Santos, won their lawsuit in 2004 against the City of New York after the department of consumer affairs refused to issue them a permit to spray-paint blank baseball caps (charging between $10 and $100 per hat) from a sidewalk stand. "Civilization," the US district court judge wrote in his decision, "has traveled too far down the road in the evolution of art as embracing the whole spectrum of human imagination for the law to countenance a classification of an artist's design as art only when imparted in conventional shapes and forms sufficiently familiar or acceptable to a government licensor."

City officials around the country remain of two minds on allowing artists to sell their work—or, in the case of musicians, to perform—on

the streets. They are reluctant to open the door to unruly behavior, noise, tax evasion, and littering (as a result of terrorist threats, the City of Boston sought to eliminate musicians in subway stations, worried that their music would drown out important messages, but then were convinced that the trains themselves were much louder), yet urban planners are consistently promoting the value of having artists in public spaces as a means of livening up otherwise lifeless city streets. This newer attitude may be found in city council resolutions in Salt Lake City ("It is in the public interest to enliven and increase commerce and create a festive atmosphere in the downtown area and in City parks by encouraging artists and entertainers to express themselves on the sidewalks and in the City parks"); Cambridge, Massachusetts ("The existence in the City of street performers provides a public amenity that enhances the character of the City"); and wherever the courts decide that artistic expression is different from the sale of hot dogs.

Getting Art Supplies through Airport Security

There Daniel Greene stood, waiting to board an airplane at the Dallas airport, while a security official pawed his carry-on box of pastels, wondering if they were colored bombs. "She didn't know what pastels were and, because of that, I almost missed my plane," Greene, an artist in South Salem, New York, said. "The only satisfaction I got was that she had to wash her hands when she was done."

This odd scene actually occurred pre-September 11, 2001; since then, people have lost much of their sense of humor about air travel, and worries about what is being taken aboard have increased markedly. Tightened airport security since the terrorist attacks has changed the way US passengers have been accustomed to flying, including arriving two hours before departure and enduring lengthier preboarding searches to the elimination of curbside baggage check-in and more rigorous enforcement of luggage weight allowances. Airport security guards are now employees of the federal government, rather than the airlines or airports: their watchfulness is greater, and their procedures are more consistent around the country. The lengthier process of boarding an aircraft has been offset by the higher level of protection that passengers now enjoy.

The tricks that used to work no longer do: regularly flying around the United States to lead workshops in portraiture, Daniel Greene used to take three boxes with paints, pastels, paper, canvas, boards, extension cords, palette knives, brushes, stands, spotlights, turpentine, and videocassettes as his flight luggage. "I had them checked curbside," he said. "They were always considerably over the weight limit, but I tipped the baggage handlers lavishly so they wouldn't hassle me. You can't get away with that anymore." Airline officials are much stricter in adhering to package and luggage guidelines: passengers may take only two bags, weighing no more than fifty pounds apiece for domestic flights or up to seventy pounds for international trips. Beyond that weight limit, one may be required to pay substantial penalties or not be able to take the packages at all. These days, Greene ships these materials ahead of time by Federal Express, paying between $150 and $160 each way.

In this new world, some fine artists have found seemingly harmless materials removed from their bags by airport guards. "Artists call me: they've had their paints confiscated, and they are very upset," said Joe Gyurcsak, a painter and brand manager at Utrecht, the art supply manufacturer and store. Artists have also called or emailed Robert Gamblin, president of Gamblin Colors, a paint supplier, with similar complaints, "and this is probably just the tip of the iceberg." He noted that an artist typically takes a paint box as part of carry-on luggage. "The security person asks, 'What is this?' and the artist says, 'These are my paints,' and that triggers the problem." Gamblin explained that "paint" is a hot-button word for security agents, since it is described as a hazardous, combustible material by the federal Transportation Security Administration. "The word 'paint' never appears on our products," he said. "They are called 'Artist Colors,' which is how artists should refer to them."

Safer yet (at least from the standpoint of getting on board) is to check paint boxes and all other art materials with regular luggage. Those artists who need to keep their art supplies close at hand ("My paint box is very fragile," portrait artist Ray Kinstler said) should remove any palette knives, regardless of how dull the edge.

Changes in airport security have had an effect on how artists travel and what they take along. Kent Ullberg, a sculptor with studios in

Colorado and Texas, used to buy two tickets for flights, one for himself and the other for the seat next to him, in order to have a safe place for the box containing the clay model (or maquette) of whatever public artwork he was taking either to a presentation or to a foundry for enlargement. "Clay is very fragile," he said. "I want to keep it upright; I want to keep my eye on it. If you check it through with luggage, it gets thrown around and put on its side." Pre-September 11th, Ullberg would just take the top of the box off for a security official to peer inside and then get passed through. Since then, he has been required to stow the work with luggage, forcing him to triple box his models—a foam-packed box holding the maquette inside a foam-packed box inside yet a third foam-packed box—or to save on the hassle and just drive the piece himself.

Ray Kinstler, who lives in New York City, has also taken to driving more or taking Amtrak to Boston and Washington, DC, where he regularly travels for presentations and commissions. "Trains are much simpler," he said, "and you don't have to worry about any type of security." Prior to September 11th, Kinstler used to take a dozen flights every year, but now "less than half that number." When he does travel by air, Kinstler increasingly leaves his paint box at home and takes a sketch pad and charcoal or a lighter weight watercolor set in order to make visual notes.

Yet another response to the difficulties of transporting art for presentations is to not travel it at all. Dan Ostermiller, president of the National Sculpture Society, stated that "I don't transport maquettes anymore" and, instead, presents models through photographs or, digitally, by visual attachments to email. "It's not the same as a three-dimensional presentation," he noted, "but people can get a pretty good idea."

Regardless of hassles, artists traveling overseas or across vast distances in the United States are likely to take airplanes, and the watchword for them is to travel light and ship certain items ahead—such as by United Parcel Service or Federal Express Ground (if the items are combustible, such as solvents, fixatives or turpentine, and are not permitted on aircraft)—or to purchase needed materials where they are going. "Most of the places I go to will have an art supply store, if it's a city of any size," said New York artist Richard Haas. "If it's a small town, there may be a problem. The secret is, don't do things in small places."

Artists, of course, may want to use the supplies and materials with which they are most familiar, rather than hope to find the same or similar wherever they are traveling. A problem with shipping materials ahead may include rough treatment, extremes of cold storage (if acrylic paints freeze and then thaw, they become difficult to use, turning stringy and not workable with a brush), or intense heat. Ostermiller noted that he won't ship wax models during the summer. "If they stop somewhere along the way, the whole thing can melt," he said. As a result, he will "overnight everything to the locations I am going to." Combustibility can be an issue for certain items, such as solvents, which spontaneously ignite if the temperature rises to 140 degrees Fahrenheit, the federal limit for transporting inflammable materials by air. Joe Gyurcsak stated that Dorlands Wax Medium, an oil paint additive, has a "flash point" of just above 100 degrees, while linseed oil is safety rated to 550 degrees.

A list of prohibited items for air travel can be found on the website of the Transportation Security Administration (www.tsa.gov). Robert Gamblin suggested that artists obtain and bring with them Material Safety Data Sheets, the manufacturer's description of the product, and recommendations for safe and proper use. Below is the safety data sheet for Gamblin's refined poppy oil, which includes the fact that the material will not combust below 400 degrees.

```
MATERIAL SAFETY DATA SHEET

Manufacturer's Name: GAMBLIN ARTISTS COLORS CO.
PO Box 625
Portland, OR 97207
503.235.1945
Product: Refined Poppy Oil
```

SECTION 1—PRODUCT IDENTITY

```
Date prepared: 9/01/98  Emergency telephone no.
503/235-1945

Preparer's Name: R. Gamblin   HMIS Information
```

```
Health              0
Chemical name:     Vegetable oil   Flammability      1
Reactivity          0
Chemical formula: N/A
DOT shipping class: Class III Combustible
```

SECTION II—HAZARDOUS INGREDIENTS

```
Chemical names  CAS#  Wt%  OSHA PEL  ACGIH TLV
                                    68956-68-3
None
```

Is not hazardous under the Department of Labor definitions.

SECTION III—PHYSICAL CHARACTERISTICS

```
Boiling range:  N/A
Vapor pressure: N/A    % volatile (volume): 0
Vapor density:  N/A    Evaporation rate (BuOAc=1): N/A
```

Solubility (specify solvents): Insoluble in water.
 Soluble in most petroleum solvents.
Appearance and odor: A pale yellow, oily liquid.

SECTION IV—FIRE & EXPLOSION DATA

Flash point: >400 degree F
Extinguishing media: CO_2, dry chemical
Special firefighting procedures: water or foam may
 cause frothing if directed into container of
 burning material. Use water to cool containers
 exposed to heat.

Unusual fire & explosion hazards: contaminated rags
 or other easily ignited organic materials are

spontaneously combustible. Immerse in water after use.

Reactivity: product is stable

Hazardous polymerization: will not occur

Conditions to avoid: avoid extreme heat

Hazardous decomposition products: None

Usual products of combustion: CO, CO_2, and possibly acrolein.

SECTION V—HEALTH HAZARD DATA

Route(s) of entry: Eye contact, ingestion of paint

Acute health effects: Eye contact may cause redness or irritation

Inhalation: N/A

Ingestion: No known adverse health effects

Excessive inhalation of oil mist may affect the respiratory system.

Oil mist is classified as a nuisance particulate by ACGIH.

EMERGENCY FIRST AID PROCEDURES:

Eye contact: wash with clean water for at least fifteen minutes. If irritation persists, get medical attention.

Inhalation: N/A

Skin contact: Sensitive individuals may experience dermatitis after prolonged exposure to oil on skin. Wash skin with soap and water.

CHRONIC HEALTH EFFECTS:

Not listed as a carcinogen by the NTP, IARC, or OSHA; no adverse long-term effects are known.

No known adverse health affects to poppy oil.

SECTION VI—SPILL OR LEAK PROCEDURE

Spills of this material are very slippery. Cover spills with some inert absorbent material and scoop into container.

Wash floors with detergent or soap and water and rinse with hot water.

Steps to be taken in case material is spilled: remove all sources of ignition. Soak up spill with absorbent materials.

Waste disposal method: Rags and absorbent materials should be immersed in water. Small amounts can be dried and disposed of as ordinary trash.

SECTION VII—SPECIAL PROTECTION DATA

Respiratory protection: none normally required
Ventilation: none normally required
Protective gloves: none normally required
Eye protection: safety glasses if eye contact is likely; eyewash fountain should be accessible.

SECTION VIII—STORAGE & HANDLING DATA

Precautions to be taken in handling and storage: store away from high temperature, sparks, or open flame. Read and observe all precautions on product label.

Other precautions: wash hands after use. Immerse contaminated rags in water.

In general, Gamblin added, artists should "keep your cool" around airport security and "seem to know what you're doing. If there is any question about what you're bringing, show them the Material Safety Data Sheets and explain that you are going on a painting holiday."

Disaster Preparedness

If people chose where to live based on the likelihood of natural disasters, few would choose to settle the earthquake-prone West Coast or the hurricane-plagued Gulf Coast and Carolinas. However, California and Florida are the first and fourth most populous states, with tornado-alley Texas coming in second. Clearly, people are willing to take their chances with the environment, and their collections will have to suffer along.

Suffer, but not necessarily perish, if a disaster strikes. There are a variety of precautions that homeowners may take to mitigate the potential for damage.

Floods

No matter how well sealed the basement, artwork should never be stored or placed below ground level, especially for those living in flood zones. Even on the first floor, all artwork (such as sculpture) should be elevated at least twelve inches off the floor. Similarly, because flooding usually is accompanied by power outages, backup generators (that may power smoke, humidity, and break-in alarms) also need to be sited above the highest expected flood level.

Individual artists in New Orleans certainly learned some of these lessons seven years earlier during that city's devastating Hurricane Katrina. "I was very fortunate," said New Orleans sculptor Lin Emery, whose studio and most of her sculpture and sculpture-making equipment were submerged in five feet of water by Katrina. Luckily for her, at the time of the storm, Emery's most recent work was on exhibition at the city's Arthur Roger Gallery, which is located in New Orleans's Warehouse District and was spared significant flooding or even a lengthy power outage. Lucky for her, too, her show sold out within the first week and none of the buyers reneged on their purchases. She also deemed herself fortunate in the fact that, although her studio was lost, her house is located elsewhere in the city and only suffered relatively minor wind damage to the roof.

Another New Orleans painter, Alan Gerson, discovered that there were six and a half feet of water in his studio following the breaching of the levees, resulting in the destruction of five paintings. However, another thirty paintings were only damaged and reparable ("Down here,

we call the water marks 'Katrina patina,'" he said), and he has stamped all those works on the back with the letter "K" to indicate which pieces had suffered. Additionally, there were a number of other artworks stored on racks just above the water line that came out unscathed.

Like Emery, Gerson's studio was located in the downtown, called MidCity, away from his house, which only suffered wind damage. Like Emery, too, he did not have any insurance on his studio, suffering a loss of perhaps $20,000 (Emery had no insurance on her equipment, although she had some coverage for the artwork in her studio).

Quite a few art galleries in Manhattan's flood plain suffered from water damage during 2012's Superstorm Sandy, as did low-lying homes with art collections on the Jersey Shore in New Jersey and Long Island, New York, resulting in an estimated half a billion dollars in insurance claims for artworks.

"We still have a basement, but we no longer use it for storage," said Elisabeth Sann, associate director of the Jack Shainman Gallery, which had suffered extensive water damage to photographs stored below street level. The basement's current use is for "private viewings" of artwork and otherwise is mostly empty. Some ground-floor galleries in New York City moved. Jack Shainman did not, although it added two new spaces, up four blocks to an address where there are "antiflooding valves" and at a 30,000-square-foot converted schoolhouse in Kinderhook, New York, where there are exhibitions and where almost all the gallery's inventory will be stored.

Katja Zigerlig, manager of the fine arts department of the insurance company AXA, recommended creating a protective storage area in one's home, such as a closet. In this closet might be waterproof crates, plastic wrap, and moisture-absorbing materials—paper towels, cotton rags, or the higher efficiency products that museums keep on hand and that they purchase through laboratory supply companies.

Flood coverage is usually an exclusion on homeowners insurance policies, but most homeowners and renters may purchase additional protection against flood-related damage from one of the eighty-six companies offering this kind of insurance through the federal government's National Flood Insurance Program (www.fema.gov/national-flood-insurance-program). The average annual premium is $300, providing approximately $100,000 in coverage. The maximum coverage one may purchase is $250,000.

Hurricanes

Similar to floods, hurricanes deposit a considerable amount of water on and around a house, and all of the same types of precautions apply to them as to floods. A hurricane, however, is also characterized as a windstorm that may blow a tree onto one's roof, blow the roof off the house, and send projectiles (mailboxes, lawn furniture, tree branches) through the windows. Well before hurricane season, one should trim all tree limbs that overhang a roof, "and you might want to get a tree service in to see if any parts of the tree are weak and likely to snap off in a storm," said Thomas Blanchick, director of the Williamstown Regional Conservation Center in Massachusetts. The roof itself should be securely attached to the walls by special brackets that are designed to withstand up to 150-mile-per-hour winds; each tile in a slate roof should be individually secured. Any outdoor sculpture should be bolted to a cement base and stand apart from any trees. There is usually enough warning before a hurricane strikes to allow time to bring lawn- or pool furniture indoors.

Besides the roof, windows tend to be the weakest areas of a house, but there are ways to make them less vulnerable. Traditional, colonial louvered shutters may serve as a barrier, although most of these shutters are purely decorative rather than functional. Nailing a sheet of plywood over a window frame will work; however, because they are bulky, numerous sheets of plywood are not easy to store, and there is likely to be a long line at the hardware store for plywood as soon as a hurricane watch is issued (with the possibility that the store will run out). Additionally, in one's haste to nail the boards on, some may not fit well and allow damage to occur.

There are various types of hurricane glass and hurricane shutters that one may purchase. This glass, which is a sandwich of glass and plastic, may crack when hit by a projectile but not shatter, similar to a car windshield. Hurricane shutters are made of wood or metal, and certain types are rolled down from above a window or folded up accordion-like and stored on both sides of the window. There are also metal removable panels that can be hooked into place.

Some homeowners' policies regularly cover hurricane damage, while others require a separate rider—usually a 15–20 percent increase on the regular insurance premium. Deductibles also vary, from 1 to 5 percent (the highest for houses right on the water).

Earthquakes

Whereas there is usually some notice before a flood or hurricane takes place—allowing time for buying food, boarding up one's house, or evacuating—earthquakes are not predictable. "You never have time to prepare," said Scott Reuter, a former preparator at the J. Paul Getty Museum in Pasadena, California, and now a private consultant to insurance companies, museums, and art-collecting homeowners. "You have to be prepared for it to happen every day." He noted that new homes should be built, and older homes retrofitted, to the most stringent earthquake codes. Unlike hurricanes, however, protecting the outside of the house cannot substitute for securing the art within the home. "It would be a shame if the building withstood a quake but an art collection did not."

Wall-hung art should be placed on two hooks, rather than one—in the event that one hook fails—which are rated to hold double the weight of the artwork. (The hardware stores where one purchases them has them sorted by carrying weight.) The hooks should also be connected to the wall studs, and the picture wire should be braided, rather than a single strand, and also rated for twice the weight. Pictures are usually attached to the wire by eye-screws in the back of the frame, sited at the upper fourth or third of the piece. In the event of an earthquake, however, the lower part of the picture is likely to swing out and knock against the wall one or more times. Reuter recommended also attaching a wire connecting to an eye-screw at the bottom of the frame to a screw in the wall as a way of cutting down on movement.

Sculpture poses a more difficult challenge, since it is rarely affixed to a wall. If the piece is hollow, one may place a metal mount inside, which is secured to a pedestal or the floor; additionally, many bronzes have screw holes made by the foundry, enabling the piece to be attached to a base. It is also possible to drill a hole into the nondecorative base of a marble sculpture, permitting it to be screwed into a base. Smaller pieces may be "glued" down to a surface by means of what is called museum wax, which is available at many hardware stores. This is removable, although not easily. Sculpture pedestals might also need to be attached to the floor or held in place by restraints.

The downside of these solutions is that drilling a hole into a work of art or attaching a hard-to-remove wax at the base has the potential of

lessening the value of the art. Some waxes also may leave a permanent stain on the base of a wooden sculpture.

As with hurricanes, insurers of homes in earthquake zones regularly require separate riders, costing between 15 and 20 percent of the normal homeowner premium and requiring a 2 percent deductible.

Tornadoes

The bad news about tornadoes is that, first, one may only have an hour or two's notice, and, second, there is practically nothing one can do to secure an art collection or the house itself against the high winds and flying objects. Taking valuables (and oneself) down to the basement is one's only recourse. Tornadoes are most prevalent in the Plains states, since they need wide expanses of flat land for the two air fronts to meet. Hills get in the way of this process and lessen the chances of tornados forming.

Lessons (to Be) Learned

If Superstorm Sandy presaged some consequences of global warming on coastal areas, it also changed the "insurance climate," according to Nicholas Reynolds, vice-president of Berkley Asset Protection, one of the main providers of insurance coverage to Manhattan art galleries. "Premiums have gone up for all galleries, but most of all for ground-floor galleries in Chelsea, 20, 25, or 30 percent." He added that "no one is providing flood insurance" for galleries using their basements for storage, and galleries that have not developed a disaster preparedness plan "may receive a policy but one that excludes coverage for floods."

An acceptable disaster plan, he and others in the insurance field noted, includes specific procedures for getting valuable artworks and other valuable property to safe locations (upstairs or to an art storage facility), staff training, emergency supplies (such as fans, mops, brooms, storage bins on wheels, and gasoline-powered generators) on hand, and a list of contact numbers (for security alarm services, utility companies, and one's insurance broker, as well as gallery staff). "Sandy is now a benchmark," Reynolds said.

A disaster plan details what actions the gallery is to take when a hurricane warning is announced in order to protect artwork and other property, allocate specific responsibilities to various gallery staff, and indicate

how damaged objects are to be treated in order to begin the restoration process. "Do you freeze wet works on paper? Should you try to dry out a wet canvas?" said Claire Marmion, president of the Haven Art Group, a privately held fine art claims adjustment and management firm who has led disaster planning workshops for art galleries and fine art storage facilities. "We call this 'triage,' creating a plan so that within the first twelve to twenty-four hours you can start to make things better."

William Fleischer, an insurance broker with Bernard Fleischer & Sons, which works with a number of Chelsea art galleries, stated that a growing number of policies are written with "stop limits" or caps on the amount of damage that an insurer will cover. Lowering the cap by 25–50 percent may keep the insurance premium from rising. "Galleries have realized the value of risk management and risk tolerance."

Disaster plans are being required by insurance carriers not only of commercial art galleries, but increasingly, also of private collectors with significant holdings. In short, they identify the worst problems that may occur and what to do about them. They may be developed in-house or with the help of an outside consultant (cost: $200 per hour). Among the key elements of such a plan is that it be in writing and kept on hand at the gallery, "in order that people there can reach for it to understand what they are supposed to do now and later on," Claire Marmion said.

- Specific tasks—such as who contacts the storage facility site and who assesses damage to artworks and other property—should be assigned to individual staff members, and there should be training and periodic practice sessions.
- It makes sense to ask for suggestions from one's insurance carrier for an effective plan to protect artworks.
- Develop a system by which staff will be able to communicate with one another in the event of power outages and downed telephone lines (Crozier Fine Art, a company that operates a series of fine art storage facilities in New York, New Jersey, and Pennsylvania, used shortwave walkie-talkies).
- Pay attention to hurricane warnings and take action immediately (the mayor's office in New York City issued a warning 72 hours in advance of the arrival of Hurricane Sandy, as did insurers of artworks).

- Purchase emergency equipment in the event of a power outage, such as a portable generator and flashlights, as well as extra wrapping and packing material for a large number of objects that might need to be moved quickly. (Cost: several hundred dollars.)
- Remove all stored items from basements.
- Rent an upstairs storage area or put a retainer on a fine art storage facility outside of a flood zone. (Cost: between $2,000 and $15,000, with additional hourly expenses for the physical removal of the objects by the storage facility.)

CHAPTER 7

Legal Considerations

WHEN THE FIRST VOLUNTEER LAWYERS FOR THE ARTS (VLA) group was created in New York City in 1969, the idea was simple: Help artists and arts organizations understand their legal rights and obligations through workshops and one-on-one consultations. These VLA groups, which now exist in twenty-six states and the District of Columbia, are an information clearinghouse, most of the time providing advice on contracts and licenses, how groups should incorporate and run their organizations, and how individuals and organizations can protect their intellectual property (copyrights, trademarks, and patents). A much smaller amount of their time is helping individuals and groups resolve legal disputes, but a local VLA chapter may be an artist's first recourse when a problem arises. For good reason: at a relatively small cost—$20 or $30—artists may discuss their dispute with a practicing attorney, who will provide a legal analysis of the problem and offer an opinion on how it might be settled. That type of counseling is both the VLA's greatest strength and shortcoming, since these groups arm people with information about their rights but don't actually provide the costly legal representation to protect those rights. At times, VLA attorneys might write a letter to an offending party, threatening legal action, if some wrong was not corrected, although they are more likely to refer artists and organizations to an arts-knowledgeable lawyer who has registered with the VLA group. That lawyer would take the case at a regular or reduced fee, sometimes accepting artwork in lieu of a fee, occasionally working on a contingency basis (they are only paid out of their clients' settlement), usually requiring a retainer and charging hourly fees. Some lawyers do take cases on a pro bono, or volunteer, basis, but,

as one staff attorney for Texas Accountants and Lawyers for the Arts said, "lawyers are reluctant to get themselves in situations where they have to take time away from their paying clients." Going to trial is an expensive proposition, with court costs and a lawyer's fees (hundreds of dollars per hour, usually) that add up to thousands (or tens of thousands) of dollars. If artists had that kind of money, they wouldn't need charitable organizations in the first place. The American legal system is so expensive, time consuming, and emotionally draining that "we never recommend litigation," said William Rattner, former executive director of Lawyers for the Creative Arts, a VLA group in Chicago, Illinois.

Mediation for Artists

Recognizing this gap between free legal advice and costly legal representation, a third approach is being tried by a number of VLAs around the United States. Arts resolution services, or mediation, are being offered by volunteer lawyers groups in California, Colorado, Georgia, Illinois, Missouri, Texas, and the District of Columbia. In mediation, the two parties are brought together in order to resolve differences, if not amicably at least in a less costly manner. "Mediation is cheap, it's private, it's fast and you don't need a lawyer," Rattner said, adding that "it makes people feel better afterwards, than if they had gone through litigation or the small claims court system, and that is the whole point." That feel-better quality arises from the fact that "you get a chance to tell your story, in a more comfortable setting, just you, the other person, and a mediator. It's not like litigation, where you have to answer questions. There is a great value in just venting." In addition, the other side is able to tell its version ("some people aren't fully aware that there is another side"). Another benefit is the fact that the two sides will themselves craft a resolution and are not "reliant on a judge with a gavel."

The mediator—who may be a practicing lawyer, professional artist, arts administrator, or an accountant who has received special training in problem resolution—acts as a referee, conducting a conversation, keeping it on track, and generally trying to clear the air. Part of the mediation session involves caucuses, a form of "shuttle diplomacy," in which the mediator meets separately with one side, then the other, to determine

areas of possible agreement and generally edging both sides toward a common goal or consensus.

Not every problem or dispute can be handled through mediation. Mediation relies upon the goodwill of each side to want to resolve the matter short of hiring lawyers, through a structured conversation they enter into voluntarily. Someone who claims that "I'm reasonable, but the other guy isn't" probably would have little faith that mediation could accomplish anything. Mediation is used, and is useful, when there is a preexisting relationship that the two sides—say, a visual artist and an art dealer—want to maintain. However, it may also be the case that "people don't want to be perceived as jerks and are willing to sit down and hear the other person out," said Jane Lowry, executive director of Texas Accountants and Lawyers for the Arts. "Eighty-five percent of the time, you can get parties to mediation and, once you establish the ground rules—no interrupting, let everyone have their say—you find that empathy kicks in. Most people want to do the right thing. People will be happy with the outcome, which you never see in court."

Mediation works in this way: someone with an arts-related problem, who fits the VLA's low-income guidelines, comes to the offices of the volunteer lawyers group upset and looking for help. At Lawyers for the Creative Arts in Illinois, an eligible individual must have a household gross income under $30,000 per year, and the annual budget of a non-profit organization should be under $250,000 per year, while Colorado Lawyers for the Arts sets the baseline at $25,000 for individuals and $150,000 for organizations. A VLA staff person fills out an intake form, which describes the nature of the dispute, the type of creative work involved, and more personal information about the individual or organization. Depending upon the nature of the dispute and if the volunteer lawyers group has an arts mediation service, the individual may be put in touch with a mediator, who will attempt to bring the other party to the dispute in for a meeting. (At VLA chapters that do not have mediation programs, a staff lawyer may try to bridge the gap by making phone calls or holding a meeting or two with each side in order to find some type of resolution.) "If the problem is an out-and-out violation, like copyright infringement, that's something we would advise taking to court," Lowry said, "but if it's a people thing, such as a gallery sold an artist's work but won't pay the artist, then we recommend going to mediation."

While mediation is a less expensive approach to dispute resolution, there may be other costs. At California Lawyers for the Arts, the costs for mediation are low, set on a sliding fee scale, starting at $25 for the first two three-hour sessions; however, after two sessions, a flat fee of $150 is assessed each party. "Very often, we recommend mediation clients seek legal counsel to learn their legal rights" before entering a mediation session, said Jill Roisen, director of the California program. After a session, artists "come out of mediation with a draft agreement, and we recommend they take it to a lawyer for a review of the language and other details." Additionally, compliance with the terms of an agreement can be enforced, but that usually will take place in a court of law. In order for everything to work, disputants must want to resolve a matter quickly and painlessly and abide by the terms of their agreement. Most of the time, that is what happens, Roisen stated, noting that only 10 percent of the time do resolutions reached in mediation result in a refusal to live up to the terms by one side or the other—"people get what you might call buyer's remorse."

Below is a list of volunteer lawyers for the arts organizations around the country. In states where no such group exists, artists may contact the state bar association for the names of lawyers who handle arts and entertainment law matters, some of whom may take a case on a pro bono basis. Not every organization has a physical address or website.

California
California Lawyers for the Arts
www.calawyersforthearts.org

Wells Fargo Building
2140 Shattuck Ave., #310
Berkeley, CA 94704
(888) 775–8995

2015 J St., Ste. 204
Sacramento, CA 95811
(916) 442–6210

Fort Mason Center
2 Marina Blvd.
Bldg. C
San Francisco, CA 94123
(415) 775–7200

18th Street Arts Center
1641 18th St.
Santa Monica, CA 90404
(310) 998–5590

Colorado
Colorado Attorneys for the Arts
cbca.org/programs/cafta

789 Sherman St.
Denver, CO 80203
(720) 428–6720

District of Columbia
Washington Area Lawyers for the Arts
waladc.org

Florida
Florida Volunteer Lawyers for the Arts
www.artslawfl.org
(786) 347–2360

Georgia
Georgia Lawyers for the Arts
glarts.org

887 W. Marietta St. NW
Atlanta, GA 30318
(404) 873–3911

Illinois
Lawyers for the Creative Arts
law-arts.org

213 West Institute Pl.
Chicago, IL 60610
(312) 649–4111

Iowa
Iowa Volunteer Lawyers for the Arts
(319) 354–1019

Kentucky
Kentucky Lawyers for the Arts
www.kylawyersforthearts.org

Louisiana
Louisiana Volunteer Lawyers for the Arts

225 Baronne St., Ste. 600
New Orleans, LA 70112
(504) 523–1465

Maine
Maine Volunteer Lawyers for the Arts
http://maine-vla.squarespace.com/
(207) 619 2787

Maryland
Maryland Lawyers for the Arts
mdvla.org

120 W. North Ave.
Baltimore, MD 21201
(410) 752–1633

Massachusetts
Arts and Business Council of Greater Boston
artsandbusinesscouncil.org

15 Channel Center St., Ste. 103
Boston, MA 02210
(617) 350–7600

Michigan
Michigan Volunteer Lawyers for the Arts and Culture
www.creativemany.org

1310 Turner St.
Lansing, MI 48906
(517) 371–7029

Minnesota
Springboard for the Arts
springboardforthearts.org

308 Prince St.
Saint Paul, MN 55101
(651) 292–4381

Missouri
Kansas City Volunteer Lawyers and Accountants for the Arts
www.kcvlaa.org

PO Box 413199
Kansas City, Missouri
(816) 974–8522

Saint Louis Volunteer Lawyers and Accountants for the Arts
vlaa.org

6128 Delmar
Saint Louis, MO 63112
(314) 863–6930

New Hampshire
New Hampshire Business Committee for the Arts
www.nhbca.com

One Granite Pl.
Concord, NH 03301
(603) 224–8300

New Mexico
New Mexico Lawyers for the Arts
www.nmlawyersforthearts.org

460 Saint Michael's Dr.
Santa Fe, NM 87505

New York
Volunteer Lawyers for the Arts
vlany.org

1 E. 53rd St.
New York, NY 10022
(212) 319–2787

Ohio
Volunteer Lawyers for the Arts
Cleveland Metropolitan Bar Association

1375 E. 9th St.
Cleveland, OH 44114–1785
(216) 696–3525

Oregon
Oregon Lawyers for the Arts
www.oregonvla.org

325 NE 20th Ave.
Portland, OR 97232
(503) 768–6940

Pennsylvania
Arts and Business Council of Greater Philadelphia
artsbusinessphl.org

200 S. Broad St.
Philadelphia, PA 19102
(215) 790–3620

Greater Pittsburgh Arts Council
www.pittsburghartscouncil.org/programs/consulting-services

810 Penn Ave.
Pittsburgh, PA 15222–3401
(412) 391–2060

Rhode Island
Ocean State Lawyers for the Arts

PO Box 19
Saunderstown, RI 02874
(401) 789–5686

South Carolina
South Carolina Lawyers for the Arts
www.scvolunteerlawyersforthearts.org

Tennessee

Arts and Business Council of Greater Nashville

abcnashville.org

1900 Belmont Blvd.
Nashville, TN 37212
(615) 460–8274

Texas

Texas Accountants and Lawyers for the Arts

talarts.org

PO Box 144722
Austin, TX
(512) 459–8252

Utah

Utah Lawyers for the Arts

www.utahlawyersforthearts.org

Washington

Washington Lawyers for the Arts

thewla.org

PO Box 61308
Seattle, WA 98141–6308
(206) 328–7053

Wisconsin

Arts Wisconsin

www.artswisconsin.org

Box 1054
Madison, WI 53701–1054
(608) 255–8316

Incorporating

Owen Morrel, a New York City sculptor, has a lot of publicly installed works to his credit, a number of which have been sited on the roofs of major Manhattan landmark buildings. In the same breath, Morrel also announces that he has "a wife and family, a home, a dog and a cat, a car, skateboards and computers, a lot of this and that." Most people like to separate the personal and professional sides of their lives, but he knows that any lawsuit resulting from his work—it falls down on someone, someone helping to install it gets hurt, a supplier isn't paid, some point in the commissioning contract is neglected—could wipe him out. "We live in a litigious society," he said, "and I don't want it all to be taken from me if someone is unhappy about something and decides to sue me for everything I've got."

As a result, Owen Morrel became Owen Morrel Inc., a corporation of which he is the principal shareholder and employee (there are some part-timers). Anyone who wants to bring a lawsuit concerning Morrel's work may only go after the assets of the corporation, rather than those of the artist himself. Setting up and operating a corporation, which includes holding annual meetings, taking minutes, and electing officers, isn't what students are taught in art schools. In addition, incorporating is not an inexpensive process, since fees must be paid to lawyers and accountants, as well as to the secretary of state when the business is set up and annually to accountants and the secretary of state thereafter. Since 1978, when Morrel first became a corporation, he estimated that he has paid out between $40,000 and $60,000 in fees—"the down payment on a Ferrari. But I sleep at night, and I think it's the right thing to do."

With an eye on protecting themselves from one type of mishap or another, more and more artists have incorporated as businesses: if you sue Owen Morrel Inc., you only can go after the assets in the corporation in which Owen Morrel is the principal or sole shareholder, rather than after Owen Morrel's belongings (his home and its contents, IRA, bank account, and whatever else he has). "First and foremost, artists look to form corporate entities in order to shield their personal assets from legal judgments and creditors," said Robert Powers, a lawyer and partner in the Virginia-based law firm McClanahan Powers that represents a number of visual and performing artists.

Some of his artist clients have been sued for breach of contract—they didn't do something they promised to do—or for nonpayment, as well as for copyright infringement. "The legal entity limits their exposure" to what the corporation itself owns and controls.

There are several types of corporate entities, such as partnerships and S Corporations, which tend to have more than one shareholder, although most artists tend to set up limited liability companies (LLCs). "LLCs generally are used for one-man shops," Powers said. In all cases, the corporation is the employer and the artist the employee. When a sale or commission is made, that money is paid directly to the corporate entity, which then pays the artist, either in a lump sum or in increments (as a salary), and the artist pays taxes on that money as ordinary income. (A salary or "guaranteed payment schedule" tends to be taxed at a lower rate than a one-time distribution.) Not all the money transfers directly through to the artist. The corporation retains some cash to purchase materials that are to be used for artmaking, health insurance, workmen's compensation to protect employees who may get injured during transit or installation, commercial premises and liability insurance to protect against personal injury claims, and to hire employees or consultants, such as accountants, engineers, and lawyers.

If it is written into the corporation's operating agreement, the corporate entity also may own the artist's artwork and archives. The fact of his S Corporation owning the entire body of work was helpful to Fort Collins, Colorado, sculptor James G. Moore, as he and his wife divorced in 2015. She was not a partner or officer in the corporation, and the split of their marital estate did not result in his losing half of his artwork or otherwise adversely affecting his career, according to Moore's father and business manager, Don Moore.

The corporate entity owning most or all of the artwork also is beneficial for estate planning, according to Boston, Massachusetts, lawyer Steven Ayr, as the objects and intellectual property rights to them "will not go through the standard probate process, saving the estate those costs." The operating agreement would identify what the artist intends for the corporate assets after he or she is dead—these objects will go to this person or that institution, the copyright will be controlled by someone or something else.

Setting up a corporate entity doesn't occur naturally to every artist. Ralph Helmick, a sculptor in Newton, Massachusetts, had been

commissioned to create more than a dozen public artworks by 2000 without ever giving a thought to incorporating. However, "I started doing larger projects, and the client contracts contained clauses that referred to liability and indemnity, which got me a bit concerned. I ran those contracts by a lawyer who explained to me what could happen to me if someone got hurt on one of my sculptures." He, or his corporation, Helmick Sculpture LLC, has never been sued, but having a "firewall between my business and my personal assets" has taken one large worry away.

Similarly, it was on the recommendation of another artist that muralist Tom Taylor of Orlando, Florida, set up a corporation in 1999, Mural Art LLC, in order "to cover my you-know-what in the extremely unlikely event that I'm sued for a mishap."

The protection that a corporate identity offers to an artist becomes quickly apparent when one looks at the indemnity clauses in public art commission contracts, which sometimes are pages long, but the focus is principally on who is responsible in the event that a passerby is injured by the artwork (climbing on the piece, tripping on it, or some element of the work falling onto someone), as well as any patent (visible) or latent (hidden) defects. The contracts seek to assign all liability to the commissioned artists, requiring them to bear legal and court costs in full. The language also may be quite broad and one-sided. The standard contract for Percent for Art commissions in Maine, administered by the Maine Arts Commission, for instance, states that "the artist shall, at his own cost and expense, defend and indemnify, and hold harmless the contracting agency, their officers, agents and employees, from and against all claims, damages, losses and expenses, including attorneys' fees, arising out of, or resulting from, the performance of this agreement, provided that such claim, damage, loss of expense (1) is attributable to bodily injury, sickness, disease or death, or to injury to, or destruction of, tangible property, including the loss of use therefrom, and (2) is caused in whole or in part by any negligence, act, or omission of the artist, anyone directly or indirectly employed by him, or anyone for whose act he may be liable, except to the extent that it is caused in part by the contracting agency, their officers, agents or employees." A very long sentence, and one that places the entire burden on the artists. A shorter statement in the basic commission contract of the North Carolina Arts Council—"the artist must hold the agency harmless for any action or claims arising from the artist's

negligence or omission"—has much the same effect. Both place the onus of defending against all claims, including the most frivolous ("blocks my view") and fatuous ("I needed stitches after I tried to skateboard off it"), on the artist.

"When I negotiate a commissioning agreement for an artist, I require indemnity from the city or agency and that there is no liability for the artist if someone walking by somehow gets hurt," said Chicago lawyer Scott Hodes. However, public art commissioning agencies do not always accept modifications to their agreements. Another possibility, he recommended, is incorporating the specific public art project, a practice that he has established with his client Christo and other artists who create artworks in the public sphere. If there is a legal action taken, the corporation (of which the artist is a salaried employee) may be sued for its assets, which can be no more than the value of the commission. The potential omissions or defects in their artworks are the responsibility of the artists, for which they may purchase short-term (artwork usually comes with a one- to three-year warranty) professional liability insurance, and the contracts that artists sign with their foundries and other fabricators might include a clause indemnifying the artist—the foundry's insurance would be responsible.

Artwork sometimes can be the cause of death or injury to people working on it or to bystanders, resulting in a legal action: one of the umbrellas installed on a California hillside by the environmental artist Christo was uprooted by a strong wind, killing a tourist; a child was hurt after falling off a Glenna Goodacre sculpture he had ill-advisedly climbed. The corporate entities created by these artists protected their personal assets from any claims that were made. "When the specific project has a tendency to be dangerous, I always recommend incorporating the project," Hodes said. In fact, Christo's *Umbrella Project* was separately incorporated to "further insulate the artist from any claims that might be made. When the project is over, and after the statute of limitations has run and you have paid off all the debts of the project, you can close the corporation, which leaves nothing for anyone to go after if they feel like suing you."

Lawsuits against artists can come from all directions: someone visiting an artist's studio, such as during an open studio event, may get injured; also in the studio, a paint bucket or can of turpentine could spill and ruin

someone's dress, or a toxic substance might cause an allergic reaction. Equally, collectors may become upset if the fragile objects they bought are damaged, accusing the artist of not making it sufficiently durable.

The principal drawbacks to incorporating are the formalities and the costs. One must fill out an initial application with the office of a state's secretary of state corporation division, identifying the name of the corporation, its address, the name and address of officers and business managers, and then pay a filing fee. (These forms are online and downloadable.) An annual renewal filing must be made, which largely asks if the corporation's name and address are the same as in the previous year, and a fee is to be paid. The fees are different in every state. In Colorado, the initial fee is $50 and the annual renewal $10, while Massachusetts is $500 and $500. When in 2008 James Moore set up J. G. Moore LLC, a company with no other employees but that does periodically hire independent contractors "for things like bronze chasing or occasional help with larger pieces and installations," his father said, he paid a local lawyer $880 to ensure that the company complied with the law.

Artists may fill out the forms and file them on their own without the use of a lawyer or accountant, or with the assistance of online companies that specialize in incorporation, but Steven Ayr said, "and perhaps this is a bit self-interested, artists may want someone to help them set up their LLC financially, how they will be paid, how expenses of the LLC will be handled, how things will be handled if a partner or investor leaves the company and needs to be bought out, who owns what if the artist gets divorced, what the law requires in terms of establishing bylaws and holding annual meetings." As noted, a corporation may be set up to own not only the artist's work but also the copyright to it. However, as a practical matter, an artist has little to fear from a tyrannical corporate entity, as the operating agreement will be written to favor the artist's interests above all others.

He noted that artists can find that the protection against creditors or judicial rulings going after their personal assets that a corporate entity offers may be lost—referred to in legal parlance as "piercing the corporate veil"—if the legal requirements of an LLC, for instance, are not adhered to. For instance, the courts would frown upon the lack of an operating agreement that states who the shareholders are and what amount of the company they own or if the corporation is not treated as an entity separate from the artist's personal sphere, such as when personal expenses

such as the payment of a car loan or household groceries come from a corporate account rather than the artist's own checking account. If all the money paid to the corporation goes directly through to the artist, leaving the LLC with no money in the bank to pay for insurance or creditor claims, or if the corporation was found by the courts to have been created largely to perpetuate a fraud, courts would be apt to bypass the LLC and directly bring a judgment against the artist.

Trouble may also arise if an artist sets up a business entity simply as a means of escaping financial responsibility. Louise Nevelson's Sculptotek Inc., for example, was successfully challenged in 1996 by the Internal Revenue Service in tax court for excessive administrative costs, all charged on tax returns as deductions, which the IRS viewed as tax evasion. As the artist had died some years earlier, her estate was charged with a substantial tax and penalties, and the lawyer who had set up Sculptotek Inc. was later sued for malpractice.

As a practical matter, artists principally concerned about liability claims can obtain liability insurance policies on their own, the same type that they could purchase as a corporation. "That's really what most artists do," said John Silberman, a New York City lawyer who has represented artist Richard Serra, whose large metal abstract sculptures have twice killed workmen installing them. "You don't need all the other stuff."

Deciding whether or not to form a corporate entity may be a toss-up for those artists and craftspeople in the position to establish one. Susan Duke Biederman, a New York attorney, worried that "incorporation might have a chilling effect" on organizations and agencies that provide grants and fellowships to artists—"it sounds like they're businesses, not artists." On the other hand, Kent Ullberg claimed that providing a corporate identification number to suppliers "gives you formal heft, makes you more legitimate even though you're just a little studio." The decision to incorporate may also depend on the types of risks one faces on a regular basis and, as Owen Morrel suggested, how much protection an artist needs to get a good night's sleep.

Soliciting Investors

For all the talk about how the art world is really an industry and how artists should think of themselves as being in business, actual examples of

corporate behavior in the fine arts often come as a surprise. Two sculptors, Zachary Coffin in Atlanta, Georgia, and Sharon Louden in New York City, have applied business models to financing the creation of recent work, both developing a prospectus and soliciting investors, both offering the opportunity for a significant return on investment.

For both artists, the plans grew out of the need for money to pay for materials and fabrication. In 2002, Louden was invited by the Kemper Museum of Contemporary Art in Kansas City, Missouri, to exhibit a yet-to-be-built sculpture in its main gallery. Sounds great: the exhibition would surely bolster the artist's career, and the imprimatur of a major art museum would likely improve the chances that the work might be purchased. The problem was the $20,000 cost of creating the work, entitled *The Attenders* and consisting of 16,105 individual pieces that are clipped together and hang from the ceiling. Louden and her husband, Vinson Valega, a jazz musician and former commodities trader, developed the idea of issuing shares to people who would invest in the work. The potential investors were a cherry-picked group, consisting of "people who had bought my work in the past or who had expressed interest in buying my work," Louden said. Between twelve and fifteen people were contacted, eight of whom agreed to contribute, combining to cover the $20,000.

Louden wrote up a prospectus for investors, describing 100 shares that would sell for $200 apiece and a return on investment ranging from 50 to 150 percent, depending on how long it took to sell the finished work: a $4,000 investment would be worth $6,000 if sold in the first year, $10,000 if sold in the fifth. If the work was not sold after five years, each investor would receive some portion of *The Attenders* for their own collections. As it turned out, the installation was purchased within months of exhibition by Progressive Mutual Insurance Company, based in Mayfield Village, Ohio, which has an extensive contemporary art collection (art.progressive.com), and each investor received his or her money back with a 50 percent profit. The project was successful enough to convince Louden to pursue the investing concept again, this time for $15,000, for a work that was displayed at the Neuberger Museum in Purchase, New York. "All the investors who did it before have expressed interest," she said.

A similar but more lawyerly approach was taken by Zachary Coffin, who created a limited liability corporation to finance the creation of a

monumental—65-ton assemblage of granite and steel—outdoor sculpture called *The Temple of Gravity* that was to be exhibited at the Burning Man Arts Festival in Nevada. The festival provided the artist an initial grant of $20,000, but that still left Coffin $60,000 short of the actual costs of fabricating the piece.

"In real estate, it's quite common for developers to form an LLC when they look to put up a building," said Atlanta lawyer David Decker, who added that he has "set up a lot of LLCs" for developers and formed one for Coffin. "The beauty of an LLC is that it can take out insurance to insulate the investors from claims, and it is only intended to have a limited life span. The investors come in, pool their money, the project is completed and sold, and then the money is distributed back to the investors, and the LLC is dissolved."

Investor-seeking LLCs are not unknown in the arts. Most theater productions that reach Broadway are either LLCs or a related entity, limited partnerships. They are also found in the film and music recording industries, where the search for financial backing is essential for projects to proceed. Many fine artists will incorporate themselves as businesses, in order to purchase various forms of insurance and protect their personal assets from lawsuits, and those who create public artworks (murals and sculptures) often incorporate these projects for the same reasons. All of Christo's projects, for instance, are set up as limited liability corporations.

The ten actual investors, all from Georgia, who own the majority of shares bought in at $1,000 per share with a minimum purchase of five shares. These ten people—some of whom are collectors of Coffin's work or fans or friends of the artist or, in one case, the aunt and uncle of the corporation's business manager, Keith Helfrich, all personally contacted by the management team—may expect a 200 percent return on their investment, Coffin said, when the work is sold. "One of the investors had lost a lot of money in the stock market," he noted. "He knew my work and thought it a better bet than a mutual fund." As an incentive "goodie," all of the shareholders received the management team's prospectus affixed to a 50-pound slab of sculpted granite, suitable for pedestal or coffee table display.

The business plan of Gravity Group LLC is to exhibit *The Temple of Gravity* at a variety of locations, generating interest in the piece and eventually resulting in its sale to some museum, sculpture park, corporation,

or other collector for an amount exceeding $200,000. So far, the sculpture has traveled to a spa in Desert Hot Springs, California, "and there have been a number of inquiries," Helfrich said, but no offers to purchase the work have come about as yet. "We expect and have explained to investors that the work may not be sold for several years," he said. "Investors have to be flexible."

Hanging over the corporation is the prospect that *The Temple of Gravity* may never be sold. An earlier outdoor sculpture for which Coffin created an LLC and found investors, entitled *Rock Spinner*, which was first exhibited in 2001, is still on the market. Helfrich noted that the corporation's business plan takes this possibility into account, as investors may deduct losses on their tax returns, based on the actual expense of fabricating the sculpture and transporting it from site to site. "If it doesn't sell," he said, "we would have the work appraised and donated to a nonprofit or public institution, and then the investors would be able to declare a charitable contribution," declaring deductions on their tax returns based on their share of the corporation. Expecting the appraised value of *The Temple of Gravity* to top $200,000, shareholders would be able to deduct more than they actually invested.

The experiences of Louden and Coffin differ in a number of respects, but there is one glaring contrast. Coffin is a minority shareholder in the corporation that owns *The Temple of Gravity*, with 21.5 percent of the shares. His contribution was not cash but "sweat equity," based on his actual labor. (The corporation's management team—Helfrich and Corbett Griffith, an engineer who has performed structural safety tests—have received fewer than ten shares apiece as payment for their efforts. David Decker, the accountant, and even the corporation's web designer all agreed to be paid in shares of the corporation.) Louden, on the other hand, did not own any shares of *The Attenders*, only pocketing the net proceeds of the sale, that is, after the investors were paid. (She declined to reveal the selling price.) For her next project, however, "I will definitely buy shares for myself. I deserve to make a profit, too."

Artists' Estates

This story begins where most end: the artist dies. Unless that artist has sold every piece he or she ever created, there is likely to be a potentially

sizeable inventory of artwork that must be valued as part of the artist's estate for tax purposes. How to value that art can be tricky, as it involves speculating about the market for an artist's work when that artist is dead.

It was no easy matter when sculptor David Smith died in an automobile accident in 1965. The 59-year-old artist had only begun to receive major art world recognition and appreciation late in life. Between 1940 and 1965, he had sold but 75 works, only five in the last two years of his life. Part of the reason for this was the fact that Smith deliberately kept prices high, with the result that 425 sizeable sculptures were in his estate when he died. Within two years of his death, 68 works were sold for just under $1 million. The remaining body of work in his estate, with each piece appraised at the fair market value, was originally valued at $4,284,000, ensuring that a hefty tax payment was due to the Internal Revenue Service within the standard nine-month period. After a hearing before tax court and some complicated negotiations between the IRS and lawyers for the Smith estate, the entire estate was discounted to 37 percent of the fair market value, greatly decreasing the amount of tax money due the federal government.

The Smith case developed in the field of artists' estates what is called the "blockage rule" or "blockage discount," which previously had only been applied to securities and recognizes that forcing an artist's heirs to sell most or all the art in the estate for the purpose of paying death duties would result in fire sale or "distressed" prices that are likely to be well below fair market value. Expected fair market prices are more readily obtained when individual works are sold gradually.

Over the years, this principle has been applied to such artists as Jean-Michel Basquiat (who received a 70 percent blockage discount), Alexander Calder (60 percent) and Georgia O'Keeffe (50 percent). There is no rule of thumb for determining the percentage discount, which clearly is elastic. "Different discount percentages reflect different judges, different jurisdictions, and different lawyers representing the estate, and some lawyers are better and more persuasive than others," said Bernard Rosen, a New York City attorney with a number of artist clients. Additionally, a number of other considerations are taken into account in determining the discount, such as the subject of the works, the period in the artist's career in which works were created, and the medium.

For instance, there were 1,292 gouache paintings in the estate of sculptor Alexander Calder. As these gouaches were not the artist's principal medium, as well as the fact that Calder's estate executors claimed that it would take the art market 25 years to absorb this number of his paintings (at 52 per year), the IRS permitted the estate to discount these works by almost 68 percent.

Predicting what art is worth after the artist dies cannot be scientifically measured, and a number of factors may apply. "The death of the artist may sabotage the market," Karen Carolan, former head of art evaluation at the IRS, said. "If the artist doesn't have a regular dealer, his death may have a very negative impact on prices." She added that having "a ready market, being a well-known artist, being represented by dealers, selling work all over the country" make valuing artwork in an artist's estate considerably easier. Artists without one or all of those elements produce work that is far more difficult to appraise after they are dead.

Complicating variables are frequently found in these kinds of valuations: there may be a record of sales in a nondepressed art market, but, when the market goes down, formerly sellable works have no prospective buyers. Some artists sell very well, but their success may be dependent upon their presence to actually sell the work—without the benefits of the artist's personality, works may not sell at all. Artists without a gallery connection may be the least likely to have works sell after they are dead. The IRS combs through auction records in order to see what prices were paid for an artist's work, but most contemporary art is not resold at auction (if it is resold at all). Another way in which the IRS often looks to determine the value of artworks is by examining an insurance policy, which requires an expert appraisal, but this is more applicable to collectors than to artists who rarely insure their own work.

Basquiat, Calder, O'Keeffe, and Smith, of course, were all renowned artists who supported themselves exclusively from the sale of their artwork. Many more artists hold teaching positions or other jobs (arts related or otherwise) from which they receive their main income. These artists may also sell their work; however, the market is limited, perhaps almost nonexistent. What the deceased artist's work is worth is a question on which lawyers and the IRS sometimes disagree. "A lot of people teach or do something else and sell one painting every three years to a cousin," James R. Cohen, an estates attorney in New York City, said. "The IRS couldn't

really demonstrate that the art has any value. You don't get into the discount issue because no one is really buying their art in the first place."

Another New York lawyer, Susan Duke Biederman, coauthor of the book *Art Law*, agreed, noting that "you don't want someone who paints 16" × 24" oils, and only sells one painting a year for $1,000, and has a backlog of 500 pictures when he dies, to have the art in his estate valued at $500,000. My interest would be to say the art is worth zero. If the IRS said that people have bought this work in the past, I'd say, 'You go find me 500 people who want to spend $1,000 on each work.'"

Certainly, the IRS is in the business of collecting money, not selling artworks. Still, Karen Carolan stated, "you can't say that art has no value if the artist has sold during his lifetime. You have to place a value on all the property in the estate." The IRS has no rule-of-thumb cut-off for the amount of money earned through sales, or the percentage of one's income derived from sales, of art in order to determine whether a deceased artist's work has market value at all or if a blockage discount (and the amount of that discount) applies.

These artists may have just as many works in inventory as David Smith or Alexander Calder, but with a far less reliable market than either Calder or Smith, estate executors face a far greater challenge when determining value and any potential discount on that amount.

The problem is not necessarily an immediate one for all artists. The entire estate goes tax-free to the surviving spouse, and the first $5.34 million of the estate is tax-free to the heirs. There is no need to individually appraise works of art in an estate if the entire estate is worth less than $5.34 million. In fact, if the rest of the estate is small, it behooves the heirs to value the art high enough to get as close to that $5.34 million number as they can. This protects the heirs if they some day sell the art. For instance, if an heir values a work at $10,000 and sells it for $15,000, he or she only pays a tax on the $5,000. However, if the heir claimed that the art was worth nothing and sells it for $15,000, the heir pays a tax on the entire $15,000.

The problem with that planning, however, is that "reasonable men may disagree, and the IRS may come in and value the art higher, moving the heirs above that $5.34 million tax-free limit and then taxing the heir at 35 percent," Cohan said. That might happen when an heir begins to claim that the art has some value and tries to sell.

Certainly, some heirs may expect to eventually sell these artworks and earn a considerable amount of money from them. Sales during an artist's lifetime are no absolute indication of future value, as the art of Vincent van Gogh is a clear example. During his life, van Gogh only sold one painting, but his work became far more popular and earned record prices at auctions years later.

Competing values are involved in this issue: On the one hand, heirs look to minimize the value of an estate in order to lower inheritance taxes; yet, if they plan to sell works from that estate later on, heirs would hope to limit the tax burden on those sales. Many well-known artists, such as Adolph Gottlieb, Lee Krasner, Robert Mapplethorpe, and Andy Warhol, have resolved this problem in a third way, establishing a trust or charitable foundation for their art through their wills and using the periodic sale of artwork to create and replenish the foundation's endowment. Yet others, including photographer Ansel Adams and painter Hans Hofman, donated a large number of their works to educational institutions. Artists who are concerned with keeping their inventory of works intact for their heirs might also plan for money, such as through a life insurance policy, that would pay the inheritance tax. Any of these choices is preferable to the decision by an Arizona artist in the early 1980s to publicly incinerate all of his paintings in order to spare his heirs the burden of paying taxes on them. Artists, their attorneys, and their heirs need to examine what they reasonably expect to do with the artwork after the creator dies and plan accordingly.

Artists' Private Foundations

Many successful people have time to plan their legacies, but the last months of Nancy Graves's life were hectic. In May of 1995, the 55-year-old sculptor was diagnosed with ovarian cancer, and five months later she was dead. With no heirs, she had to decide quickly what to do with her belongings and wealth. Like a number of other artists with significant holdings of artwork and other assets, she created a nonprofit foundation through her will to shelter her estate from high death taxes. But what sort of foundation should this be? What would be its purpose? Most artists' foundations serve the posthumous interests of the artists, as trustees and administrators arrange exhibitions of their work, prepare a catalogue

raisonné, inventory work, and make documents and archival material available to scholars. The Henry Moore Foundation in England, for instance, was set up in 1977 to "advance the education of the public by promoting their appreciation of the fine arts, particularly the work of Henry Moore." In somewhat more inflated language, the foundation created by Salvador Dalí in 1983 in Spain aims to "promote, boost, divulge, lend prestige to, protect and defend in Spain and in any other country the artistic, cultural and intellectual oeuvre of the painter . . . and the universal recognition of his contribution to the Fine Arts, culture and contemporary thought."

Instead, Graves's idea of the type of foundation she wanted was modeled on those set up by Adolph Gottlieb and Lee Krasner, whose primary purpose is to provide grant awards to artists in need.

One needn't be at death's door to start thinking ahead, artists especially. At the end of their lives, artists leave behind their own bodies, the assets and property they accumulated over a lifetime, and a body of work. For most people, a will suffices to dispose of assets and property, but an artist's own work may require special attention if there is a desire to preserve and promote that creator's market and reputation into the future. A growing number of artists who have experienced success in their careers have established foundations during their lifetimes or through their wills for that very purpose. Into the foundation is donated some or all of the artist's own work and archives (such as documents, letters, photographs, and receipts) and usually some other assets—cash, for instance—to operate the foundation. The foundation set up in 2001 by the niece of sculptor George Sugarman, two years after his death, for example, included hundreds of his two- and three-dimensional artworks, as well as the proceeds from the sale of the artist's loft in SoHo, which provided the organization's initial endowment.

The difference between a will and a foundation is that a will disposes of the entire estate, all of which is taxable, while a foundation may have a much longer life and is tax-exempt. It is possible for an artist to leave an entire estate to a foundation, but that would deprive heirs of the ownership of any of the estate assets, such as a house, the art, cash, and securities, since a foundation is designed to be a charitable institution that has a public, rather than a purely private, benefit. A foundation may sell art and license the copyright for the artwork, but proceeds must go back into the foundation to fulfill its mission rather than be distributed to heirs.

In general, according to Christine Vincent, project director for the Artist-Endowed Foundations Initiative of the Aspen Institute, an artist's foundation's mission is to "increase public knowledge of, and access to, an artist's body of work, usually through lending pieces to museums, maintaining an archive, supporting scholarship, and making grants." Those grants may be intended to support academic research or the creation of a catalogue raisonné, and occasionally they may go directly to living artists. The George Sugarman Foundation, for instance, received a $10,000 grant from the Judith Rothschild Foundation to help pay for the creation of a catalogue raisonné of the sculptor's work, and the Sugarman Foundation itself made direct grants to living sculptors in order to help them complete their own artwork. Between 2003 and 2008, the Sugarman Foundation "gave more than $250,000 to artists. It is something for which I am very proud," said Arden Sugarman.

Although the best-known artist foundations are those of very successful artists (Jackson Pollock, Willem de Kooning, Joan Mitchell, Jacob Lawrence, and George Segal), wealth and fame are not requirements for setting them up. An artist may create a foundation at any time in his or her career, but as a practical matter, emerging and midcareer artists would be more interested in selling their work than giving it away to a nonprofit entity. Christine Vincent noted that "foundations are economic things and need a certain scale of resources" in order to fulfill their mission. Judith Rothschild, for example, who died in 1993 at the age of 71, was a wealthy but little-known abstract painter who sought through her foundation to promote her reputation and the careers of other artists of her generation who had not received the attention they believed they deserved. She left her foundation with several million dollars in cash, a fine art collection, and a Manhattan townhouse. The Sugarman Foundation, on the other hand, only had the sale of the SoHo loft and of artworks left to the foundation for its maintenance, which is why it closed in 2013. "We literally ran out of money," Arden Sugarman said. However, during its twelve-year tenure, the foundation placed the artist's works at the Carnegie Museum of Art, the McNay Art Museum in San Antonio, Texas, and the Whitney Museum of American Art, as well as at college museums at Harvard, Purdue, and the University of California at Los Angeles.

The cost of setting up an artist foundation ranges widely, based on the scale of the enterprise, ranging from $1,500 to $50,000, and it requires

the services of a lawyer or accountant, or both. When creating during an artist's lifetime, the lawyer or accountant will establish a not-for-profit trust under the laws of a particular state, as well as arrange for tax exemption under IRS regulations. If created through a will or by executors after the artist's death, the foundation will be set up as a tax-exempt nonprofit or charitable trust.

New York City lawyer Barbara Hoffman stated that an artist foundation is run by a board of directors, usually three to five people, which may include the artist if he or she is alive. Those directors usually are chosen by the artist, or may be named in a will, and may include heirs. If an artist foundation has sufficient funds, executive directors and advisors to the foundation can be paid. Importantly, in order to qualify as a tax-exempt charitable entity, board members and the artist are not permitted to benefit personally from sales of artwork held by the foundation.

Promoting an artist's art can involve considerable time and effort. Susan Fisher, director of the Renee & Chaim Gross Foundation, which aims to "further the study of Chaim Gross's work and that of his contemporaries," puts together exhibitions from the artist's personal collection at the Grosses' downtown Manhattan home and studio. A 2015 exhibition, titled *The Word of Modern Art: Artists as Writers*, included selected artworks from the collection by Benny Andrews, Jacob Epstein, Red Grooms, Jacob Lawrence, Henry Moore, Pablo Picasso, and Raphael Soyer, as well as that of Chaim Gross and his painter daughter, Mimi Gross.

Christina Hunter, who directs the Nancy Graves Foundation, noted that she prods museums into acquiring and exhibiting the artist's work. "I suggest themes to curators, provide archival information and research to curators writing catalogue essays" and sometimes writes those essays herself, she said. Additionally, she lectures on the artist at colleges and art history conferences and provides tours for both museum curators and contemporary art history professors—"and, in a few instances, for artists"—of Graves's two- and three-dimensional work belonging to the foundation.

Some artists have the time and energy to be involved in their own foundation, informing those serving on the board of directors of their specific wishes, while others prefer to let others take charge. "The downside for many of my artist clients is that operating a foundation in a responsible and effective manner can eat away at valuable time for artistic

production," Hoffman said. "The pitfall is that the artist may be creating a new form of artwork, a foundation, rather than dedicating his or her efforts to building the important legacy in his or her traditional manner of working."

There is a wide range of artist foundations, from the Chaim Gross and Nancy Graves foundations, which largely exist to further the prestige of the respective artists, to Faith Ringgold's Anyone Can Fly Foundation, which operates an Art for Kids program that brings arts to public schools and teaches children about African and African-American art. The Robert Mapplethorpe Foundation, on the other hand, both promotes exhibitions and research on the artist and provides funding for AIDS research.

CHAPTER 8

Spending Money, Making Money

ART IS OFTEN EXPENSIVE TO BUY, BUT it also may be costly to make—and, then, to insure, frame, crate, ship, and promote. As in any other business, artists look to make money, but, in order to do so, they may need to invest some money. Some of these expenditures are undoubtedly necessary—without art supplies, works cannot be created, for instance—but others need to be taken on faith. Publicists, whose work was discussed in Chapter 1, may generate media attention (or they may not), but if and when they do it is never fully clear that their work (and the costs involved) is paid for by additional sales. Health insurance is another expenditure that may or may not be cost effective: What if you don't get sick? Or, if you get sick once in five years but the medical attention received would have been cheaper if paid out of pocket than through monthly or quarterly HMO payments, was having health insurance worth it? Artists may choose to become a corporation, in order to limit their liability in the event of a lawsuit, but these suits are quite rare, only leaving them owing money to lawyers, accountants, and the attorney general of the state in which they live. Other artists may decide to invest in the services of a career coach, who will help them devise a marketing strategy, create press materials, and even arrange exhibitions, but no amount of marketing savvy and glossy brochures will sell artwork that no one wants to buy. Much about an artist's life is taken on faith that what he or she creates is art at all and that others will esteem it as good.

Can You Deduct That?

It is all well and good to say that artists need to be businesslike, rather than bohemian, but those who want the Internal Revenue Service to accept work-related deductions (price of materials, studio rent and insurance, travel expenses, advertising and promotion, photography, postage, shipping, and other costs) on their federal tax returns do not have a choice because if the IRS believes someone is just a hobbyist rather than in business, those deductions will not be allowed.

"The IRS has rules about hobbyists versus professionals," said New York City accountant Steven Zelin (www.stevenzelin.com). "Basically, the IRS wants to know if the taxpayer intends to make a profit as opposed to just make art." Artists are in business as soon as they earn money from their work, in the form of sales or grants or fees if they give a public demonstration. Some sort of transaction is required: if there is no money, there is no business. A business still may be a hobby, however, unless it is conducted in a certain way, and the difference between the two determines whether or not expenses may be deducted.

There are nine criteria that the IRS applies in order to separate professionals from hobbyists:

- Is the activity carried on in a businesslike manner?
- Does the artist intend to make the artistic activity profitable?
- Does the individual depend in full or in part on income generated by the artistic work?
- Are business losses to be expected, or are they due to circumstances beyond the artist's control?
- Are business plans changed to improve profitability?
- Does the artist have the knowledge to make the activity profitable?
- Has the artist been successful in previous professional activities?
- Does the activity generate a profit in some years and, if so, how much of one?
- Will the artist make a profit in the future?

The artist need not answer "yes" to every question in order to legitimately deduct business-related expenses, and spending more money than one takes in does not disqualify someone from claiming to be in a real

profit-oriented business. "In every business, you expect to have losses in the first few years," said New York City accountant Todd Thurston (www.taxtodd.com). The IRS demands proof that an artist make a genuine effort to earn a profit in three years out of a five-year span. If an artist has had three consecutive years of losses, the federal agency will want to see some sort of profit in the next year. "Losses that an artist has already taken won't be challenged" if an audit takes place, he said, "only losses claimed going forward."

Zelin noted that creating a business plan, which a company or sole proprietor would need when applying for a bank loan, is useful if the IRS needs proof of an artist's profit-making intent. This document might feature an executive summary (the nature of the business and the expectation of earnings), a description of the business operations (the studio, how much time is spent in the studio every day or every week, how artwork is transported to one site or another, the website, exhibition venues, how payment is accepted), staffing and management (a studio assistant, a business manager), revenue forecasts, marketing plan (how the artwork produced will be made known to prospective buyers), expected expenses, and expected milestones (exhibitions, grant awards, prizes).

The IRS does not define what makes an artist a professional, but certain elements help in the determination of whether or not there is a serious intent on earning a profit. "Having a BFA is something, having an MFA is more," said New York accountant Susan Lee (www.freelancetaxation.com). "Having a website helps, especially if the website is set up for making sales, as is having a separate business credit card and business bank account. Using the services of a lawyer or an accountant in setting up or running your business shows you are serious. Belonging to an artist organization, subscribing to an industry-related magazine, or going to professional conferences is helpful, because it builds a picture of you doing everything you can do to be on top of the market."

If an artist believes that the IRS has denied business-related expense tax deductions unfairly, he or she may challenge the auditor's decision in tax court, which requires petitioning the court and paying a $60 filing fee (400 Second Street NW, Washington, DC 20217, 202-521–0700, forms and instructions are available online, www.ustaxcourt.gov) within ninety days of receiving the IRS's notice of deficiency. Tax court generally operates in the manner of a small claims court—there is no jury, and taxpayers

tell the judge their story. However, many applicants to the tax court hire lawyers to represent them.

Artists have gone to tax court with claims that they are not just hobbyists and won. Back in 1977, a precedent-setting decision was handed down with regard to a painter, Gloria Churchman, who had claimed losses of several hundred dollars in her tax filings in 1970 and 1971. For all of her twenty-year career, Churchman's income from art sales never had exceeded her losses, and the IRS also claimed that the artist was supported by her husband, a college professor. As a result, IRS auditors labeled Churchman a hobbyist, and her deductions for art-related expenses were denied. However, when the artist took her case to tax court, it was ruled that Churchman pursued her art career "with a bona fide intention and expectation of making a profit," and the fact that she did not rely on sales of her artwork for her livelihood was irrelevant. Lack of income, the court ruled, and "a history of losses is less persuasive in the art field than it might be in other fields because the archetypal 'struggling artist' must first achieve public acclaim before her serious work will command a price sufficient to provide her with a profit."

More recently, Cambridge, New York, painter and Hunter College art professor Susan Crile successfully challenged an IRS auditor's rejection of her claimed deductions on her tax returns for art-related expenses on the basis that her work as an artist was "an activity not engaged in for profit." Noting that she had received fellowships from the National Endowment for the Arts in 1982 and 1989 and that more than two dozen museums had her work in their collections, including the Metropolitan Museum of Art, the Hirshhorn Museum and Sculpture Garden, and the Phillips Collection, the tax court ruled that "in a qualitative as well as a quantitative sense, we conclude that the balance of factors favors [Crile] and that she has met her burden of proving that in carrying on her activity as an artist, she had an actual and honest objective of making a profit. We therefore hold that she was . . . in the 'trade or business' of being an artist."

Artists and Advertising

Investing in one's career is good, but which types of investment? If it is difficult to determine whether expenditures are warranted in the case of

publicity, insurance, and career development, it is just as difficult with regard to advertising costs. Gail Wells-Hess, an artist in Portland, Oregon, spends roughly $6,000 per year on something that many people would view as quite ethereal: "creating a presence." That money pays for advertising her paintings in magazines. If the goal of those ads were limited to selling her paintings, it is not clear that the money would be well spent at all, since most of the people who call or email her (that information is listed in the ad) "get sticker shock when they find out what my paintings cost," she said. "A lot of people think that a painting should cost $100." Sometimes, galleries have contacted Wells-Hess based on her advertisements, inquiring about exhibiting her paintings, and some sales have resulted from that, but can anyone say that the ad created those sales or that the work of the gallery owners did? Advertising itself has an ethereal quality that requires belief in its power and effectiveness, often defying simple cause and effect and leading Wells-Hess to claim that she is "not trying to sell a painting but to create a name and presence." Toward that end, she has even advertised paintings that cost less than the ad itself. "Selling the painting is an added treat, when that happens."

Based on the increasing quantity of artists' advertisements found in art and other consumer magazines, a growing number of other painters and sculptors have a similar idea. Seeing a painting reproduced in a magazine, even though the publication received money to publish it, has the mysterious effect of elevating the stature of the artwork and the artist in the eyes of readers, many artists and gallery owners claim. Bill Mittag, a painter in Phoenix, Arizona, who spends $10,000 per year on ads in *American Art Review* and *Southwest Art* magazines, noted that whatever painting he uses in the advertisement is usually snatched up by a buyer early on. As a result, he created a website in order to direct callers to other examples of his work. "I'll advertise 'til I die," he said. Mittag's paintings are exhibited in eleven galleries west of the Mississippi River, and most of the sales of his artwork take place in those galleries, but they only advertise his paintings when there is a one-man show, which doesn't take place very often. In addition, many of the galleries have only seasonal markets, and this leads to long stretches of time when public attention is not paid to his work. The ads, he believes, keep people interested in his work throughout the year, and, when he is called or emailed by potential collectors, "I refer them to whatever gallery is closest to them."

Certainly, some artists want to make direct sales as a result of their ads, and those happen, too. Huntington, Massachusetts, sculptor Andrew DeVries, whose annual advertising budget is in excess of $35,000, noted that the first ad he ever placed, in the *Maine Antique Digest*, "resulted in the sale of a $36,000 piece." (The buyer saw the ad and called him up.) On the other hand, the ads placed in *American Art Review* by Camille Przewodek of Petaluma, California (costing from $2,000 to $5,000 per year, depending upon their size), have produced "very few" sales through the artist's website, where readers are directed. However, collectors do visit her website (a "hitometer" counts those) and learn where the artist will be traveling next. "I love to travel," she said, "and I do so as much as I can." She teaches between three and five art workshops annually, attends Plein-Air Painters of America events (of which she is a member), and visits the galleries that display her work. "A lot of people like to meet the artist. They don't fly somewhere to meet me, but if I'm in town or not that far away they come out to meet me." Half of her sales come about from meeting people who have seen her work in an advertisement. Considering the cost of travel, the ads may be the least expensive element in her marketing strategy, and Przewodek's approach raises the question of how many people would purchase her work if they didn't meet her, but she is firmly convinced that advertising is the key element to her sales success.

"Advertising brings credibility," she said. "It says to the world, 'I am a serious, committed artist.' People who look at the ad see success, because I can afford to advertise."

Belief in advertising often leads to beliefs about how to advertise. Noting that subscribers tend to keep art magazines around for months or years and may look at the same advertisement again and again, Palo Alto, California, painter Lesley Rich said that artists should "use a good image" in the ad, "not one with bad design or things wrong with it. Why have your name connected with something shabby?" Gail Wells-Hess claimed that certain colors and subjects were "guaranteed to sell" and should be included in ads, such as red poppies in summer issues and "a pear or still-life in the winter." Strong, contrasting colors are the key, to Bill Mittag's mind, because "light colors will wash out on you" in the reproduction, and the four-color separation process used in printing the ad will not adequately capture a delicately blended tone. Anatoly Dverin, a painter in

Plainville, Massachusetts, stated that he only buys full-page ads, because "I don't want to share the page with another artist; it creates competition. The other artist may use, I don't know, some combination of red and blue that kills the balance of color in my painting." People only start recognizing your name, said Andrew DeVries, if there is something else going on, such as an exhibition or an opportunity to meet the artist where potential buyers can go in person—"by themselves, ads can't do it all."

The purpose and nature of advertising is a subject on which there is considerable disagreement, although there is one point on which everyone agrees: one needs to think of advertising as a long-term, rather than a one-shot, effort. To develop name and artistic recognition, the same or similar images must be present in ads that follow one magazine issue after another. Many artists split the costs of advertising with their galleries in advance of an exhibition, and some galleries carry the entire expense, but it is rare for a gallery to pay in full or in part to advertise an artist when there isn't a show. If the concept is to keep one's name and images before the public on an ongoing basis, one-shot ads are not likely to produce the desired results. Too, galleries generally have a local audience, and the advertisements they place are likely to be in local or regional publications rather than national ones.

Different gallery owners have their own purposes in mind when they place an advertisement in a newspaper or magazine, and they may not be quite the same as the artist's. For them, advertising increases attendance rather than sales, as those who visit once may come again (buying work, if not by the artist on display on the first visit, by a different artist another time), and it improves the chances of media coverage (the publishing world's dirty secret).

Galleries usually have sizeable budgets for advertising and promotion—promotion refers to press packages, which are intended for the media, rather than advertising that is aimed at the general public—and they buy ads for every exhibition, although the amount of advertising and the nature of the particular ads are dependent upon the importance (and the volume of sales) of the particular artists. Artists who want to stay in the public eye between shows find that they must take on the job of year-round advertising. "If you're going to advertise," Wells-Hess said, "the trick is to make a commitment for at least a year, because you can't judge the response in less than one full year."

SELLING ART WITHOUT GALLERIES

A year of advertising can be a great financial burden on an artist, especially if the aim is not direct sales but largely keeping one's name and art in front of the collecting public. The bimonthly *American Art Review*, which is a relatively inexpensive art publication in which to advertise, charges $3,295 for a single full-page ad and $1,895 for a half-page (smaller ads are also available); there is a price break for each additional ad taken out in the course of twelve months, which may be helpful since "most artists tell us they didn't really sell a painting until after three or four ads," according to Tom Kellaway, editor and publisher of the magazine. Prices are higher at *Art & Antiques*, where a full-page ad costs $9,200 ($8,640 per ad if one purchases three and $7,910 per ad for six), a half page is $6,080, one-third of a page is $5,070, and one-quarter page is $3,680 (again, with price reductions for buying a series of three or six). *ARTnews* also lowers prices for repeat advertisers, with one-time, four-color, full-page ads costing $8,300 and a half page at $5,975. (For three ads, the full-page rate is $8,050 each, and half pages cost $5,650 each.)

With cash flowing outward, it may be quite understandable if artists panic after an ad or two does not produce any sales or commitments from a gallery. "I got one call from an interested buyer," said John Loughlin, a painter in Lincoln, Rhode Island, who placed ads in two issues of *American Art Review*. "I quoted a price, and he never got back to me. I don't know if I will do any advertising again. It's good to get exposure, but that doesn't put bread on the table." Many artists, even those who strongly believe in making a long-term commitment to advertising, recognize that a lot of the money they spend will produce nothing and, even when there are results, they cannot always point with certainty that the ads were the principal cause. The only call that Anatoly Dverin received one month after placing an ad in *American Art Review* was from a sales representative from another art magazine, asking him to advertise there. Robert Gamblin of Portland, Oregon, who founded a paint supply company and paints on the side, noted that he "got really close once" to a sale when he "shipped a painting to someone in California who wanted it on approval." Unfortunately, that person sent the work back. Another true believer, Michael Budden of Wrightstown, New Jersey, called his advertising plan a success: "Of course, if measured in terms of actual sales, well no, it hasn't been successful; but if measured in terms of recognition, then it has been a big success, because people have seen my ads. People

tell me, 'I saw your ad.' Down the road, I expect some of them to become buyers."

As one decision leads to another, artists who take on the job of advertising their own artwork also assume the role of selling their work directly to the public—regardless of whether or not they are currently represented by galleries—and must create the mechanisms for these sales (websites, employees, brochures, a dedicated telephone line, crating, shipping, framing), which adds to the overall expense. Few people are like Bill Mittag, who will pay thousands of dollars for ads simply to refer potential buyers to his dealers. Yet, as Wells-Hess claimed (and many other artists agree), direct sales are not the main purpose or goal of advertising. Artists need to have all the personal qualities that can sell their work directly but may not have abundant opportunities for putting those qualities to use. Since "75 percent of the time, the people who respond to my ads are shocked by the prices of my work," Wells-Hess uses that time on the telephone not to make a sale, but "as an opportunity to educate people about what art costs and why it's worth it. Maybe I'm nurturing a potential art patron."

In some ways, advertising artwork is at a disadvantage to advertisements of more mundane objects. A photograph of a kitchen appliance or other product in an ad sells not only the machine itself but a sense of what it will mean in one's life: this car will impress my friends; that coffee maker will make great espresso for dinner parties; this food processor will allow me to make gourmet treats in just minutes. In effect, these ads offer an image of one's own ideal life rather than just a thing with a specific use. However, when showing works of art, ads present just the images themselves, and potential buyers must imagine how the artwork would fit into their lives and homes. Also, as photographic reproductions of art in ads are shown smaller than the originals, in almost all cases, they tend to conceal the very details that give them character. That is one reason that Internet sales of artwork have been so lackluster.

Advertising does offer the opportunity to establish name recognition and, along with the familiarity of seeing someone's name or images repeatedly, a sense of celebrity: people know the names of more laundry detergents than they ever will use. (This may be the reason that art advertising may add to the number of inquiries or visitors to a gallery without necessarily increasing sales of artwork.) The magazine advertisements

for Lexington, North Carolina, landscape painter Bob Timberlake often feature a photograph of him and his name in large type, with much smaller reproductions of his paintings underneath, as well as information on where his works may be seen or purchased. "What you do in advertising is the same thing over and over, so that people recognize you when they see you," Timberlake said, noting that he has been interviewed repeatedly about his artwork on television. "I've been told that I'm recognizable and that the name Timberlake is recognizable."

He spoke disparagingly about most artists' advertisements, which largely consist of one large reproduced image in a one-time ad, as not being part of any marketing plan. He places ads in the same publications on a regular basis, in order to familiarize readers with his name. "Do I want to sell the name or the product?" Timberlake asked. "I want to sell the name, because you'll see the name many more times than you'll see that one picture."

Some artists find that advertising is just one element in the process of establishing control over their own careers. The number of galleries that will doggedly pursue collectors through paid ads and other means throughout the year are few and far between, which regularly frustrates artists. (It may frustrate some art dealers who find that the artists they represent take out ads and make direct sales, setting themselves up in implicit competition for sales with the gallery.) For others, advertising is the means to an end. Both Camille Przewodek and Michael Budden stated that they would like a gallery to take on the job of selling their work directly in order that they could be less involved in the business of being an artist and more of a full-time creator of art. "I want someone else to promote my work," Przewodek said, "but there aren't many galleries that will do it, and I also find that I am better and more creative at promoting myself than anyone else."

Leasing One's Artwork

Over the years, Jenny Laden's paintings been purchased by homeowners, but perhaps even more important than that, "my art looks like something you'd see in someone's home." That may be good enough for the film industry. Several of the Brooklyn, New York, artist's figurative pictures of women have been used as set décor by small-scale movie makers who

have rented the paintings for the few days it took to design a set and film a scene. Her art does more than just look like art, and her work has been exhibited in galleries in the United States and Europe. The big screen is now one more place where people can see her art.

"It's exposure," she said, "and exposure leads to a wider audience of people who might like what you do." However, Laden has no illusions that her paintings as backdrop in a movie, even if it were to have international distribution, will be a big break in her career. For one thing, few moviegoers pay attention to what's on the set (Academy Awards go to set designers, not to the individual makers of props), and the film credits won't list her work. The claim that a particular painting appeared in a movie isn't likely to raise the value of the piece, "although it will make an interesting story when I talk with collectors. It always helps when you have something to say about your work." And, it's money in her pocket ($300 per painting), plus she gets to keep—to rent again or sell—the artwork.

Sales of art always seem to get the headlines, but rentals have become a major growth area in the art market, catering to an audience of corporations, film and television producers, realtors, and homeowners. This grouping has its own individual reasons for wanting to rent rather than to buy.

For instance, corporations that may be facing economic uncertainty, takeovers or mergers, and possible relocations want art for office decoration but don't want to invest in a collection that may need to be put into storage or sold; renting is less expensive, less permanent, and tax-deductible. "They're not married to the art," said Barbara Koz Paley, chief executive officer of the Manhattan-based Art Assets, which has leased works of art ("some valued in the six figures") to businesses since 1993. The objects that Art Assets rents out come from a variety of sources, including galleries, museums, and private collectors, but increasingly from individual artists. "It's just so much easier to deal directly with artists than with their dealers," she noted, "and in the age of the Internet it's just so much easier to get to artists." Many of Art Assets' almost fifty clients are office building owners and managers who are using art as a tool to sell their properties, upgrade their buildings, and set a "cultural tone." The rental of artwork is 3 percent of the object's value over a negotiated period of time. The cost to the

corporate client, she noted, is usually passed along to tenants. In addition, "by renting, they pay a fraction of the cost of buying, and there are distinct tax benefits."

Among the artists who have leased their work through Art Assets is Jill London of New York City, whose art involves gold leaf on paper and other surfaces. She earned "$3,600–3,800" for the rental of sixteen pieces on two separate occasions, each lasting one month. The income was welcome as was just getting some artwork out of her studio. "I live in the Lower East Side in a small, cramped apartment-studio, and it's great for me when I can move work out," she said. The opportunity for having her work seen was no less valuable. "People ask if my work is being shown anywhere, and I tell them, 'Yes, you can see my work over there in that building.'"

On a smaller realm, realtors seek artwork when "staging" houses and apartments, giving a property a more lived-in look that may entice buyers. Shawn McNulty, a painter in Minneapolis, Minnesota, who has sold his artwork at gallery exhibitions and through his website, entered the art rental business in 2007 when "a realtor working with a stager asked me to lease some paintings" for some properties she was working to sell. Six of his large-scale (3' × 4') abstract paintings were used in a downtown Minneapolis loft, and another five medium-sized (2' × 2') works were placed in a house in Saint Paul. Both properties sold (maybe the art helped), and he earned $780 and learned a new way to earn money as an artist. "I offer rentals now on my website," he said. "I'm pretty prolific, and I'd be happy if I can move some older work out of the studio this way, at least temporarily."

More and more artists have taken the same direction as McNulty, soliciting rental business and developing art rental agreements that cover the cost (his prices range from 7 to 10 percent of the retail value for a three-month rental), insurance (renter is liable for lost, stolen, or damaged artwork), transportation (renter pays), the manner of payment (credit card, usually, since the rental agreement automatically is renewed at the same terms unless the item is returned), and the process by which a leasing agreement turns into a purchase ("half of the rental money goes toward the purchase price," he said).

In large measure, artists have left the particulars of art rental agreements up to organizations (for instance, Santa Monica Art Studios in

California or the Peoria Art Guild in Illinois both promote and arrange leases) to which they belong. A number of art galleries—the Monsoon Galleries in Bethlehem, Pennsylvania, Hang Art gallery in San Francisco, and Larsen Gallery in Scottsdale, Arizona—promote art leasing plans, while others rent pieces more informally and only occasionally for the artists they represent. Art galleries tend to structure their rentals as lease-to-purchase agreements, while companies such as Art Assets tend to offer straight leasing agreements, "although sales take place maybe 10 or 12 percent of the time," Paley said.

Sales haven't taken place for Jill London, who stated that building lobbies "aren't selling spaces, and people who look at art there don't think of it as something to buy." However, the work of Serena Bocchino, a painter in Hoboken, New Jersey, which was rented through Art Assets for the Manhattan headquarters of the tax accounting firm Pricewater-houseCoopers (for which she earned a leasing fee of over $4,000), so favorably impressed the company that it purchased twenty of her paintings for its corporate collection. "I got paid for exhibiting my paintings and I got paid for selling my paintings," she said. "All in all, it was a very good experience for me."

Additionally, various museums around the country permit select private and corporate backers to rent pieces for varying lengths of time. The deCordova Sculpture Park and Museum in Lincoln, Massachusetts, for instance, "will install an exhibition of Museum-owned and artist-loaned artwork in Corporate Member offices for the duration of the membership," according to its website. A number of other institutions (the Coos Museum in Oregon, the Los Angeles County Museum of Art, the San Francisco Museum of Modern Art, and the Seattle Art Museum, among them) have volunteer-run sales and rental galleries; however, the pieces for sale or rent are not part of the museum collections.

Another market for art leasing is the entertainment industry, which continually needs props (preferably ones that don't require storage), and the rental of objects frequently fits into a budget better than purchases. Artworks aren't the only cultural objects rented—antiques and crafts items also are used on film sets, in magazine advertising shoots, and as displays in store windows (Bijan Nassi, owner of the Bijan Royal antiques shop in New York City, claimed that he rents between 300 and 400 objects per month for use as props)—but it tends to be the

largest category in terms of dollar value. Sometimes, homeowners rent artwork on a lease-to-own arrangement that allows them to pay over time while making sure they really like the artworks; if, after a month or six months or a year, they decide the art isn't right for them, they may return it.

Jenny Laden herself did not look for rental business from movie studios but was part of a Brooklyn-based company, Art for Film (www.art-forfilmnyc.com), which promotes the work of two dozen painters and sculptors to the film industry in New York City and elsewhere. Jessica Heyman, the owner of Art for Film, noted that her pricing is flexible, because "some studios have bigger budgets than others, and you have to work within their budgets rather than have a set price." A rental payment is split evenly between the company and the individual artist. Frequently, the film studio set decorator doesn't take the physical painting but, rather, a digital image of it, which can be printed out at a size that better fits the actual set. One of Laden's watercolor paintings, a 75" × 40" work titled *Lady*, "needed to be smaller than it was," she said, and was reduced through a computer printer. At the end of the shoot, the digital print was returned to her, "which actually gave me something else I could sell."

In effect, the artist is allowing a studio a one-time right to license the image for a relatively brief period of time. The benefit to the studio of working directly with artists or through a company like Art for Film is that they gain clearance, or permission, to use the image; the failure to acquire those rights when copyrighted artworks are purposefully or inadvertently included in scenes has resulted in lawsuits and judgments against studios.

Film and television studios don't usually have large budgets for set props (Heyman noted that some artworks have been rented but not used on a set, simply because the set designer wants to have a variety of choices), which makes this type of income supplemental rather than primary for most artists. Set designers sometimes find artwork online, but they are more apt to use local artists or local galleries, simply because they don't tend to travel hundreds of miles for a two-day $300 rental; as a result, artists in southern California, New York City, and Vancouver, Canada—the three largest areas of filmmaking in North America—tend to benefit the most. Sculptor Bruce Gray of Los Angeles and painter

Susan Manders in Sherman Oaks, California, had their first art rentals to film studios through galleries, but they both moved to represent themselves in rentals, doubling the amount of money they earned. "I started to notice that there was a lot of art in TV shows and movies and thought, 'That could be mine,'" Gray said.

Still, for them, the money doesn't add up to a livelihood, thousands rather than tens of thousands of dollars per year. Art rentals don't "happen all that often, maybe a few times a year," said Gray, whose sculptures have been in the backgrounds of all three Austin Powers movies, *Meet the Fockers*, *The Truth about Cats and Dogs*, and *Sleeping with the Enemy*, as well as in over 100 commercials (Honda and Sprint among them) and television shows (including *CSI* and *Six Feet Under*). He has advertised in industry publications and sent postcards to set designers about his work, but "most of my art rentals have come about through word of mouth."

There are benefits and drawbacks to renting works of art. Gray had one sculpture stolen off a movie set ("I got paid for it, though maybe not what it was worth") and another scratched ("They actually rented it a second time in order to repaint it. Turned out good as new"); yet a third sculpture was repainted in different colors ("a crappy job") to match the colors on the set. "If you can't bear to see something happen to your work," he said, "you shouldn't rent it out."

Manders noted that she has been lucky in terms of no thefts and no damage and even luckier that arrangements that started out as rentals turned into purchases. "Doing business with studios has other benefits," she stated, noting that she has been commissioned each year since 2005 to create an edition of prints that are included in the gift bags for presenters at television's Emmy Awards. "It brings my work to well-known celebrities, and that leads to other sales, because a number of the presenters became buyers."

There is no industry standard for rental agreements between artists and those who would lease their artwork. The document that Susan Manders created for these situations covers a lot of ground and may prove the basis for other artists' arrangements.

Rental Agreement
Between

**SUSAN MANDERS FINE ART
RENTAL AND SALES GALLERY**
11830 Ventura Boulevard
Studio City, CA 90604
Gallery: 818.506.7804 Office: 818.995.0009 Fax: 818.995.0020
Email: skmanders@aol.com

And

Name _____
 "Renter"

Address _____
 City State Zip Code
Billing Address
(If Different) _____
 City State Zip Code

If Corporate Account, Bill To:

Work No. () _____ Home No. () _____

Fax No. () _____

email: _____

[] Visa Card No.: _____
[] MasterCard Expiration Date: _____
[] Amex

Title of Work
Catalog # & dimensions
Rental fee
Purchase
Per month
Price

Condition of Work:

At time of rental: _____

At time of return: _____

Initial term:

[] Three Month-Individual, beginning on _____, 20 ___
 ("Contract Date")

[] Six Month - Corporate, beginning on _____, 20 ___
 ("Contract Date")

SUSAN MANDERS FINE ART Rental and Sales Gallery ("Gallery") rents to the Renter of the Work(s) listed above on the following terms:

1. Term: The minimum term of this Rental Agreement is three months for individual Renters and six months for Corporate Renters (the "Rental Period"). The term shall begin on the Contract Date and may be renewed for successive Rental Periods until terminated as provided in Paragraph 2.

2. Termination:

 (a) Either party may terminate this Agreement, with or without cause, at the end of any Rental Period. Gallery may terminate this Agreement for delay or nonpayment of rent or other even of default.

 (b) The Agreement shall also be terminated at the end of any Rental Period during which the Artist has requested the return of any Work(s), unless the Renter has exercised the option to purchase described in Paragraph 6.

 (c) If Renter fails to return any Work(s) on or before the date specified for return, Renter shall be charged the rental fee for another Rental Period.

3. Rent: The rental amount specified in the Schedule of Rentals is payable for each Rental Period of portion thereof. Payment of rent is due in advance. No refund of rent shall be made for any reason.
4. Delinquent Rents: Renter grants Gallery the right to charge the credit card of Renter or Corporate Renter for rent which remains

unpaid more than 30 days after the beginning of each Rental Period and / or recall the Work(s).

5. Default: Renter shall be in default if Renter (a) is delinquent in rental payment; (b) fails to exercise proper care of the Work(s) while in Renter's possession; (c) fails to notify Gallery of any damage or loss of the work(s); or (d) fails to meet any other requirements of this Agreement. The cost of any legal action, including attorney's fees or collection agency fees, resulting from any event of default shall be the responsibility of the Renter.

6. Option to Purchase: Renter may exercise the option to purchase the Work(s) at the purchase price specified on the Schedule of Rentals by giving notice to Gallery. Prior to any sale all past and current rental fees shall have been paid. The purchase price shall be reduced by 75 percent of the Rental Fee specified on the Schedule of Rentals, up to a maximum of 70 percent of the purchase price. Gallery will complete the sale, and all sales are final. Upon notice to Renter during any rental period that Artist or Artist's agent has an offer to purchase work, Renter shall have 15 days to notify Gallery of Renter's exercise of the option to purchase. Such notice of exercise shall be accompanied by the balance of the purchase price.

7. Price Changes: Artist may increase the purchase and rental price of Work(s) once a year. Renter may exercise the option to purchase the Work(s) at the purchase price in effect immediately prior to the increase in price on the same terms specified on Paragraph 6. If Renter does not wish either to pay the increased rental or to purchase the Work(s), the Work(s) shall be returned to gallery at the end of the current Rental Period.

8. Possession: Renter takes possession of Work(s) at the time of transporting to renter's premises. Transportation is at Renter's risk and responsibility, and renter shall be responsible for all the expenses even if the transportation is arranged by the Gallery. Renter shall not remove Work(s) from the Southern California area.

9. Care: Renter is responsible for proper care of the Work(s) and agrees to return the Work(s) in the condition that they were in when originally rented. Renter will maintain security against fire and theft of the Work(s), and protect the Work(s) against risk of loss or damage. Renter shall not clean or repair any Work(s), nor remove any Work from its frame or base. If any Work(s) is lost or damaged, Renter shall

immediately notify Gallery in writing, giving specific details. Within 30 days after a Work is returned, Gallery may make a claim against the Renter for any damage to the Work(s).

10. Insurance: Renter is responsible for insuring the work(s) against damage or loss. The Gallery reserves the right to request evidence of Renter's insurance coverage.

11. Conditions of Use: Rent is solely for non-commercial display at Renter's address only, or at such other location as Gallery may approve in writing in advance. Renter shall not sub-let any Work(s) nor license nor permit anyone else to possess or use any Work(s).

12. Reproduction Prohibited: Work(s) may not be reproduced by photography or other means except with the prior written consent of Gallery.

13. Entire Agreement: This agreement contains the entire agreement between Gallery and Renter and can be amended only by a writing that is signed by both parties.

Renter's signature below evidences that Renter has read and agreed to each of the terms contained herein.

Renter

Signature

Date: _____

SUSAN MANDERS FINE ART
RENTAL AND SALES GALLERY

By: _____

Pricing is another area in which artists may need to make up their own standards. Below are the cost guidelines that Shawn McNulty developed:

Rental Fee Schedule	
Purchase Price	**Rental Price for 3-Month Period**
Less than or equal to $749	$50
$750–$999	$80
$1,000–$1,499	$125
$1,500–$1,999	$160
$2,000–$2,499	$200
$2,500–$2,999	$250
$3,000–$3,499	$300
$3,500–$3,999	$350
$4,000–$4,499	$400
$4,500–$4,999	$445
$5,000–$5,499	$485
$5,500–$5,999	$525
$6,000–$6,499	$565
$6,500–$6,999	$605
$7,000–$7,499	$645
$7,500–$7,999	$705
$8,000–$8,499	$785

I can deliver and install work in the Twin Cities and surrounding suburbs for the extra fee:

1–3 pieces	$30
4–6 pieces	$45
7+ pieces	$60

Otherwise, the work needs to be picked up from my studio in Northeast Minneapolis, as well as dropped off after the rental time period.

Emergency Funds for Artists

A lot may happen to an artist or artisan in a career: important sales, prestigious awards, museum exhibitions, write-ups in major magazines. They may also lose much of their work in a studio fire or fall off a ladder while creating a mural. The glamour part of the arts and crafts world is much better documented than the catastrophes that may place an artist's life or career in jeopardy. A high percentage of artists and craftspeople have no health or studio insurance, creating a small margin for any type of sickness or accident that may occur.

"Injury and illness top the list" as reasons that craftspeople regularly apply to the Craft Emergency Relief Fund, according to Dorothy Bocian, former assistant director. The fund, which has been in existence since 1985, provides both loans (a no-interest "quick loan" up to $3,500 and a low-interest "Phoenix loan" up to $8,000) to help craftspeople get back on their feet and a $1,000 grant for people with chronic or terminal illnesses and who are unlikely to be rehabilitated.

At Change Inc., a foundation that Robert Rauschenberg set up in 1971 to aid needy artists facing substantial medical expenses (and later expanded to include damage to a studio, potential eviction, high utility charges, and other emergencies), there are no loans but only awards to qualifying artists, up to $1,000. Additionally, whereas Craft Emergency Relief Fund has an application form, Change Inc. only requires applicants to submit a letter detailing the nature of their emergency. Still, the basic procedure is the same. An individual describes a major problem in his or her life, offering some form of proof of both the catastrophe (such as bills or estimates and accident reports) and an inability to pay (the previous year's tax return), as well as some indication of the professional's standing as an artist or artisan (résumé, reviews, announcement of a performance, perhaps a letter or two of reference)—students are not eligible.

There are a number of emergency funds and loan programs for artists and craftspeople, all with their own procedures and limited grantmaking budgets. Uniting almost all of them is the fact that they were created and funded primarily by artists wanting to help others in distress. Change Inc. was established by Rauschenberg and his accountant, Rubin Gorewitz, to systematize the artist's habitual generosity, which consisted largely of

simply handing out cash to people who needed it. "I was doing his taxes one year," Rubin Gorewitz said, "and I told him, based on what he had earned, what he owed the government. He said that was impossible; he said that he didn't have any money left, because he had been giving away so much. He expected a big deduction, not to owe anything to the government."

No two emergency funding organizations operate the same. Some have specific application deadlines, while others accept requests for help throughout the year. The process by which a foundation or organization evaluates applications, and their rates of approval, also differ from one to the next. The Craft Emergency Relief Fund receives an average of fifty applications per year and funds thirty-five or so, based on a review by first the administrative staff and then a committee formed of some of the Fund's board members. The Adolph and Esther Gottlieb Foundation also has a two-tiered process, in which staff winnow through the pile of approximately 100–150 applications that arrive annually to eliminate the requests that do not reflect a recent emergency or that aren't describing a problem that is truly catastrophic ("my car broke down, and you really need a car in Los Angeles"). Some requests are rejected because the applicant has the financial means to meet the emergency. "Only 15 percent of the people who write to us for help are asking for something that is really within our guidelines to fund," said Alden Smith, former director of Aid to Artisans, an organization that assists some individual craftspeople but mostly crafts groups outside the United States. "Some of the things they say they need money for are truly heartbreaking, but it's not what we're set up to do."

As with any other grant, fellowship, or award that artists may receive, the money received as an emergency grant is part of ordinary income and taxable. Paperwork may also attend the receipt of the funds, such as a midterm or final report, perhaps some proof that the money was actually used for the purpose described in the application. The Gottlieb Foundation and Artists' Fellowship Inc., another private nonprofit organization that provides emergency assistance to artists in financial need, have very different ideas about reporting. The Gottlieb Foundation demands that recipients describe by letter how money was used within six months of receiving their grants. The letter accompanying the foundation's check states, "You should be advised that the Foundation may request copies of receipts, which document your expenditures." Artists' Fellowship Inc.,

on the other hand, requires no reporting whatsoever, believing that the essential documentation took place as part of the application process.

Sources of emergency funds for artists appear below:

Fine Artists and Craftspeople

Aid to Artisans
5225 Wisconsin Ave. NW, Ste 104
Washington, DC 20015
(202) 572–2628
www.aidtoartisans.org
Provides assistance in product development and design consultation, business training, and marketing assistance through bringing new artisan products to major venues, direct grants to artisan groups through ATA's Amex Grants Programs in India and Mexico, as well as through its own small grants program

Artists Fellowship
c/o Salmagundi Club
47 5th Ave.
New York, NY 10003
(212) 255–7740
Grants for emergency aid to visual artists and their families, primarily in New York

Artist Trust
1835 12th Ave.
Seattle, WA 98122–2437
(206) 467–8734
(866) 21TRUST
www.artisttrust.org

Artists Benevolence Fund
935 Laguna Canyon Rd.
Laguna Beach, CA 92651
(947) 494–6277 or (949) 497–1129
www.sawdustartfestival.org/about/artists-benevolence-fund
For artists in need in Laguna Beach, California

The Artists' Charitable Fund
338 E. 4th St.
Loveland, CO 80537–5604
(970) 577–0509
www.artistscharitablefund.org
Emergency grants

Change Inc.
PO Box 1818
Sanibel, FL 33957
(212) 473–3742

Chicago Artists' Coalition
217 N. Carpenter St.
Chicago, IL 60607
(312) 491–8888
www.chicagoartistscoalition.org

Craft Emergency Relief Fund Inc.
535 Stone Cutters Way, Ste. 202
Montpelier, VT 05602
(802) 229–2306
www.cerfplus.org
Immediate support to professional craftspeople facing career-threatening emergencies such as fire, theft, illness, and natural disasters

Foundation for Contemporary Arts
820 Greenwich St.
New York, NY 10014
www.foundationforcontemporaryarts.org/grants/emergency-grants
Emergency grants

J. Happy Delpech Foundation
1579 North Milwaukee, Ste. 211
Chicago, IL 60622
(312) 342–1359
Grants of up to $250 to artists in the Midwest with AIDS or serious illness

Florida CraftArt
501 Central Ave.
Saint Petersburg, FL 33701–3703
(727) 821–7391
www.floridacraftart.org
*Florida CraftArt has contributed to the Craft Emergency Relief Fund
(CERF), making it possible for members to benefit from two sources of
funding when they apply to CERF*

The Adolph and Esther Gottlieb Foundation
Emergency Assistance Program
380 West Broadway
New York, NY 10012
(212) 226–0581
www.gottliebfoundation.org
*Grants of up to $10,000 to assist established painters, printmakers,
and sculptors (working in a "mature phase" for over ten years) facing
an unforeseen, catastrophic incident, and who lack the resources to meet
that situation. Each grant is given as one-time assistance for a specific
emergency, examples of which include fire, flood, or emergency medical
need.*

Max's Kansas City Project
PO Box 53
Woodstock, NY 12498
(845) 679–2593
www.maxskansascity.org/grants.html
Emergency grants

Mayer Foundation
300 E. 74th St., Ste. 35A
New York, NY 10021
www.foundationcenter.org/grantmaker/mayer/about.html
Emergency grants

Joan Mitchell Foundation
545 W. 25th St., 15th Floor
New York, NY 10001
(212) 524–0100
www.joanmitchellfoundation.org/artist-programs/artist-grants/
emergency
Emergency grants

Pollock-Krasner Foundation
863 Park Ave.
New York, NY 10021
(212) 517–5400
www.pkf.org
Financial assistance to artists of recognizable merit and financial need working as painters, sculptors, mixed media, and installation artists. The foundation has also established an emergency grant program to deal with the crisis of September 11th.

Springboard for the Arts
308 Prince St., Ste. 270
Saint Paul, MN 55101
(651) 292–4381
www.springboardforthearts.org/grants-funding/overview/
For Minnesota artists

UNESCO
International Fund for the Promotion of Culture
1 rue Miollis
75732 Paris France
33 1 45 68 42 15
Funds are designed for artists with a disability and artists facing exceptional emergency situations; however, they are limited and principally destined for beneficiaries from developing countries.

Borrowing Money

Artists, as other small businesses—shall we call them sole proprietors or independent contractors?—sometimes need money they don't have to complete their work, perhaps to frame a show of paintings, fabricate a sculpture, or produce an edition of prints. Where will that come from? Numerous public and private grant programs exist, but the process of applying, being accepted (or rejected), and then receiving money generally takes months. Opportunities can come and go during that wait. Banks are another option, but they tend to be quite reluctant to make small loans of perhaps just a few hundred or a few thousand dollars, first, because the return on investment is so low, and, second, it costs as much administratively to make a small loan as a large one; additionally, small-scale borrowers might not have collateral for the loan or the available collateral doesn't fall into a bank's customary notion of assets. Banks also are fearful that self-employed people, especially those working out of their homes and particularly those who call themselves artists, can be relied on to repay their loans.

The remaining options are hitting up parents and friends or maxing out credit cards (or both). For some, another possibility looms. Artists might want to look into what are called "microloans," some of which are directed specifically to individual artists and arts organizations but more generally exist to help small businesses and those working on their own to pay for expenses and opportunities that are too small-scale for a bank lender.

There are hundreds of other nonprofit microlenders around the United States, which also provide business counseling and training to applicants, and many of these organizations themselves borrow money from the federal government's Small Business Administration at discounted rates in order to make loans to small businesses in a variety of fields. These nonprofits make loans to eligible borrowers in amounts up to a maximum of $35,000. The average loan size is about $10,500, and repayment plans range from a few months to six years (the average is three and a half years). The Small Business Administration guarantees between 50 and 75 percent of the principal amount of its guaranteed loans, thus reducing some of the risk in lending to start-ups that might not have enough collateral or a solid credit history.

As opposed to banks, microlenders don't assess penalties for early repayment, since they are not-for-profit organizations and seek the return of their loan money to lend again. "We're in the ownership business, not the loan production business," said Malcolm White, a spokesperson for Self-Help, based in Durham, North Carolina, which since 1980 has provided almost $22 million in financing to more than 1,950 small businesses (including artists and craftspeople), nonprofit organizations, and homebuyers in North Carolina. Self-Help's loans range in size from $1,500 to $25,000, with interest rates of the prime rate plus four points and a term of five years maximum. The nation's largest microloan provider, Accion USA, which is based in Boston, has made $150 million in loans to fifteen thousand entrepreneurs around the country since 1991, "and that includes artists," said Erika Eurkus, the organization's New England program director. Two-thirds of its borrowers are women, and a large percentage of them work out of their homes. "They can't get loans from banks," she stated. "They often have no or poor credit history and no collateral to put up as security for a loan." She added that "we don't do different things than a bank would—we look at credit and cash flow and a business plan—but we also listen to ideas that banks might not think are worth their while." Accion's loans start as low as $500, increasing to $25,000, with terms of between two months and five years and fixed interest rates of 12.5 percent.

Many of the country's microlenders are members of the Association for Enterprise Opportunity (1601 North Kent Street, Suite 1101, Arlington, VA 22209, 703-841-7769, www.microenterpriseworks.org) or may be located through a small business development center (www.sba.gov/sbdc). Some microlenders target particular groups, such as women or minorities, for assistance, while the majority are more general in their focus.

The interest rates for microloans tend to be higher than for loans offered by banks, in part because the borrowers are more risky and in part because of the greater amount of time that the lenders spend in helping them achieve creditworthiness. With some exceptions, these rates tend to fall somewhere between bank loan and credit card interest rates. The highest interest rate charged by Northern California Grantmakers, a granting agency that established an Arts Loan Fund in 1981 providing bridge loans to individual artists up to $5,000, repayable within six months, is 6 percent.

Other lending programs in the arts—established by the Alliance of Resident Theatres in New York City (Bridge Fund), Center for Nonprofit Management in Dallas, Texas (Nonprofit Loan Fund), the Denver Foundation (Colorado Nonprofit Loan Fund), the Community Foundation of Greater Atlanta (the Arts Loan Fund), Fine Arts Fund (Paul Sittenfeld Revolving Loan Fund) in Cincinnati, Ohio, Fund for the City of New York (Cash Flow Loan Program), New York Foundation for the Arts (Revolving Loan Program), and the Sacramento Metropolitan Arts Commission (the Bridge Loan Program)—focus solely on small to mid-size arts organizations. Similar to many individual artists, the directors of nonprofit arts organizations also believe that "borrowing is bad. They're afraid of debt and, if they need money, will try to get it from board members, credit cards, or shifting resources away from one program to help pay for another," said Lisa Cremin, director of the Arts Loan Fund, which is part of the Community Foundation for Greater Atlanta's Nonprofit Loan Fund. "We encourage arts organizations to develop relationships with banks. We have identified banks that are willing to lend to nonprofit arts organizations, and we will provide an introduction. If something positive develops, good. If not, we're there."

For art loan funding, the need has to be arts related, rather than for a car loan or paying an artist's medical bills (other organizations have funds for catastrophic events). Money would be loaned for opportunities, such as a performance for which ticket revenues or other earned income will repay the loan or an exhibition in which the sale of artwork will produce the money to cover the loan. These loans also benefit individuals and organizations that have been notified of being accepted for a grant but have not yet received money—the grant notification secures the loan and serves as collateral. Otherwise, collateral consists of anything of value, such as an automobile or machinery, but not the artist's own work.

The Benefits of Donating Art

Like the smart woman who marries Mr. Wrong, artists often find their hearts and minds going in different directions when confronted by some great social need calling for a donation. Charity auctions regularly ask artists to contribute a work of art that can be sold to raise money, and certainly there is satisfaction in doing what one can to help a worthy

cause. However, as opposed to art collectors who are entitled to deduct on their tax returns the full market value of any object they might donate, the Internal Revenue Service only permits artists to deduct the cost of the materials used in creating their own artwork that they contribute. The sentiment involved in giving is fine, but the drawbacks—seeing one's artwork picked up for a fraction of its real value, forgoing any tax benefits, the limited likelihood of a donation furthering one's career or even being singularly publicized—are enormous, leaving them with the choice of being stupid or stingy.

Not everyone agrees with the dire assessment, including artists who continually offer their work for one worthy cause or another. According to New York City art dealer Edward Winkleman, who represents emerging artists, donating one's own artwork to some charity benefit is, "first, good karma. Helping an organization that hosts benefits reflects well on you. Secondly, it's exposure and can result in getting your work into a collection that opens other doors." Noting that he often buys art at charity auctions, he stated that "I automatically pay more attention to the artists whose work I get in benefits. At the very least it puts your name on that organization's radar. Third, it can be fun."

Perhaps, however, there is something in between the extremes of pessimism and optimism, and a situation that is inherently unfair to artists may be turned to their advantage. Wisconsin Public Television, as part of its ongoing fundraising efforts, holds a six-day auction in May, the first day of which consists exclusively of antiques and artwork—170 pieces by contemporary area artists—and has been doing so for twenty years. "We asked ourselves, how can we best showcase the talent and commitment of the artists who donate work for the auction, and then we realized that we should ask the artists themselves," said Kathleen Callaghan, auction manager for Wisconsin Public Television in Madison. "We want to give more to artists who donate their work than to businesses that donate $125." As a result, the station initiated a program of featuring the artists and the artwork in the weeks leading up to the auction and throughout the year in the monthly magazine (*Airwaves*) that is distributed to members.

The catalogue for the on-air auction is available for viewing online several weeks before the event, and artists who contribute their own work are permitted to set up links to their own websites for browsers who want

to see more. The public television station also allows these same artists to leave their business cards and brochures at the physical site of the auction for those bidders and visitors who come in person. "This opportunity for exposure has helped a number of artists raise their profile in the community," Callaghan said.

Wisconsin Public Television isn't alone in its efforts to make these donations more professionally rewarding for artists. The West Valley Art Museum in Surprise, Arizona, holds an annual two-day Arts Silent Auction for the institution that splits proceeds 50–50 with participating artists, enabling them to both give and receive something tangible. "This seemed like a great way to motivate artists to do things for us," said Mike Bailey, the museum's education coordinator and manager of the auction, "and it only seemed fair, since artists get a split when they see their work through a gallery." Additionally, the museum runs art fairs in the spring and fall, reducing artists' booth fees $75 when they donate to the institution a work of art worth $75 or more.

Another annual silent art auction is held in Fort Wayne, Indiana, by an organization called Artists Against Multiple Sclerosis, which provides as incentives to participating artists a brunch, thank-you gifts, and individual display areas at the site of the auction where they may meet and show more of their work to potential bidders. In another approach, an annual Art Against AIDS benefit staged by the Chicago-based Heartland Alliance solicits contributions of artwork that will be put on exhibition and sold to the public, all proceeds directly going to support the Alliance's HIV/AIDS programs. The artists who have donated their work may deduct on their tax returns the money paid for their art.

A somewhat different program of soliciting donations from artists is the Boston-based Art Connection, which seeks contributions of artworks to be placed in nonprofit social service agencies throughout the city, such as hospitals, senior and community centers, domestic abuse shelters, and others. "It is bringing artwork to populations that may not have much exposure to the Museum of Fine Arts," said Tova Speter, program manager for the Art Connection. She noted that many donations are older works from series that "the artists aren't exhibiting anymore," but some of the donations are newer. It is unlikely that the clients of these social service agencies will become collectors, but these organizations put up plaques next to each artwork, identifying the artist and the individual piece, and

they also hold receptions for the artists, to which the community is invited. Their websites frequently feature the artwork and provide links to the artists' own sites, as does the website of the Art Connection itself.

Once artists donate a work to a particular organization, they tend to get asked again and again by the same and other groups, which can lead to resentment. "The number of requests for donations of your work jumps up geometrically after you give once," photographer Nicholas Nixon said. "You find yourself on everyone's list. They sometimes treat you as though they're entitled to your work and, once you start to say 'no,' they are not particularly sympathetic. Sometimes, they sneer." Charity events should be sensitive to the tax disadvantages for artists to give their creations, and artists should point out to event organizers groups around the country that have sought to increase the incentives for artists to make a donation. Artists may also look to negotiate their own arrangements with charities holding auctions, such as establishing minimum bids, which would ensure that the art is not sold unless the bid reaches a certain amount. Artists may prefer to offer works for sale at charity auctions, donating the money earned (or a certain portion of that money) to the charitable cause, which they may deduct in full on their tax returns. Certainly, since artists may come to feel resentment over how little their work sells for at charity auctions—vacations and free dinners tend to be more coveted, especially at mixed auctions—and that they receive precious little response to their work at these events, they should try to gauge what their feelings will be in advance: it may be difficult to feel pride in being a do-gooder if you personally haven't done well.

The (Apparent) Benefits of Giving Art Away

Art critic and historian Irving Sandler doesn't just write about art, he has a collection of dozens of two- and three-dimensional works by noted artists of the postwar era. For instance, there is a large-scale Joan Mitchell painting in his living room that he has pledged to donate to the Brooklyn Museum upon his death. However, he said, "I'm not a collector," meaning that what he owns he didn't buy. These works were gifts from artists he reviewed favorably; a few were wedding gifts. The artists had become his friends. There was "no quid pro quo, so no ethical problem, because

the gifts were given after a review was published and not in order to influence what I was going to write."

Friendships are important for artists, as personal relationships with the right people may lead to recommendations and tips to collectors, curators, and dealers, perhaps resulting in commissions, gallery representation, invitations to exhibit, and sales. Nothing so unusual about this: in the business world, it is called "networking." What may distinguish friendships between artists and art writers from relationships in other fields is the practice of gift giving.

"I've done it. I think it is pretty common to give artworks to writers," said Elyn Zimmerman, a New York City sculptor and photographer. "There are a number of artists I know who make drawings that they keep in a desk drawer for just this purpose. The drawings aren't overly involved but are identifiable as their work." This practice may extend beyond just artists, according to Phyllis Tuchman, a critic and curator, as well as a former president of the US chapter of the International Association of Art Critics, who claimed that "some galleries give small works by artists to critics." Thanks for the kind words in *Art in America*.

The problem—if you see it as a problem, and many art writers do not—is that the gift giving is all one way. Art critics don't give away essays and reviews but expect to be paid, and if they write favorably about an artist, or even if they don't, they simply are doing their job. An artist's job is to create objects to sell, but they also appear to need to make things in order to ensure goodwill. "Is it quid pro quo? I'll write a good review of your show if you give me a painting? I don't really think so," said Eleanor Heartney ("I've been given gifts of art from artists who were friends"), a critic and former president of the US chapter of the International Association of Art. "It may be inferred that the critic should write about the artist again and that the artist is buying favors for the future."

Besides having drawings or prints kept in a drawer in a desk, some sculptors cast unlimited editions of small pieces that may be given as presents or donated to a charity benefit auction. Minimalist artist Robert Mangold creates a Christmas-timed print edition every year to send out to friends and supporters, as did Sol Lewitt during his lifetime, according to Lewitt's business manager, Susanna Singer. "It is the part of the art world that operates on a handshake instead of a contract," Zimmerman said.

That isn't to say that art writers who accept gifts from artists are lacking moral scruples. It is a point of principle with Irving Sandler that none of the artworks given him be sold; all will be donated to museums. That Joan Mitchell painting planned for the Brooklyn Museum was one the artist planned to throw out, he said. "She hated the painting. We argued about it for a while over the phone, and she finally said, 'If you want the goddamned painting, come over here in the next thirty minutes and pick it up or I'm throwing it out,' so I did." To Phyllis Tuchman, there is "a huge difference between being a good friend of the artist and someone whom an artist hardly knows" in terms of being a recipient of an artist's gift. Early in her career, she wrote about the work of sculptor Seymour Lipton "whom I felt was a very overlooked artist. He wanted to give me some drawings to show his appreciation. I didn't accept them, and now those drawings are worth a lot of money." Yet another critic and former president of the US chapter of the International Association of Art Critics, Kim Levin ("a few artists have given me things over the years"), draws the line with artwork she doesn't care for. "I've never accepted anything from an artist whose work I didn't like," she said.

Right and wrong on the issue of accepting gifts of artwork tend to be personal issues for art writers rather than a generally accepted practice. Levin noted that the *Village Voice*, for which she regularly wrote reviews at one point, "had a rule against accepting things," but different publications operate with different or no rules. The International Association of Art Critics has no policy regarding the ethics of receiving gifts. At a board meeting, Tuchman said, "someone brought up the issue, and I said to that person, 'You've never gotten any gifts.'"

Newspapers generally have stricter policies for their staff reporters and freelancers than do magazines and online publications. The *New York Times*, for instance, requires reporters and stringers to read and sign an ethics policy, which includes the statement that writers "will not accept free transportation, free lodging, gifts, junkets, commissions or assignments from current or potential news sources." The Code of Journalistic Ethics promulgated by the Bloomberg publication *BusinessWeek*, on the other hand, notes the need for integrity, accuracy, and fairness but makes no mention of whether or not staff writers or freelancers may accept gifts, meals, or other freebies.

Levin did not recall any discussion of the proprieties of accepting gifts from artists when she was president of the art critics association. "We were more concerned with the proposal that gallery owners might become members of the association." The drawback to galleries as members, she explained, is that they might seek to influence critics in one way or another.

It seems easy for people in the art world to acquire art at no cost. Alicia G. Longwell, chief curator at the Parrish Art Museum in Long Island since 1984, said that she and her husband, Dennis, a curator at the Museum of Modern Art, only purchased one artwork since they married in 1976, a shaped paper piece by artist Mon Levinson. "I don't remember the price of the work, but [art dealer] Rosa Esman knew we were young and starting out, so she let us pay monthly until it was all paid off," she said. "Maybe the fact that my husband worked at the Modern helped, I don't know. I don't think we ever bought another piece of art. You know, when you're surrounded by art every day, you don't want to go home and start thinking about art again. But, we do have art in our home. My daughter is an artist, and we have many of her paintings, and we also have gifts from artists that we've received over the years."

Some may think that artists' gifts are a perquisite of the job. John Perrault stated that when he began writing for *ARTnews* in 1963, the magazine paid $4 per review and $150 for a feature-length article, "so everyone knew critics were underpaid. And if you were also a poet, like myself, you were clearly starving." (Perhaps one of those grateful artists might have given him a sandwich instead of an artwork.) Dore Ashton, an art critic, historian, and curator, also complained about the low rates of payment. "When you think of what writers are paid, it's almost for free. I was a working mother; I had to pay school fees and that sort of thing." One of the gifts she received some decades ago was a large sculpture ("it probably weighs 500 tons") by Isamu Noguchi, whom she called a family friend. "I gave my daughter the Noguchi. It's for her future."

Art critics aren't the only ones who might justify receiving gifts for doing their jobs because of how poorly they are paid. In his 1952 "Checkers Speech," which sought to explain why he took $18,000 from a group of supporters, then-vice-presidential nominee Richard Nixon claimed that his then-current job as a California senator was inadequately

compensated: "Let me tell you in just a word how a Senate office operates. First of all, the Senator gets $15,000 a year in salary. He gets enough money to pay for one trip a year, a round trip, that is, for himself and his family between his home and Washington DC." That speech, now proverbial as an effort to talk one's way out of an ethical jam, was a success at the time. The context has changed but perhaps not the sentiment.

For artists, the question may be whether or not giving gifts to art writers and curators is valuable for their careers. Zimmerman said that "my experience of giving things is that it hasn't really helped me," while Tuchman called it "a good career move." Still, the artist continues to have giveaway art on hand, and the critic continues to have her hand out.

Index

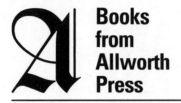

Books from Allworth Press

The Art World Demystified
by Brainard Carey (6 × 9, 308 pages, paperback, $19.99)

The Artist-Gallery Partnership
by Tad Crawford and Susan Mellon with Foreword by Daniel Grant (6 × 9, 216 pages, paperback, $19.95)

The Artist's Complete Health and Safety Guide (Fourth Edition)
by Monona Rossol (6 × 8, 576 pages, hardcover, $34.99)

The Artist's Guide to Public Art (Second Edition)
by Lynn Basa with Foreword by Mary Jane Jacob and Special Section by Barbara T. Hoffman (6 × 9, 240 pages, paperback, $19.99)

Business and Legal Forms for Fine Artists (Fourth Edition)
by Tad Crawford (8½ × 11, 160 pages, paperback, $24.95)

The Business of Being an Artist (Fifth Edition)
by Daniel Grant (6 × 9, 344 pages, paperback, $19.99)

How to Survive and Prosper as an Artist (Seventh Edition)
by Caroll Michels (6 × 9, 400 pages, paperback, $24.99)

Legal Guide for the Visual Artist (Fifth Edition)
by Tad Crawford (8½ × 11, 304 pages, paperback, $29.99)

Making It in the Art World
by Brainard Carey (6 × 9, 256 pages, paperback, $19.95)

New Markets for Artists
by Brainard Carey (6 × 9, 264 pages, paperback, $24.95)

The Profitable Artist (Second Edition)
by The New York Foundation for the Arts (6 × 9, 240 pages, paperback, $24.99)

Starting Your Career as an Artist (Second Edition)
by Stacy Miller and Angie Wojak (6 × 9, 304 pages, paperback, $19.99)

To see our complete catalog or to order online, please visit *www.allworth.com*.